CLASSIC HOLLYWOOD STYLE

Caroline Young

F

FRANCES LINCOLN LIMITED
PUBLISHERS

CONTENTS

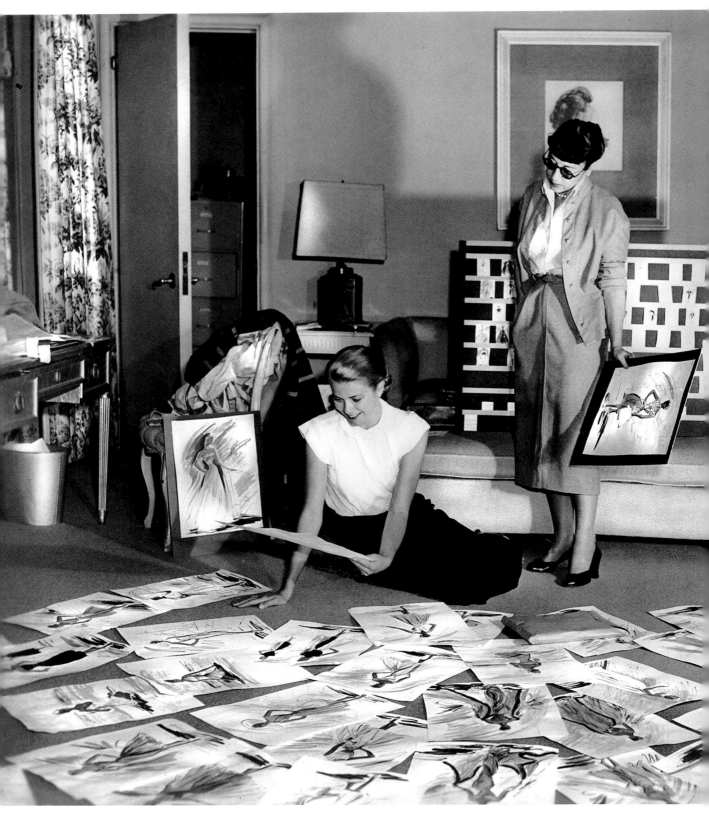

INTRODUCTION

Selecting just thirty-four films to represent the look and style of Hollywood's golden age was a difficult task. There are so many films in which the costumes have stood the test of time and have become an intrinsic part of screen history. Audrey Hepburn on a deserted Fifth Avenue in a black evening gown and sunglasses, Marilyn Monroe standing over a subway grate as her white pleated dress blows up around her, Marlene Dietrich performing in a Moroccan nightclub in top hat and tails.

Behind each of these iconic looks was a costume designer who created the wardrobe to not only suit the star, but shape the character and perfectly blend into the scene. It just so happened that these clothes sparked fashion trends and shaped some of the best loved and most remembered moments in cinema. Under Hollywood's studio system, costume designers like Adrian, Travis Banton, Orry-Kelly, Irene and Jean-Louis were stars in their own right. Pages in movie magazines were devoted to the gowns worn by the stars onscreen, offering tips and sewing patterns for women to recreate the look themselves. But perhaps the most celebrated costume designer was Edith Head, winner of eight Academy Awards for Best Costume Design.

In the early years of cinema, costumes were a secondary consideration in filmmaking. Actors were required to supply their own costumes and so those with a large wardrobe would get the better parts. One of the early exceptions was French designer Paul Poiret's Renaissance wardrobe for Sarah Bernhardt in *Queen Elizabeth* (1912). But by the 1920s the wardrobe department began to take shape. Cecil B. DeMille was one of the first directors who believed costume added exoticism to movies in his epic silent films, while designer Natacha Rambova explored modernism in her costumes.

Legendary costume designer Edith Head shows Grace Kelly the sketches for her role in *To Catch A Thief* (1954).

Ordinary women began to look to Hollywood to copy the style of their favourite movie stars. Jazz babies Clara Bow, Louise Brooks and Joan Crawford led the fashion stakes in flapper style. After the Wall Street Crash in 1929 unemployment skyrocketed, banks closed and farmers lost their land. Hollywood embraced glamour as a way of escaping the reality of the Great Depression. From the short fringed flapper dresses of the 1920s, hemlines suddenly fell to the floor and waistlines lifted as they entered the next decade.

The 1930s is often considered the golden age of cinema. It was a period marked by the Depression, with bread lines, soup kitchens and millions out of work. But studios defied the crippling economic climate to blow the budget on glamorous stars, costume and sets, depicting a silver screen of exotic people, places and luxury. Each week 85 million Americans queued up around the block to experience the mysterious beauty of Greta Garbo and Marlene Dietrich, the synchronised chorus lines of Busby Berkeley musicals, Fred Astaire and Ginger Rogers spinning on the dance floor and glamour girls like Carole Lombard and Jean Harlow sipping champagne and slinking in satin gowns at society parties. 'The early motion pictures were pure escapism and quite unreal. Sometimes the clothes were pretty ridiculous. You know, the poor working girls going to work wearing sable, fantastically dressed,' Edith Head once said. 'In that period there was something called the matinee audience. Women would stand in line, come rain or come shine, to see what their favourite stars were wearing.'

After signing with a studio, every aspect of a starlet's life was controlled. She was told what film roles to do by the studio bosses, and the publicity department would scrutinise her private life, ensuring there was no scandal for the gossip columnists to delight in. Marlene Dietrich and Greta Garbo arrived as plump European starlets but were moulded into sleek mystique while Rita Hayworth was transformed from Spanish beauty into all-American girl with the help of red hair dye and electrolysis to lift her hairline. The costume designer's job was to create a perfect silhouette for the actress. Fittings often took hours and some costumes would require several. In the wardrobe departments there were hundreds of expert seamstresses, milliners, furriers and embroiderers creating

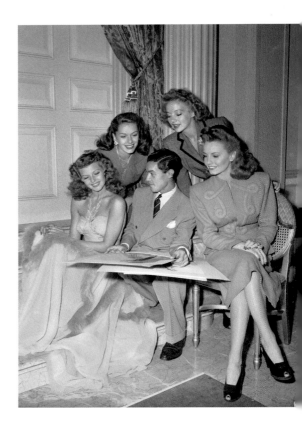

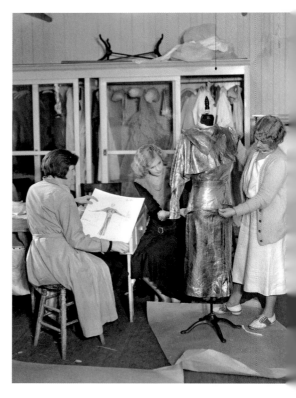

Left Jean-Louis with Rita Hayworth, Jinx Falkenburg, Evelyn Keyes and Janet Blair during the filming of *Cover Girl* in 1944.

Below left MGM's wardrobe department create a gown worn by Joan Crawford in *Letty Lynton* (1932), designed by head costume designer Adrian.

luxurious gowns and hats. The head designer's assistant would lay out the wardrobe plot with a numbered scene and description of the costume. New actresses were draped in cloth to find the style that would suit them, and were then photographed in the fit. A dummy was padded into the stars shape, and was kept in the fitting room to measure her clothes on.

A major shake up in Hollywood was the introduction in 1934 of a censorship board set up by the Legion of Decency and headed by former Post Master General Will Hayes. It was forbidden for women to show too much flesh, for there to be long lingering kisses onscreen and for any blasphemy to be uttered.

As the Second World War raged in Europe and the Pacific, Hollywood was affected by the sober mood and the necessary rationing. Instead of high society and whimsical plotlines, movies reflected the fears for the future and chose realism over fantasy. As women made do with restrictions on materials, by drawing seams down their bare legs and recycling clothing, so did Hollywood. Bugle beads that had been imported from Eastern Europe were now impossible to get hold of. Cotton replaced silk, as it was needed for parachutes, and designers raided the wardrobe departments to re-use discarded costumes. Instead of the ruffles, sequins and ribbons of the 1930s, costume designers dressed their stars in tailored suits. Shoulder pads were a popular silhouette of the 1940s, first inspired by Joan Crawford, when her favoured designer Adrian made her prominent shoulders a feature.

In the 1950s, breasts were back in fashion, with a wave of pneumatic starlets on the screen. Then along came Audrey Hepburn, with her gamine looks, cropped hair and Bambi eyes. She was the sophisticated European who was a regular visitor to Paris in her movies, a city that Hollywood looked to as the epitome of romance and glamour.

The teenager was a fresh demographic represented by a new breed of gritty young actors including James Dean and Montgomery Clift, and young starlets Elizabeth Taylor and Natalie Wood. Jeans had previously only been seen on cowboys in Westerns, but now were worn by teenagers replicating the look of their rebellious screen heroes.

By the 1960s, box office audiences had dropped dramatically as studios battled it out against television. The studio lots were emptying and the costume departments were one of the first to suffer. Instead of custom making every costume, producers decided that wardrobe could easily be bought and designers became more like shoppers. The biggest change in Hollywood was the closure of the Hays Code in 1968, when violence, nudity and sex could now be portrayed on screen in full. When Faye Dunaway was riddled with bullets in *Bonnie and Clyde*, it marked an end to the unquestionable glamour and a new move towards realism.

CAMILLE 1921

The Lady of the Camellias, the 1848 novel by Alexandre Dumas, has been adapted into around twenty different films, sixteen Broadway performances and an opera, *La Traviata*. George Cukor's 1936 version, starring Greta Garbo, with its romantic crinolines and her hair in corkscrew curls, may be the most famous, but the 1921 silent version is an Art Deco, modernist vision designed by Natacha Rambova, and starring Crimean-born actress Alla Nazimova as Marguerite and Rudolph Valentino as Armand.

Natacha Rambova was part of a tight creative female circle led by Alla Nazimova, who was said to be the controlling force behind *Camille* and other productions they worked on, including *Salome* (1923). She created a modern version of *Camille* to set it apart from previous unsuccessful versions on screen, although *Picture Play* magazine suggested Nazimova 'found that she didn't look well in hoop skirts so she made Camille a modern heroine.'[1] Nazimova had the hardened look of the 1920s, with powdered face, hard, kohl-rimmed eyes and a thin, flat-chested body which was displayed in gowns without underwear in the film.

Nazimova had 'autocratic control' over her films, but listened and worked with her art director Natacha Rambova. While the director was Ray Smallwood, it was very much Rambova and Nazimova's vision. Their collaborative work pushed boundaries and transformed Hollywood filmmaking into one of style and symbolism.[2] Nazimova and Rambova

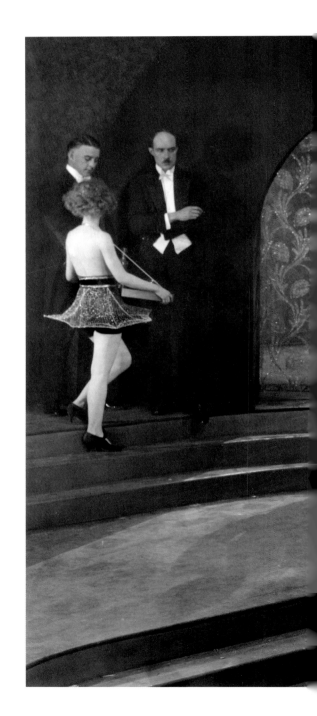

Marguerite, in the background, wears a long kimono-shaped gown covered with the emblem of camellias. With their marcelled hair, headbands and strappy dresses, the casino guests display the fashionable modern look of 1921, while the usherette's skirt is a German Expressionist spiderweb, reflecting an earlier spiderweb motif on the wall of the casino.

wanted *Camille* to reflect the latest fashions in costume and architecture in Europe, using inspiration from a wide range of sources including fashion designer Paul Poiret, Parisian interior designer Émile-Jacques Ruhlmann and Berlin architect Hans Poelzig.[3] The film opens in a snowy winter in Paris, with the words on screen, 'Camille! What a magic conjuring of players who have portrayed Dumas' immortal "Daughter of Change". And with them comes to mind the thought of basque and crinoline. But why not a Camille of today? Living the same story in this generation?'

The interior of Marguerite's apartment is Art Deco, curvilinear, with arched doorways, semi-circular glass within semi-circular windows and lights hanging low. There were shimmering transparent curtains, a round bed, a ceramic fountain in the foyer, scattered velvet pouffes and fairy lights in decorative camellias around the arched entrance to the alcove.[4]

Get the look with a sleek silver gown, worn without underwear, a sheer cape embellished with Art Nouveau camellias, dramatic kohl around the eyes and head topped with wild curly hair.

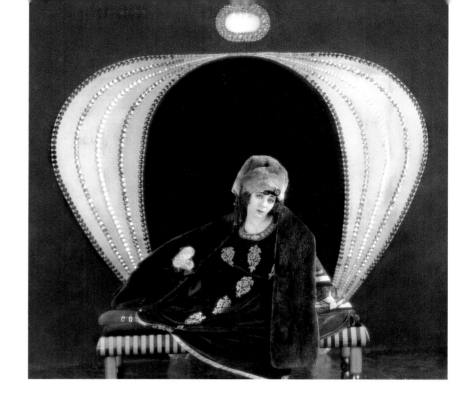

Above right Alla Nazimova's bizarre looks complimented the striking, modernist costumes and sets.

Left The camellia was used as a uniting symbol throughout the film, incorporated as decoration in the casino and Margeurite's apartment, and on her costumes. Her first sleek, shimmering gown is embellished with a camellia on the bodice. The sheer, floor length cape is decorated with large Art Nouveau camellias, and trimmed with fur which weighs it to the ground as she swishes it around her.

Nazimova was a Russian-born émigré to New York who, by the time she was signed to Metro and arrived in Los Angeles in 1918, had been a star on stage in Moscow, and a popular and critically acclaimed actress in New York, even having a theatre named after her.[5] 'Nazimova, the very name contains magic, especially to people of my generation,' said MGM's hairdresser Sydney Guilaroff. 'I recall how much I loved her silent version of *Camille* with a young Rudolph Valentino. I thought her acting in *Camille* was simply wonderful . . . There was a real mystery that surrounded Nazimova – a mystique, an almost unreal quality about her.'[6]

But Madame, as she insisted on being addressed, had a reputation as a demanding diva on the Metro lot. She would raise an eyebrow, deliver a withering look, and her artistic temperament was pandered to. She was a woman who made statements that often seemed bizarre, such as 'my closest friends are young girls', but she would give strong support to young women in the industry, including 16-year-old Patsy Ruth Miller who was given a role in *Camille*. Nazimova was a strong woman ahead of her time, who believed bearing children wasn't a woman's duty. In an interview with *Motion Picture* magazine she said 'a woman living a creative life is bound necessarily to do things sometimes defiant to convention. In order to fulfil herself she should live freely. Children bring fear, and in that way arrest personal development.'[7] Nazimova's lavish Sunset Boulevard home was known as the Garden of

Alla, a heavenly artistic haven for those early Hollywood people who were in her circle. 'There in the perfumed air, amid purple divans and buffets heaped with caviar, an international coterie gathered for costume balls, movie screenings or Madame's demonstration of Oriental dances.'[8]

Romantic icon Rudolph Valentino was cast as Armand after an extensive search by Nazimova for a dark and passionate actor. 'I was hunting for a young man to play Armand,' recalled Nazimova. 'I had already interviewed scores of young men, but none seemed to match my idea of a romantic star. Even Valentino didn't. He was fat and far too swarthy. His bushy black eyebrows were grotesque. Yet I saw that if he could reduce and pluck his eyebrows, he would be the perfect Latin lover.'[9] Nazimova brought Valentino to Rambova's office. He was wrapped in furs from filming an arctic scene on a nearby set and was covered in perspiration. Rambova was at first not impressed, but when he smiled, he showed his straight white teeth, and she was intrigued.[10] Valentino fell in love with Rambova during filming of *Camille*, and they would be married soon after, but at first she found him irritating. 'At that time I was very serious, running about in low-heeled shoes and taking squints at my sets and costumes. Rudy was forever telling jokes and forgetting the point of them, and I thought him plain dumb. Then it came over me . . . that he was trying to please.'[11]

When Valentino's tragic early death was announced in 1926, a hundred thousand fans tried to get a glimpse of his body as it lay in state. He was the first idol, adored by millions. When *The Shiek* was released in 1921, he had become an instant sex symbol, and also launched a new word: being a 'shiek' was to be romantic and hot. *The Sheik* also set a trend for all things Oriental. Valentino was a feminised version of a masculine ideal, with eyeliner, slicked back hair, slave bracelets and Arabic robes. Male audiences were said to have walked out of the cinema in protest at this virulent lover on screen, but women adored him.

It was Rambova who had helped to shape his image of the great seducer shadowed in sexual mystique. When she gave Rudy a platinum slave bracelet, it launched a trend for men. Rambova's career was overshadowed by her short-lived marriage to Valentino, but she had been one of the few to combine art direction and costume design; creating both sets and costumes for a movie.[12]

Natacha Rambova, despite the exotic name, was born in Salt Lake City, as Winnifred Shaughnessy. She trained as a ballet dancer and while on tour with Kosloff's company she began designing costumes, inspired by Orientalist and Art Nouveau designers Paul Poiret, Léon Bakst and Aubrey Beardsley. Poiret's exotic designs were cutting edge fashion for women, with his tunics, lampshade gowns, hobble skirts, turbans, Japanese obi belts, and the bra. 'I freed the bosom and gave liberty to the body,' he declared.[13] He used luxurious

fabrics such as metallic lamé, soft leather and satin hand-painted or embroidered with gold thread. These influences can be seen in Rambova's film work, including *Camille* and *Salome*, where she used strong colours, shimmering fabrics, velvet and fur.

Rambova could be aloof, icy, and as Nazimova's protégé Patsy Ruth Miller said: 'Her pretensions were too great. She had been a ballerina and would never let you forget it.'[14] Rambova used her influence with Nazimova to have more control of the production of *Camille*. She paid attention to the look of Valentino, his clothes, his hair and his presence on camera. As a provincial nineteenth-century Frenchman, Rambova insisted that Valentino was not to pomade his hair. She had him wash out 'the patent leather gloss', 'and then she fluffed his locks with curling irons'. In the later scenes, bitter and broken-hearted, he returns to having slicked back hair.[15] Nazimova also took action on Valentino's appearance, plucking his eyebrows, instructing him to lose weight, and giving him an artificial, made-up face with dark eye-shadow and lipstick.[16] In one scene he seizes Nazimova and kisses her angrily. 'This was the "cruel" Valentino,' said his biographer Alexander Walker. 'This was the so called "sex-menace". This was the element of "threat" in him that worked its way to the top of the scale of romantic emotions he stirred up in the hearts of women.'[17]

Nazimova had some positive reviews for *Camille*. *Screenland* praised her 'exotic, dazzling but baffling beauty' but *Motion Picture Classic* in December 1921 was more scathing of the film. The reviewer compared it unfavourably to the brilliant impressionism of *The Cabinet of Dr Cilagari* (1920), and likened her performance to burlesque, with 'hints at pathos'. Her decision to cut out Valentino from the death bed scene was seen to be arrogant. *Camille* marked the end of Nazimova's contract with MGM. They had had enough of her temperament, and let her go soon after the film was released.

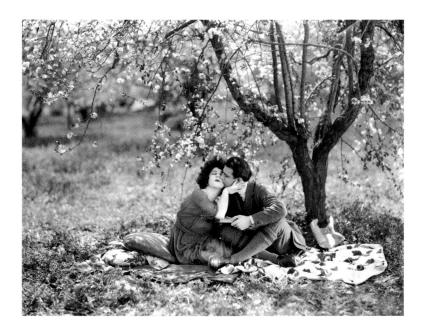

In the countryside, Valentino wears the 1920s sportswear of long socks over breaches and a Norfolk jacket. Nazimova wears a loose, layered smock with buttons down the front.

OUR DANCING DAUGHTERS 1928

MGM's *Our Dancing Daughters,* a tale of three young flappers looking for love, reflected the decadence and loosening of morals of young people in the 1920s. The plotline showed the new attitudes and freedoms that conflicted with puritanical codes of conduct, particularly prohibition which had been introduced in America in 1920. It was the film that made Joan Crawford a star and captured her silent era persona – the good time flapper with the fast dance moves. It also starred Dorothy Sebastian and Anita Page, a very popular silent screen star once named 'the girl with the most beautiful face in Hollywood.'

The flapper danced the night away in shimmering dresses with raised hems and low waistlines. Her hair was worn short and waved, and she accessorized with strings of pearls and diamante.

The 1920s was the first decade of modern society as we know it, with the advent of rapidly changing technology and a desire to live the good life. It was the era of flappers, jazz and cocktails, the era which F. Scott Fitzgerald called the 'most expensive orgy in history'. The flapper was a new breed of young woman – promiscuous, hard drinking and always with a cigarette, dancing all night and provoking outrage amongst their elders. In *The Standard of Living*, Dorothy Parker described the girls who 'painted their lips and their nails, they darkened their lashes and lightened their hair, and scent seemed to shimmer from them. They wore thin, bright dresses, tight over their breasts and high on their legs, and tilted slippers, fancifully strapped. They looked conspicuous and cheap and charming.'

Fashions in the twenties were a rejection of the constraints of women's clothes that had restricted them for centuries. Instead of the tightly bound, corseted bodies, long skirts and high necklines, women raised their hems and threw away their corsets. They rejected traditional femininity for flat chests and

Dorothy Sebastian, Joan Crawford and Anita Page were the good time girls in short, shimmering flapper dresses designed by David Cox. Anita Page's dress was described as 'a formal evening gown of gold lamé cloth trimmed with gold bead fringe, with a spray of rhinestones on the bodice.'

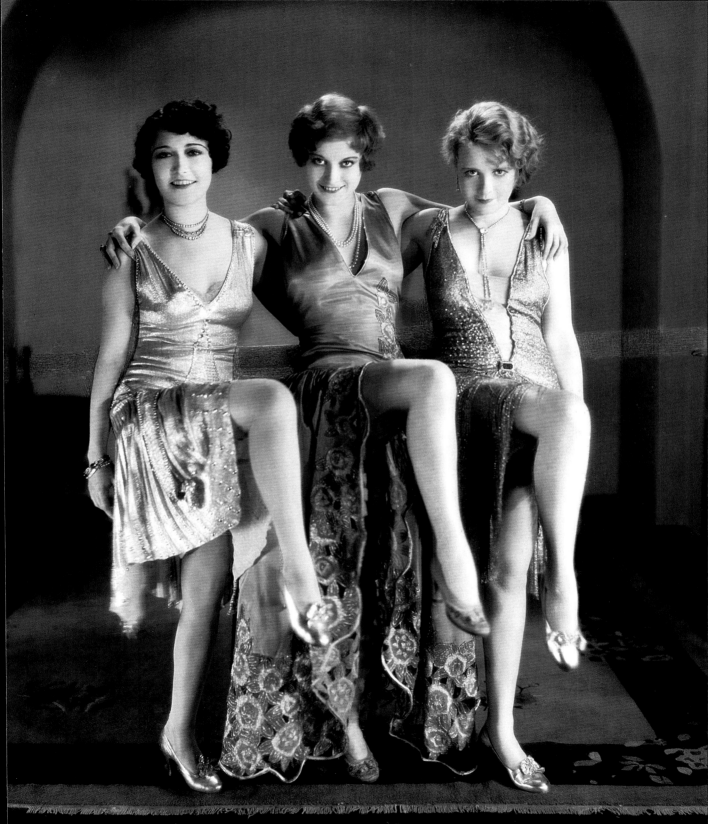

bobbed hair, while loose clothing also offered the freedom of movement for fast and energetic jazz dances like the Charleston.

Woman had fought their corner in the workplace during the First World War, albeit for necessity in keeping the country running while men were overseas. But when the war ended these social changes allowed women new freedoms not only at work but when forging relationships. Young people could meet the opposite sex in more informal situations such as at the movies, at dances and in cars.

Our Dancing Daughters was, as declared by the MGM publicity department, 'easily the best in the whole crop of flickers showing the younger generation on the loose in these days of prohibition.'[1] 'You'll see pretty girls dodging frankly in and out of teddies and tossing their dancing frocks aside.' It was one of the first films to be marketed on its fashions. Press releases were sent out to movie magazines with photos and descriptions of what the young actresses were wearing, with pages of editorial content devoted to them. As 'Dangerous Diana' Medford, Crawford said her costumes were 'the very essence of restless activity'.[2] The costumes reflect the fashions of the time and were designed by David Cox, an assistant to Gilbert Clark, designer for Lady Duff Gordon. Cedric Gibbons' fresh and modern sets acted as a backdrop to the costumes and were inspired by 1925's Exposition des Arts Decoratifs et Industriels Modernes in Paris. The designs were 'uncluttered – they were clean, functioned and often highly stylised, a look that was to cause a major revolution in movie décor.'[3]

In a reckless scene at a yacht party, 'Dangerous Diana' is carried through the crowds and placed on a table to keep on dancing the Charleston, in a fringed David Cox dress.

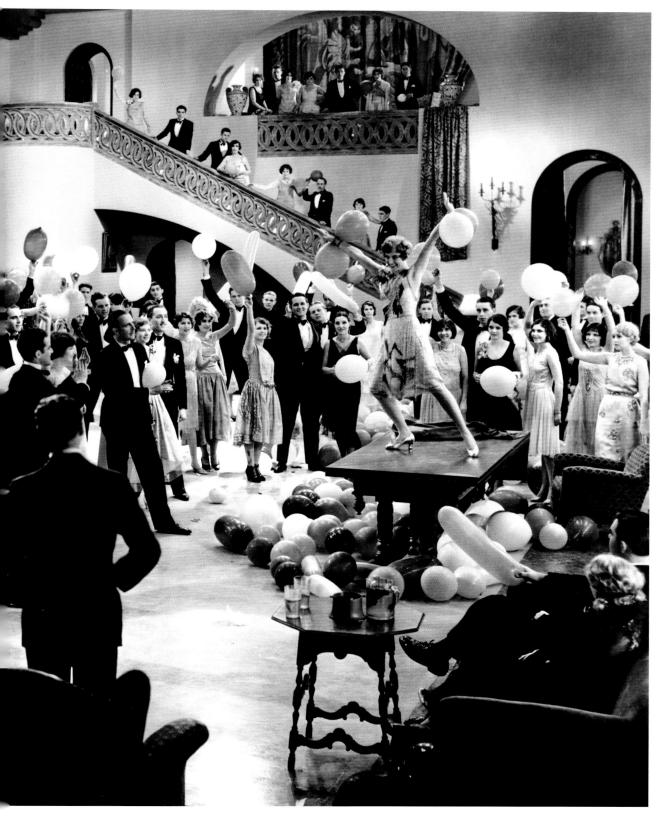

She may forever be remembered for *Mommy Dearest*, as the strict, neurotic mother with an obsession for coat hangers, but Joan Crawford was a ferocious rising talent in the mid 1920s. Before the heavily painted eyebrows and lips, she was a slender and pretty young flapper who was known as the best Charleston dancer in Hollywood. F. Scott Fitzgerald said Crawford was 'the best example of the flapper, the girl you see in nightclubs, gowned to the apex of sophistication, toying with iced glasses with a remote, faintly bitter expression, dancing deliciously, laughing a great deal with wide hurt eyes – a young thing with a talent for living.'

Arriving at the MGM lot as one of many new starlets, she was given a $75 a week contract and after being told to lose twenty pounds she dieted on coffee and steak to get her weight down. She made the effort to be seen in clubs, dancing her heart away at Hollywood hot spots like the Cocoanut Grove. 'I went to lunch dances, to tea dances, and to dance at night, and everywhere I went I informed my publicist. If I went out with even a passable dancer, and I went out with many really fine ones, I usually came home with a cup or trophy.'[4]

In a shameless publicity campaign, the actress born Lucille Le Sueur in Kansas was renamed through a competition in *Movie Weekly* magazine. The

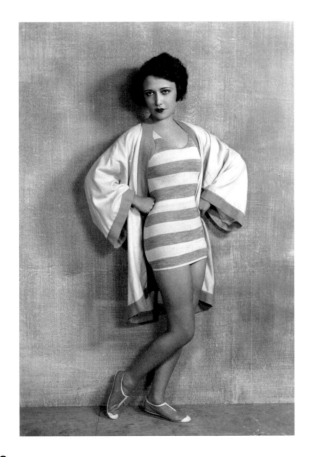

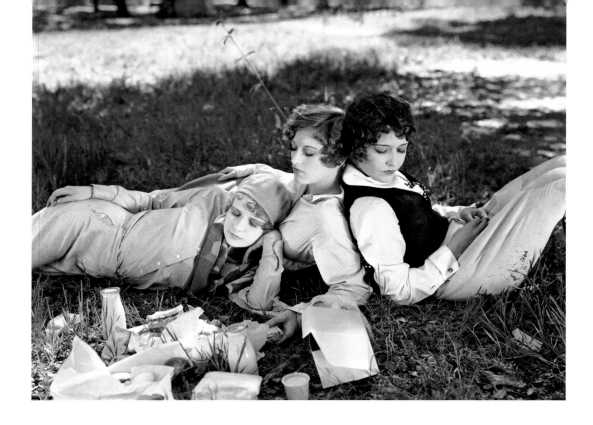

OUR DANCING DAUGHTERS 1928

Above The three young flappers spend some time in the country, in their 1920s sportswear of shirts and slacks, waistcoats, berets and printed scarves.

Far left Dorothy Sebastian wore a striped bathing suit with a loose cotton dressing gown, and her lips painted into the twenties cupid bow style.

Left A press release revealed Anita Page wore 'a negligee of peach coloured satin trimmed with crème coloured lace, the material of which the coat is made.'[7]

winning entry was Joan Crawford, a perfect name for the 'auburn-haired blue-eyed beauty . . . she photographs remarkably well, and is far above the average in intelligence. She is strictly an American type, with a charm and elegance that stamps her a daughter of Uncle Sam.'[5] After years of small roles, she was catapulted to stardom in 1928 on the success of *Our Dancing Daughters*. Inspired by her fast dance moves, the Crawford Romp became a new dance craze, and was even introduced on stage by dancers before the film was shown.

'I plucked my eyebrows to a little line and drew a tiny little cupid's bow for a mouth. Off screen when I was dancing every night, my skirts were a little too short, my heels a little too high, and my hair a little too frizzy and a little too bright,' said Crawford. 'I wore brilliant red nail polish when everybody else wore pink, and when it was the thing to be fair I got a deep suntan . . . this was the era when everybody wanted to be the complete flapper, to be noticed, to dance faster than anybody else.'[6]

The success of *Our Dancing Daughters* would trigger two sequels, *Our Modern Maidens* (1929) and *Our Blushing Brides* (1930), which was Crawford's first 'talkie' and her first pairing with MGM designer Adrian. Instead of the fringed flapper dresses, he designed sleek bias-cut gowns. It also reflected the changes brought on by the Depression, with the tagline 'America's dancing daughters go to work!'

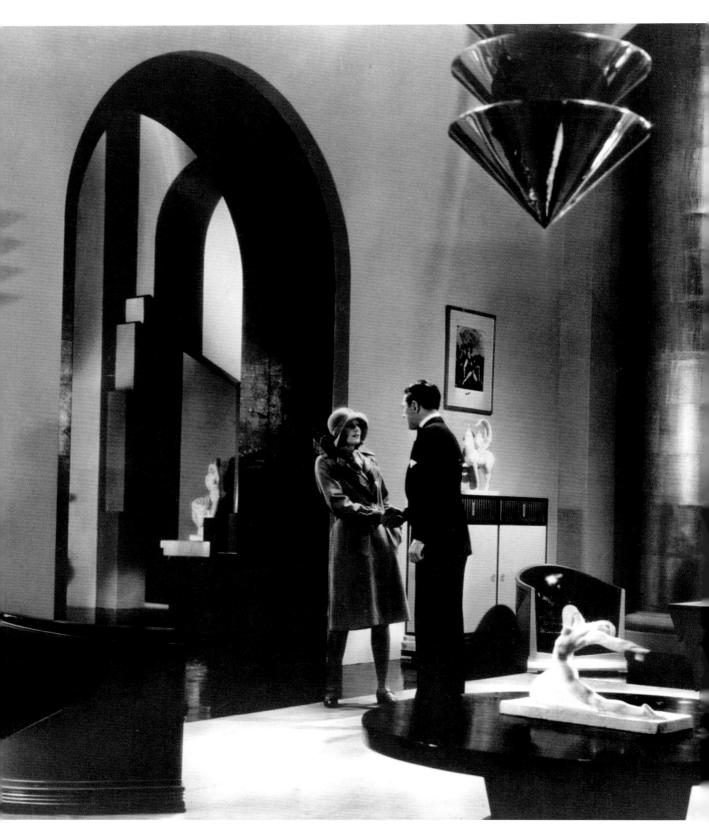

A WOMAN OF AFFAIRS 1928

Greta Garbo's plaid-lined trench coat and cloche hat in *A Woman of Affairs* was a new look and a new fashion for women in the 1920s. The trench coat was first established as a male wardrobe staple for officers in the First World War, but a woman had never worn such a style on screen. It was smart but tomboyish, and the exact opposite of the flapper in short fringed dresses and frills.

When Michael Arlen's novel *The Green Hat* was published in 1924, Iris March's scandalous and carefree actions caused a stir, but captured the mood of the times. Iris is a modern woman who strides about in men's clothing while embarking on countless affairs. It reflected the freedom women felt in the 1920s, not just in the freedom of loose, unstructured clothes, but in how they could conduct themselves. Designers like Coco Chanel were also championing sportswear and using masculine details for female collections. Young women in America and Europe sought to copy the carefree style of Iris and her androgynous sports clothes.

> For Greta Garbo's chic androgynous look, wear a belted plaid-lined trench coat with upturned collar and a cloche hat.

When MGM bought the film rights to *The Green Hat* for $50,250, they softened the more controversial aspects of the book to make it more savoury for the screen. Iris March was renamed Diana Merrick, her husband commits suicide because of embezzlement instead of venereal disease and the film was retitled *A Woman of Affairs*. Greta Garbo was cast as Diana, 'a gallant lady – a lady who was perhaps foolish and reckless beyond

Garbo with Johnny Mack Brown and Douglas Fairbanks Jr, seated. Garbo's belted plaid-lined coat was the epitome of her androgynous chic and launched the trench coat as a must-have unisex item. She thrusts her hands into the pockets of her coat, sticks up the collar and pulls a cloche hat over her head, separating herself from the rest of the world.

need.' In the opening scene, Diana's wild side is depicted by her dangerous driving, which will eventually be her downfall. Like a young Isadora Duncan, she speeds along a country road in her open top car, almost taking out a hay truck and ditch diggers.

Diana's style was also a departure for Garbo and the vamps she had been typecast as in films like *Flesh and the Devil* (1926) and *The Torrent* (1926). Garbo declared, 'I don't want to be a silly temptress. I cannot see any sense in getting dressed up and doing nothing but tempting men in pictures.' Offscreen, Garbo favoured slacks, heavy coats and brogues and she went by the mantra of comfort for clothing. 'There's nothing attractive about the suffering face of a girl with ill-fitting shoes,' she said.[1]

Costume designer Adrian had recently been signed to MGM and was given the task of dressing the temperamental Garbo, who had a habit of falling out

Director Clarence Brown showing Garbo a radiogram inbetween takes. Garbo wears a velvet embroidered dress and flat shoes. The cameraman in the background wears a typical Los Angeles 1920s sports look of long argyle socks, brogues and pantaloons.

with her designers. Before meeting Adrian, Garbo was difficult and impatient during costume fittings. 'Dresses! I wish they were all bags, and all alike, to jump into quick!' she once said.[2] Working with André-Ani on *Love* (1927) tensions reached breaking point, and when Gilbert Clark was assigned to *The Mysterious Lady* (1928), he walked out mid production. Adrian was brought in as Clark's replacement. But where other designers failed, Garbo warmed to Adrian and theirs would be a successful screen partnership until 1941, when they both left MGM.

'I decided she reminded me of a fine strong tree with her feet planted firmly on the ground. Her glamour grew out of her earthiness. I worked from that premise,' said Adrian in an interview with *Silver Screen* magazine.[3] He removed the 'tinsel and glitter' and instead he gave Garbo 'pyjama ensembles', 'geometric designs in vivid colours' and 'scarves wrapped around the head'.[4] 'The Garbo girl must never wear anything that would come under the descriptive category of "dainty". Such things are for flappers and Garbo is not a flapper,' advised Adrian in a 1929 article in *Screenland*. Garbo's style was 'lovely tweeds in shades of greys and browns . . . tailored coats with quite short skirts – tailored satin blouses or woven sweaters, preferably designed in horizontal stripes, suede pull-on gloves . . . medium low-heel Oxfords.'[5]

Adrian used the author's descriptions as a basis for Diana's costumes. Arlen wrote: 'Her hands were thrust into the pockets of a light brown leather jacket – *pour le sport* – which shone quite defiantly in the lamplight: it was wide open at the throat and had a high collar of some fur of a few minks. One small elephant marched across what I could see of her dress, which was dark and not *pour le sport*.'

Adrian designed a simple trench coat with plaid lining which Garbo loved. She wore it with a trendsetting cloche hat, pleated skirt and geometric scarf wrapped around her neck. It was this simplicity in costume that brought Garbo more confidence and the slouchy, casual look added mystery and allure to the dramatic scenes.[6] The *New York Times* said 'Miss Garbo gives a most intelligent and fascinating impersonation of that "sad lady"'.[7]

Garbo strides gloomily in her heavy coats and hats, paces back and forth on a verandah in a flowing chiffon dress with sparkling sequined jacket, and in a loose, draped white gown in the hospital, surrounded by Breton nuns, she mournfully cradles a bouquet of flowers in her arms, representing the baby she has lost.

At first MGM head Louis B. Mayer and director Clarence Brown were against this new look. 'They feared she would lose all her allure if she came down to earth,' said Adrian. But the simple clothes allowed her acting style and her features to shine through. As well as the trench coat, Diana traipses through

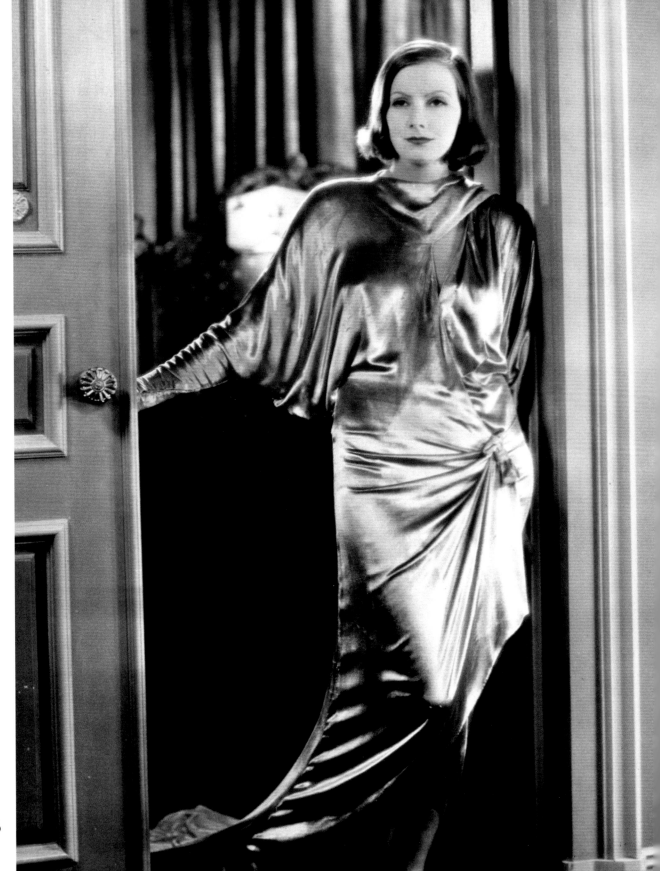

Left Garbo wears a gold satin negligee, with a low 1920s waistline gathered to the side and draping dolman sleeves. Adrian was inspired by Oriental styles and often incorporated wide sleeves that gathered at the wrist.

Right The wardrobe Garbo was given for Diana Merrick was closest to her own natural style and this trench coat with its pink and black plaid lining seemed to perfectly represent her androgynous look. Loosely tied around her neck was a geometric print scarf. 'Simplicity is the key note to her smartness, as it should be with all women of taste,' said Adrian.

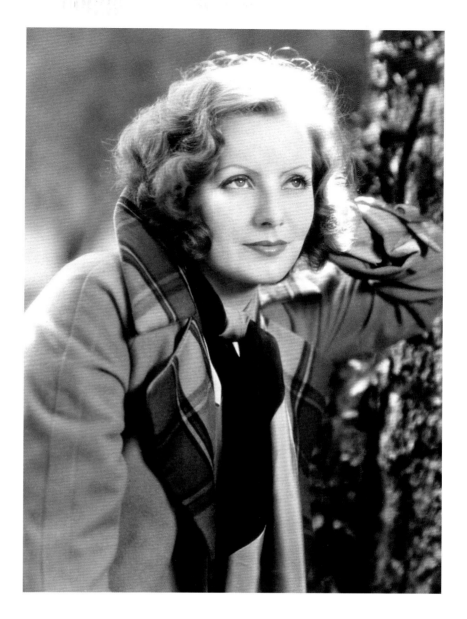

the foggy streets of London in a pleated grey skirt, suede jacket with turned up collar, cloche hat and silk scarf. For the first time Garbo was happy with her onscreen wardrobe. Adrian said: 'Her natural aloofness and the manner of her bearing make it possible for her to put meaning into simple clothes.'[8]

On release of the film, cloche hats and tweed, plaid-lined trench coats were reproduced in department stores across the country. Garbo would continually champion a masculine style of dressing. The following year, in *The Single Standard* (1929), Garbo wore the clothes of her lover, and sparked a trend for women wearing men's clothes, also imitated by Marlene Dietrich and Katharine Hepburn.

MOROCCO 1930

Marlene Dietrich marked her American film debut with a dramatic entrance in top hat and tails in *Morocco*, playing Amy Jolly, a Parisian cabaret star who performs in the seedy nightclubs of North Africa.

Morocco was the first film in a collaboration between Marlene Dietrich, the star, Joseph von Sternberg, the director, and Travis Banton, chief costume designer at Paramount. All three had a part to play in shaping the image of Dietrich, often in masculine wear: a tuxedo in *Morocco*, leather flight suit in *Dishonoured* (1931) and the white military suit in *The Scarlet Empress* (1934).

When Dietrich arrived in Hollywood from Berlin, she was billed as the new Greta Garbo, the next exotic import and the 'the woman all women want to see'. She was already a star in Berlin after playing heartless singer Lola Lola in Josef von Sternberg's *The Blue Angel* (1930) but was still an unknown in America when she arrived in Los Angeles on a contract to Paramount Pictures. She was transformed from plump German starlet to sleek movie star with the help of Travis Banton, who gave her advice on diet, exercise and massage to help shape her. Dietrich wrote in a letter back home, 'I try to eat nothing. I look good in Berlin but what was right for a buxom tart from Lubeck isn't right for *Morocco*. Amy Jolly is supposed to be sleek and mysterious.'[1]

In Benno Vigny's novel, Amy Jolly is a prostitute and drug addict, but this had to be toned down in the screenplay, and so Dietrich saw the part of Amy Jolly as '*schwabe limonade*' (weak lemonade).[2] '*The Blue Angel* had been something altogether different, the role of an ordinary, brazen, sexy and impetuous floozie, the very opposite of the "mysterious woman" that von Sternberg wanted me to play in *Morocco*,' said Dietrich.[3]

With its Moorish architecture of arches, mosaic and mud walls, and locals swathed in pale robes, *Morocco* was an exotic fantasy. Dietrich wore a sleek black evening gown with a sheer neckline, and ropes of pearls.

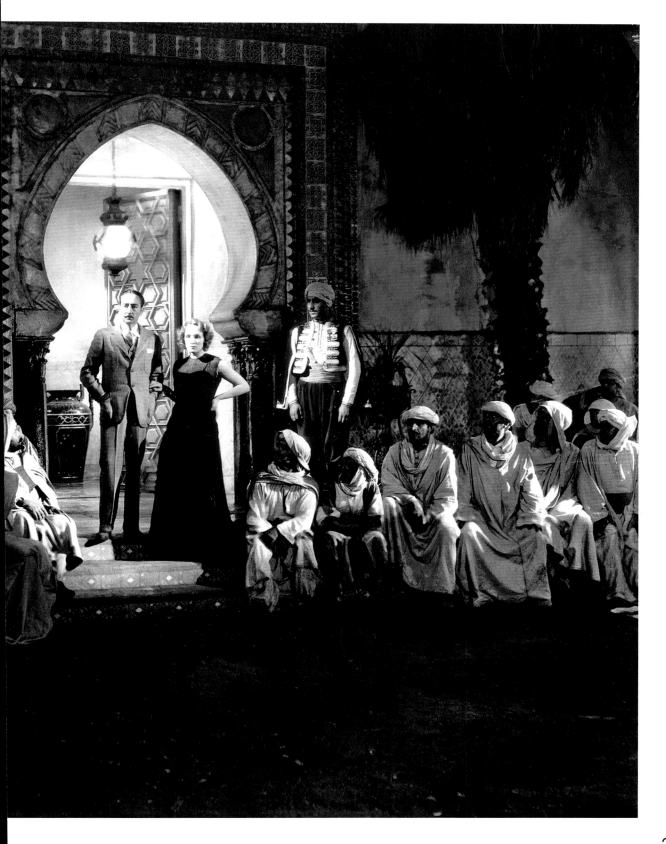

Edith Head considered Banton 'the best designer, bar none in the world'. She said she learnt more from watching him dress Carole Lombard, Marlene Dietrich and Claudette Colbert than she could have done through formal studying.[4] Banton created a camp, sexualised silhouette for Mae West and created slinky, sophisticated gowns for Lombard. He used thick luxurious fabrics on Dietrich, with layers of feathers, that didn't weigh her down because of her lean physique. 'The designer Travis Banton is talented,' Dietrich wrote home. 'Jo tells us what he wants and Travis and I discuss what the clothes should be. He has the same respect for Jo that I have and is willing to do the sketches over and over until they are right.'[5]

Texas-born Banton got his first taste of Hollywood when Mary Pickford chose his designs for her wedding to Douglas Fairbanks when he worked as an apprentice for Madame Francis in New York. He moved to Hollywood in 1924, working as Howard Greer's assistant at Paramount and when Greer left the studio, Banton became Paramount's head designer in 1929 until 1938. Despite having his own office, a team of staff and publicity, it was a highly pressurised job that turned him to drink. In Hollywood he had 'loathed those endless barbecue things, deadly-dull afternoons spent staring at people wallowing in swimming pools . . . even the French champagne went flat as soon as it was poured.'

Dietrich's legs had been made famous in *The Blue Angel* and in order to create anticipation for her first American movie, they were not revealed until the second act. Dietrich makes her Hollywood entrance on the deck of a ship bound for Morocco, in a patterned day dress, coat wrapped around her and a small hat with a veil mysteriously covering her face.

The selling point of the film was bringing a taste of the strange and the exotic to an American audience, and the press department helped to paint this picture. 'Turbanned tribesmen rub elbows with smartly tailored officers; richly gowned women mingle with women of the underworld, picturesquely uniformed men march to the beat of drums, tipsy soldiers loiter in some café. Over all the hot breath of the Sahara lies a curse, cruel, relentless, mysterious.'[6]

The Sahara was in fact on the outskirts of Los Angeles. 'We covered a few dusty roads with overhead trellises and palm leaves, and lined one of them with skulls mounted on sticks to provide for the entry of a company of legionnaires,' said von Sternberg.[7] They worked in temperatures of 120° F, 'dodging real estate signs and telegraph poles that could not possibly help to suggest North Africa'.[8]

In the seedy Moroccan cafe, western women in shimmering evening gowns and marcel waves mix with women in niqab, turbaned Moroccans and

Marlene Dietrich performs cabaret in top hat, tails, a white bow-tie and a pair of lace-up brogues.

The top hat, tuxedo and white bow-tie became Marlene Dietrich's signature look, worn for her first musical number in a Hollywood film. The mannish suit not only served to be provocative, but kept Dietrich's famed legs covered until the second musical number. 'I'm sincere in my preference for men's clothes – I do not wear them to be sensational,' Dietrich proclaimed. 'I think I am much more alluring in these clothes.'

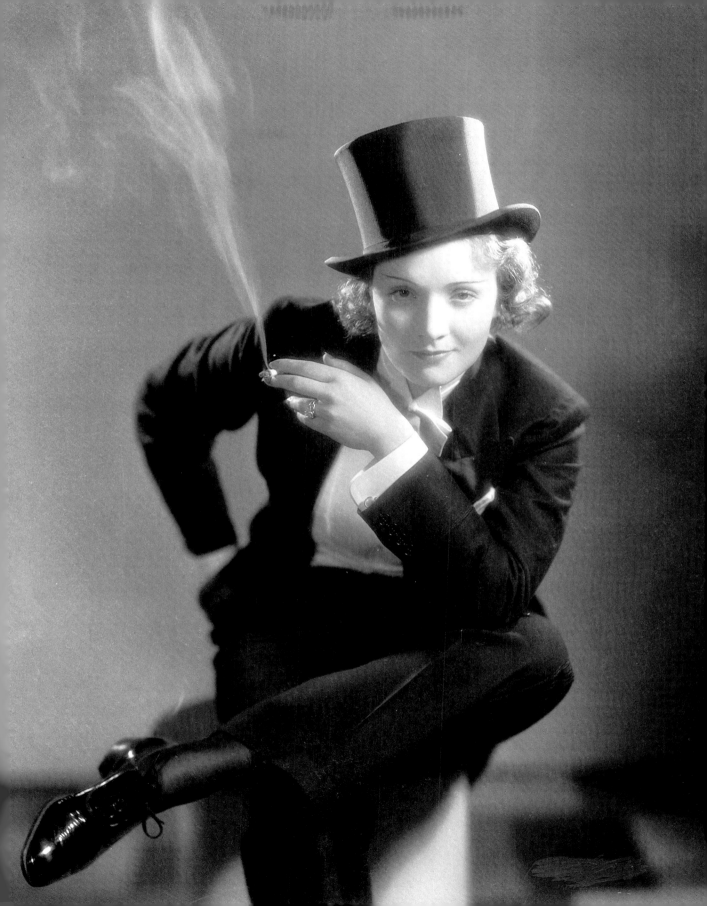

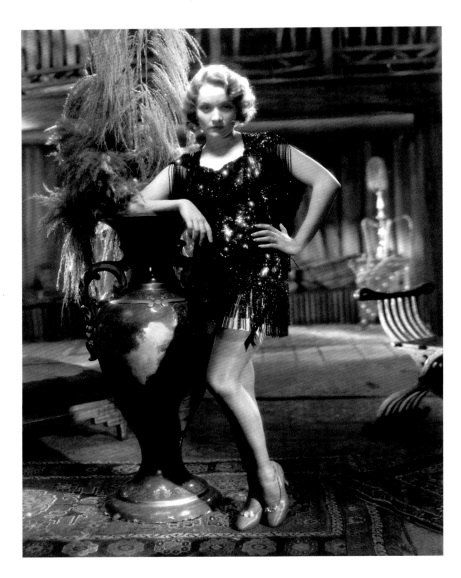

legionnaires, including love interest Gary Cooper. In her opening number, Dietrich cuts an androgynous figure in top hat and tails, titillating the audience with aloof confidence and sexuality, while she smokes a cigarette and saunters with her hands in her pockets. She flirts with a female audience member by plucking the flower from her hair, and bending down to kiss her on the lips.

Von Sternberg had seen Dietrich wearing a man's suit, complete with top hat at a Berlin party, and it inspired him to use it as a dramatic look for her first musical number in an American film. She in turn had been inspired by the drag artists of Berlin who had sported white satin top hats and could carry off garter, suspenders and stockings with style.[9] 'The formal male finery fitted her with much charm, and I not only wished to touch lightly on a lesbian accent but also demonstrate that her sensual appeal was not entirely due to

the classic formation of her legs. Having her wear trousers was not meant to stimulate a fashion which not long after the film was shown encouraged women to ignore skirts in favour of the less picturesque lower half of male attire,' wrote von Sternberg.[10]

Women wearing trousers in 1930 was controversial and seen to be wholly unnatural. But in a nightclub in an exotic, mysterious country like Morocco, anything goes. As part of the publicity, Dietrich played with the press in her mannish suits, speaking of the comfortable freedom in slacks and doing high-kicks to demonstrate her freedom of movement. 'People gasped, said "How continental!" and let it pass.'[11]

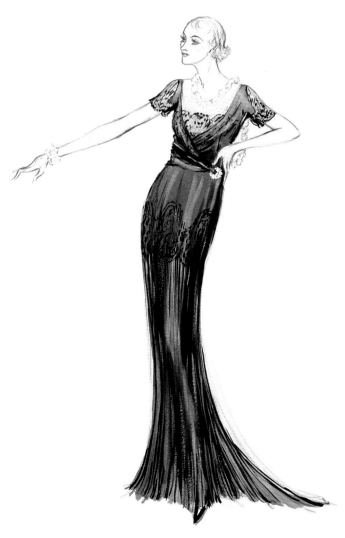

'Asked to make a trailer in which Dietrich appeared wearing white tie and tails, I ran into a storm of opposition,' said von Sternberg. 'The studio officials swore by all that was sacred that their wives wore nothing but skirts, going as far as to claim that a pair of trousers could not be lifted. Hours of debate ensued, draining my energies and theirs.'

On the release of *Morocco*, Dietrich's fame spread from Europe to America. 'Enthusiastic reviews poured in, her fan mail kept an entire department on its feet, her photographs were now requested, men wished to lay their fortunes at her feet, and celebrities vied with each other to be seen and photographed with her.'[12] As her career progressed in the 1930s with films including *Blonde Venus* (1932) and *Shanghai Express* (1932), a mystique was created through the costuming by Banton, and the way she was photographed by Josef von Sternberg, which highlighted her cheekbones and nose.

In her autobiography, Dietrich set the record straight about these myths. 'The most outlandish stories have made the rounds: that I had my molars extracted so as to highlight my hollow cheeks; that young girls and actresses would use their facial muscles to suck in their cheeks to achieve the secret effect seen on the screen. None of these tales are true. Nor are those that claim that in the shooting of *Morocco* I ran through the desert on high-heeled shoes.'[13]

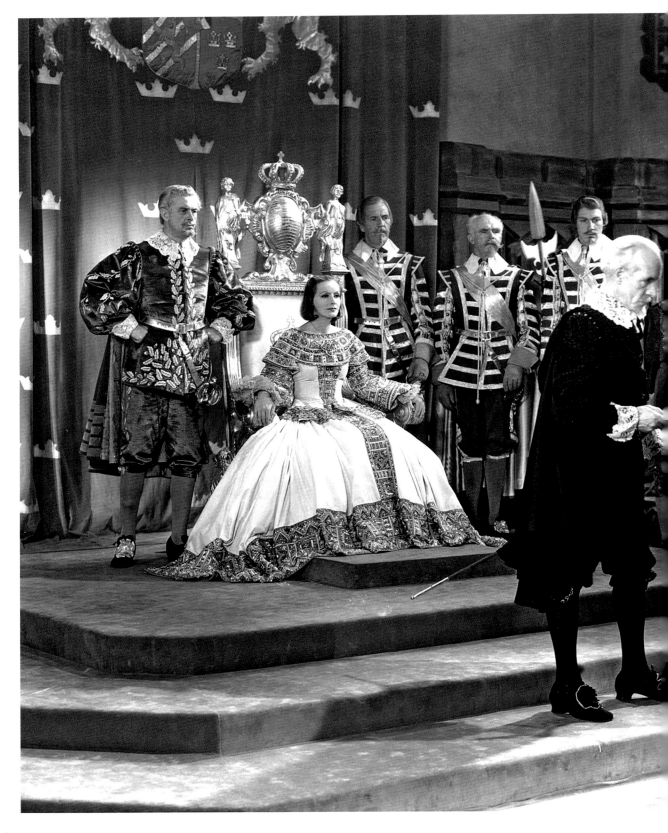

QUEEN CHRISTINA 1933

If ever there was a part that was perfect for Greta Garbo, it was Queen Christina, the seventeenth-century Swedish queen.

The MGM press machine was quick to point out the similarities between the reclusive star and the queen who abdicated the throne. They were both from Sweden, they were solitary figures, and while Queen Christina describes herself as a bachelor in the film, Garbo often referred to herself in masculine terms. *Photoplay* in October 1933 wrote in an article on *Queen Christina*: 'Her hands were beautiful and white, but strong and virile; her eyes might have belonged to either sex, her voice was clear, deep and emotional. It would be difficult to find a more exact description of Garbo.'

The mainly fictional account of the queen sees her as a strong but solitary figure, burdened by her duties and encouraged to marry for politics. But after a romantic meeting in a country inn with the Spanish envoy, played by John Gilbert, the burden of duty is too much and she chooses to relinquish her throne for love.

In the film's most famous scene, Garbo moves around the room of the inn under firelight, memorizing each surface, every object, so it will stay with her forever. 'In the future, in my memories, I shall live a great deal in this room.'

The ivory velvet gown was the most expensive MGM had made at that time, and fifteen seamstresses took six weeks to hand sew the diamonds and steel to the velvet. When it was first completed Garbo was unable to walk in it, and it had to be lightened. John Gilbert's costumes as Don Antonio were inspired by Velasquez portraits. A black velvet and gold braid coat was a replica of one worn by the brother of Philip IV of Spain.

Just before Greta Garbo sailed back home to Stockholm for a long holiday to escape the pressures of Hollywood and Louis B. Mayer, her good friend and rumoured lover, the writer Salka Viertel, gave her a biography of Sweden's seventeenth-century ruler and suggested it could be Garbo's next movie role. Viertel prepared and sent a treatment to her, and the enthused actress agreed to renew her contract with MGM as long as *Queen Christina* would be her next role.

As the most powerful actress in Hollywood, Garbo ensured she got approval of her co-stars, and she loyally insisted on the casting of her ex-fiancé John Gilbert over Laurence Olivier for the part of Don Antonio. However, *Queen Christina* did not do well at the box office and Gilbert's hopes of a comeback were destroyed. Despite the disappointing performance at movie theatres, *Queen Christina* received good reviews and particular praise for Garbo. The *New York Times* Mordaunt Hall wrote: 'Soon after entering the Astor Theatre last night for the presentation of Greta Garbo's first picture in eighteen months, the spectators were transported by the evanescent shadows from the snow of New York in 1933 to the snows of Sweden in 1650. The current offering, known as *Queen Christina*, is a skillful blend of history and fiction in which the Nordic star, looking as alluring as ever, gives a performance which merits nothing but the highest praise. She appears every inch a queen.'

Queen Christina conveys a magical quality of snowy splendor, gothic castles with oak furnishings and cozy inns lit by candlelight, where peasants swig from huge glasses of beer, and noblemen stride in cloaks, a sword by their side. MGM costume designer Adrian dressed Garbo in black broad-brimmed hats, white starched collars and cuffs and masculine travelling suits. In one scene she travels across snowy landscapes on horseback in a double-breasted sheepskin jacket with suede over-the-knee boots.

When Garbo's films were released, there was an immediate buzz around the costumes and replicas flew off the racks of department stores. *Queen Christina* in particular sparked a fashion for heavy velvet jackets, jutting white collars and bishop sleeves. Garbo was depicted in publicity stills wearing these masculine riding clothes and the *Queen Christina* look became very popular. *Woman's Wear Daily* in December 1933 noted that black velvet with a starched white collar was 'an unusual and interesting development' in fashion.[1] Boyish coats with nipped-in waists and black gowns with prominent white collars and cuffs were displayed in department store windows, while Macy's Cinema shop released a replica of the heavy velvet coat worn at the inn. A department store on Seventh Avenue took out an advert declaring, 'Seventeenth-century romance sets the keynotes for 1934 chic! Thank that forthright and fascinating lady, Christina of Sweden, for inspiring this majestic and picturesque mode.'

'It has always been amusing and interesting to me to find a woman, like Garbo, who was so uninterested in clothes, and yet had so much influence. Because she never really cared what she wore, I had to make things to fire her imagination,' said Adrian in an interview. 'I am sure the gallantry in women's clothes today – the buckle at the throat, the broad shoulder, the decidedly masculine treatment – has come from the modified Garbo clothes.'[2]

Ordinary women would take on the affectations of Garbo, with her long eyelashes, pale skin and page-boy hairstyle. It was a look that seemed to emulate magic, with a masculinity and purposefulness in the way she dressed. Cecil Beaton said of Garbo's own style, 'Her taste in clothes is a mix of what a street bandit, Robin Hood and someone from ancient Greece would wear. She dons large pirate hats and the blouses and belts of a romantic knight, always unadorned and often times with dull colours.'[3]

Greta Garbo with John Gilbert and director Robert Mamoulian. For the scenes at the inn, Garbo wore breeches with long boots pulled on over the top, a velvet doublet with bishop sleeves and large collar and cuffs.

In designing the costumes Adrian was inspired by paintings of the period, and Garbo helped during the design process by conducting research on her trip to Sweden. 'I spent many happy hours reading all I could find of the great Queen, studying the costumes of the period in the Stockholm museum, and pouring over old prints showing Sweden as it was in the days when the great Queen reigned,' said Garbo.[4]

It was the masculine costumes that Adrian created for Garbo that both the actress and Queen Christina were most comfortable in. She has a male servant to help her dress, she wakes herself by climbing out the gothic windows and rubbing snow in her face, and she gives Ebba, her favoured lady in waiting, a lingering kiss on the lips. 'But Your Majesty, you cannot die an old maid!' says the Chancellor. 'I have no intention to, Chancellor. I shall die a bachelor.'

The Queen makes her introduction galloping on horseback into the palace courtyard in black velvet and braided breaches, travelling jacket and broad-brimmed hat which slowly lifts to reveal that this masculine figure is Garbo.

Adrian took a creative license with the costumes, choosing symbolism over historical accuracy to signify the queen's conflicts over duty and love. The regal gowns that burden the queen were so heavy that Garbo could not actually

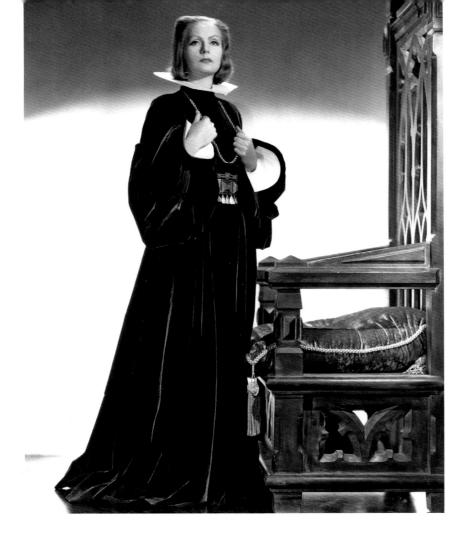

move during one fitting. One open-necked velvet gown with voluminous sleeves that fall from her shoulders creates a sense of vulnerability in a love scene with John Gilbert. But she commands her subjects in an imposing floor length military coat with upturned fur collar and rows of horizontal gold braid. Adrian said: 'In one instance, Miss Garbo wears a gown of ivory velvet adorned with bands of silver thread and bits of cut steel and square diamonds. As far as is known, the queen never possessed such a costume, but gowns on this order were then in fashion in the court.'[5]

It wasn't just Garbo's costumes that were cumbersome. Elizabeth Young, who played Ebba, recalled 'Mr Mamoulian kept on impressing on me that I was to "float" through the picture as a foil for Garbo. Nobody could have floated in that costume.'[6] While Reginald Owen, who played Prince Charles, had to be liberated from his steel breastplate with the aid of a screwdriver.

The finale of the film is one of the classics of Hollywood. Queen Christina

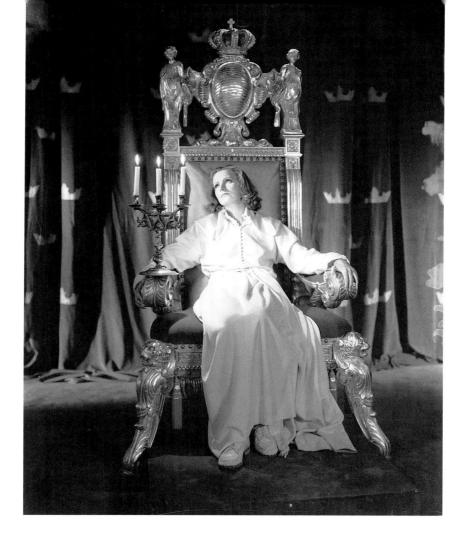

stands imperious on the bow of the ship in a velvet travelling cloak with the wind in her hair, mourning the death of her lover, yet ready to face the future with stoicism. Louis B. Mayer was worried that the unhappy ending would depress the audience. But director Robert Mamoulian promised it would be exhilarating. 'I can't describe it because it's mostly visual imagery. There are sails, there is Garbo, practically no dialogue. But I'll guarantee you will not be depressed.' At a screening for producers, he said 'they all walked out on cloud nine', overwhelmed by that final image.[7]

Left Christina is asked to choose between her country and her love for Don Antonio. Her black robes appear noble and sacrificial, her head offered up once again on a stiff white collar, and the white cuffs separating her hands from her body as Don Antonio kisses them.

Above Wearing a plain white robe as she sits on the illuminated throne, surrounded by candlelight. In dramatic moments Garbo would often be completely stripped back to allow the emotion to shine through.

FLYING DOWN TO RIO
1933

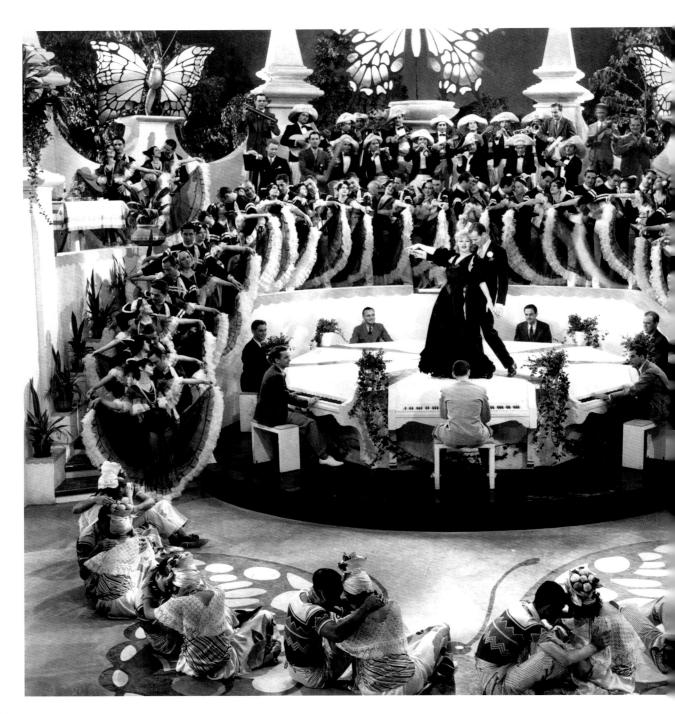

'Like lyrics and music by Irving Berlin, they blend, and we blended. It was wonderful,' said Ginger Rogers, of her famous pairing with Fred Astaire.[1]

Flying Down to Rio was the first billing of Fred and Ginger, and their Carioca dance captured the imagination of cinema-goers. Ginger played nail-filing, gum-chewing and wise-cracking singer Honey Hale. Fred was billed, as Fred Ayres, in the 'best friend' role, but people began to take notice with his comedy timing and snappy dance moves.

Producer Merian C. Cooper, the man behind *King Kong* (1931), combined his interests of jungle, aviation and South America in *Flying Down to Rio*, with the aim of knocking Busby Berkeley at Warner Brothers off the top musical spot.[2] Ginger Rogers told the BBC, '*Flying Down to Rio* was very expensive, one of the big, big films of the movie industry. We did have big sets, we did have thousands of chorus girls and boys, and dancers and singers. *Flying Down to Rio* was a top, top musical made at RKO, it was kind of the envy of everyone to be in it . . . We were not the stars of this film at all. Dolores del Rio and Gene Raymond were the stars.'

Cooper was on the board of directors of Pan Am Airways, and the film had another purpose – to encourage people to fly to South America for holidays, enticing them with songs like *Orchids in the Moonlight* that promised balmy romantic nights under the stars. In the film, Dolores del Rio also introduced the two-piece swimsuit to America, appearing briefly in a black bathing suit without a robe.[3]

RKO was famous for the 'big white set', most associated with Rogers and Astaire films, which were stark, sleek and modernist in style. In *Flying Down to Rio* the big white set pieces were the Carioca Casino and the aviators club with its Pan Am clipper and hot air balloon as a centrepiece.[4]

'I knew we had a lot of good things going for us,' said director Thornton Freeland. 'The leading lady was that dark-haired charmer Dolores del Rio, one

The Carioca was Fred and Ginger's first onscreen dance together and they stole the scene with their brief dance on an RKO big white set. The huge butterflies in the background mimic the dancers' ruffled skirts as they hold them open. Ginger Rogers wore a sleek black satin gown with ruffles on the sleeves and the hem of the skirt. As was the style of 1930s musicals, dancers pile up to form tiers on revolving platforms, like a human wedding cake.

Dolores del Rio wore pale, delicate gowns with huge puffed sleeves that contrasted with her eyes, accentuated with dark kohl and eye-shadow.

Above Irene created a pale polka dot day dress with enormous puffed sleeves and a little cap worn to the side. Dolores preferred to wear white, accessorising with diamonds and flowers such as orchids and gardenias. Dark eye-shadow accentuated her eyes and her cheekbones were highlighted, for a strong, dark look. 'I belong to the traditional French school of wearing black as the most elegant. But white suits me best; it's good for my eyes and hair,' Dolores once said.[17]

Left This satin all-in-one pantsuit was described by *Modern Screen* as a 'satin hostess gown with its stunning corded trimming'.[18]

of the most beautiful women ever to be in films. The leading man was Gene Raymond, blonde, virile, good-looking . . . the storyline was a shade slim but in those days nobody cared much about the story in a musical.'[5]

Sleek, exotic Dolores del Rio was considered the most beautiful actress in Hollywood in the 1920s. She married MGM's art director Cedric Gibbons, and they both shared a love for sophisticated Art Deco style. From one of Mexico's wealthiest families, when she got to Hollywood she was marketed as an exotic socialite with connections to European royalty.

Dolores once said, 'When they give you wonderful clothes, they give you bad parts.'[6] But in *Flying Down to Rio* she insisted that Irene Lentz design her costumes, after being introduced to the designer by friend and fellow Mexican actress Lupe Vélez. Irene's most famed creations were romantic evening gowns, and Dolores del Rio had snapped these up at Irene's dress shop on the UCLA campus. She was seen as an expensive designer; her gowns were for women of money and refined taste.[7] Irene was hired by RKO as a freelancer while the studio's chief costume designer Walter Plunkett dressed the other actors. The two designers often teamed up to design costumes together. 'Walter and I are really just a couple of disappointed movie extras,' she once said.[8]

Irene's gowns for Dolores del Rio incorporated large puffed sleeves and bands of satin cord around the neckline. She is first seen as a vision of white, a small tilted cap and huge polka dot puffed sleeves. When she runs her hands over them, she causes Gene Raymond, as Roger Bond, to trip over the trombone. 'What have these South Americans got beneath the equator that we haven't?' asks one hotel guest.

On release of the film, *Modern Screen* advised readers on how to get the Dolores del Rio look. 'Over and against her dark skin (you can do it with tan make-up, or real) white thinnesses and surfaces make her sparkle. And as for those spotted organdie puffed sleeves over her arms, around her dark face, setting off her dark eyes – well, mark that down in your June calendar for summer madness. Added, a little white cap over black hair and the enchantment is complete.'[9]

The pairing of Fred and Ginger may never have happened if Dorothy Jordan hadn't married Merian Cooper just before

production began. She was to play the role of Honey Hale, but was replaced by Ginger Rogers when she went on her honeymoon. Fred and Ginger knew each other from their time on Broadway, and they had in fact gone on dates together in New York. Ginger had been in Hollywood longer than Fred, and was an up and coming star with a seven year contract at RKO. Their dance in the Carioca casino scene caught the imagination of theatregoers. The Carioca was 'a fast tango' where the couple were to keep their foreheads pressed together as they dance.[10] Honey asks Fred, 'What's the deal with the foreheads?', and he quips 'telepathy'. 'I can tell what they are thinking about from here,' she replies.

Fred and Ginger's rendition was full of joy rather than sexual energy, but something magic happened on screen and they stole the show. 'I thought Ginger and I looked alright together, but I never believed we were doing anything outstanding,' said Fred.[11] But their few screen moments together was enough for the public and RKO executives to know that they wanted to see this couple together again. Ginger's biographer Dick Richards wrote, 'Ginger was a redhead, of course, but in the film she came out as a delicious dishy blonde. Astaire was not the conventional hero. Wasn't his hair thinning a little? Where were those male-hero biceps? But somehow the two matched like strawberries and cream or gin and martini.'[12]

Ginger's gowns were also analysed by the movie magazines. Ginger sings *Music Makes Me* in a sheer black long sleeved gown with beading cascading down the bodice and her limbs. 'Study her dancing frock when she whirls with Fred Astaire. Black, but how it fits,

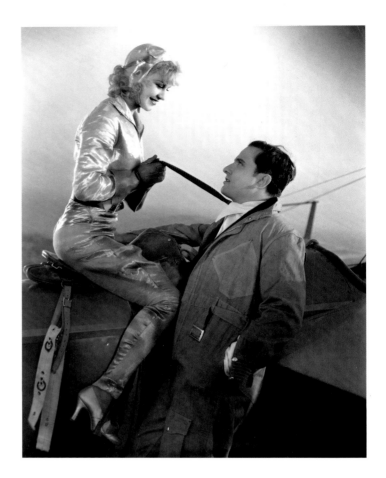

Above In a shimmering gold flying suit, high heels and goggles, Ginger leads a troupe of chorus girls who have been strapped to the wings of airplanes to perform over the South American resort hotel. Raul Roulien wears an all-in-one flight suit accessorised with goggles. The gravity defying title number was sung by Fred on the ground, with scantily-clad wing walking dancers performing high up in the sky. While it looked dangerous and thrilling, it was filmed in an airplane hanger with wind machines to simulate motion.[19]

Above right Ginger Rogers wore a very modern white all-in-one trouser suit, black and white patterned jacket and a wide brimmed hat standing almost vertical. Fred Astaire, in a polo neck and black and white tap shoes, wore the perfect get up for a hoofer in dance rehearsals.

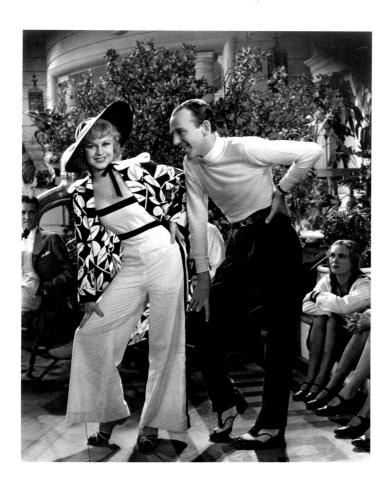

and then spreads into ruchings about the feet, not to mention ruchings over the shoulders. Don't deviate a step from her dress standard if you want to shine on the floor.'[13]

Fred Astaire was given a number of dapper outfits. The dark, double-breasted jacket, white pants and spectator shoes when playing in the band, a tuxedo with top hat and cane for the aviator club and a polo neck and slacks for dance rehearsals. Fred told the BBC, 'I like having to not change into too many well dressed outfits. That's kind of boring. I used to have a dozen changes in these different things that I did and of course the dress suits I don't like, the full dress suits I don't like at all. I don't mind a dinner jacket once in a while . . . I just don't like dressing up all the time. I like dressing well.'[14]

Fred and Ginger would dance on moonlit terraces, in a bandstand or on huge white Art Deco ballroom floors in nine other successful pairings including *The Gay Divorcee* (1934), *Top Hat* (1935) and *Swing Time* (1936). Anita Loos said 'they looked like the dream couple on top of a wedding cake who had stepped down to dance for us. You knew at once that they were headed for a happy ending.'[15]

While there were rumours that Fred and Ginger in reality disliked each other, with famous fallouts over Ginger's frothy feathered and heavily beaded gowns that tickled Fred or slapped him midst dance, they always denied this was the case. 'Ginger and I did not ever fight. Never. Never. Never. I never fought with any girls I worked with. It's so silly,' said Fred Astaire. 'We would discuss and seldom even argue about something and maybe she had a dress on I didn't like, but so what. That's nothing. But we never fought and we've always been the best of friends.'[16]

THE DANCING LADY 1933

The Dancing Lady is a film with a Depression era ethos at heart; an independent working class girl finds success through hard work and dexterity, with some stunning Adrian costumes thrown in and a snappy musical finale. David O. Selznick, Louis B. Mayer's son-in-law, was given The Dancing Lady as his first production to be responsible for. He was inspired by the success of Warner Brothers' 42nd Street (1933) to use a backstage musical template.

The Crawford Look incorporated huge bows around the neckline, structured shoulders and nipped in waists.

Joan Crawford is often remembered as the camp star of schlocky horror movies, but in the 1930s she was the reigning queen at MGM. She was hugely popular playing the shop girl, dancer or model who finds love while wearing beautiful costumes designed by MGM's star designer, Adrian.

Crawford's image changed from the flapper of silent films into a more sophisticated style, with, according to Cecil Beaton, 'her stark hair brushed to show off her archaic features'. Crawford attributed her change to Grand Hotel (1932). 'I played the prostitute and I felt that a more sensuous look was needed. Full, natural lip-line and generous eyebrows – no bra, no girdle. Definite features were called for, and I found that I liked that look so much that I kept it.'[1]

Crawford recommended Franchot Tone, who she would marry in 1935, be cast alongside Clark Gable, her on-off lover. Franchot Tone's tuxedoes showed off his good looks, and he found himself typecast as the handsome romantic lead.

It was also the movie debut of Broadway hoofer, and soon to be legendary star, Fred Astaire, playing himself. Before giving him a screen test, Selznick was enthused about Astaire: 'If he photographs (I have ordered a

Joan Crawford's dress has short-sleeved cuffs and a huge bow around the neck in the same checked pattern as the café's tablecloth, linking her to her working class roots. Her shoes with ribbons are designed to be a little common, and she tears them off in order to look the part.

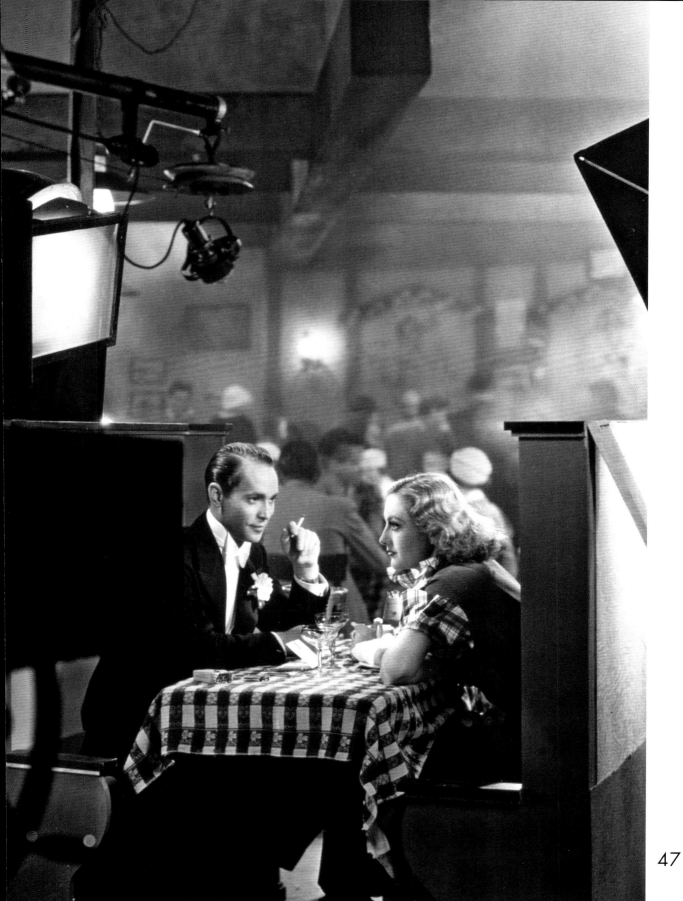

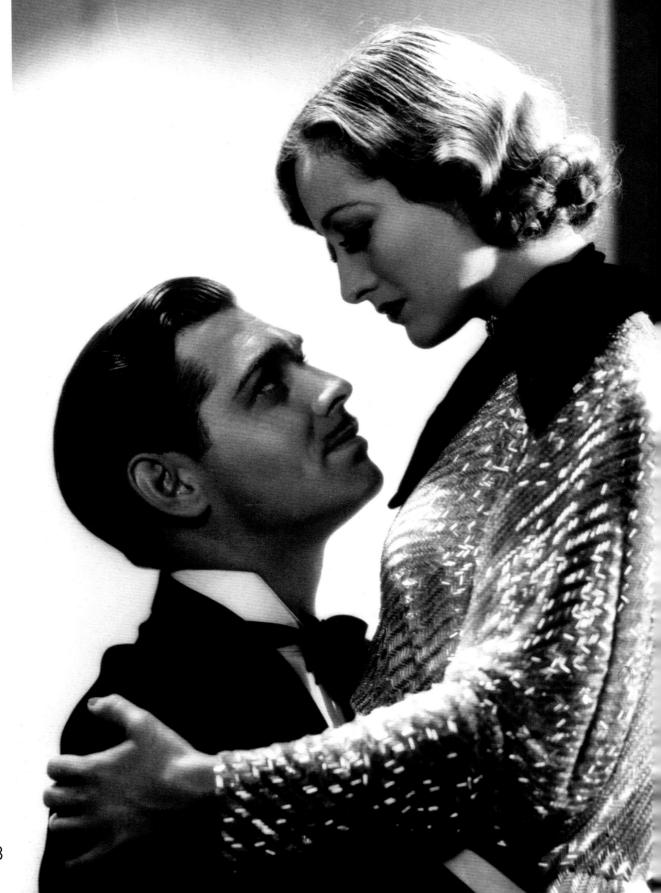

test), he may prove to be a really sensational bet,' he said. 'Astaire is one of the great artists of the day; a magnificent performer . . . he would be in my opinion, good enough to use in the lead in a million dollar Lubitsch picture, provided only that he photographs, which I hope is the case.'[2]

The Dancing Lady is often considered one of the best of the Joan Crawford and Adrian 1930s fashion pictures and it cemented Adrian and Crawford's relationship as a fashion forward team. Together they created an onscreen wardrobe that set trends and sparked department store copies, from the shoulder pads originally used to emphasise her broad shoulders, to the Crawford collar. 'Paris may decree this and Paris may decree that, but when that Crawford girl pops up in puffed sleeves, then it's puffed sleeves for us before teatime,' said *Silver Screen* magazine.[3]

'Metro regarded me as a clotheshorse as well as a dancer and an actress. I think more money was spent on my wardrobe, per movie, than on the script.'[4] Crawford claimed that the first time she met Adrian, he took one look at her and told her she was 'a female Johnny Weissmuller' because of her wide shoulders. 'Well we can't cut 'em off, so we'll just make them wider,' he said.[5]

Far left Joan Crawford with Clarke Gable. For the film's dramatic scene, Crawford wore a floor length sequined gown cut away at the back, matching sequined bolero and a huge black bow around the neck.

Left Joan Crawford's favourite flower was the gardenia and Adrian created a high necked, voluminous sleeved black gown with a garland of gardenias around the neck. While it was very modest at the front, the back was completely cut away.

THE DANCING LADY 1933

As dashing but tough Broadway director Patch Gallagher, Clark Gable wore rolled up sleeves, waistcoats and loosened ties. The chorus girls with their thirties waved hair wear the costume of backstage dancers – shorts, shirts and tap shoes.

Crawford said her 'football-player shoulders' were perfect for Adrian's styles. 'The Crawford Look', of structured shoulders and slim hips, became a model for millions of American women in the 1930s as it gave the appearance of a small waist and slim hips. Adrian predicted that in 1933 there would be 'lots of bows on everything'[6] and so he created dresses for Crawford with contrasting bows around the neckline.

In *Possessed* (1931) Crawford went from a Midwest box factory to Park Avenue, in *Grand Hotel* she was a stenographer and in *The Dancing Lady* she moves up from sleazy burlesque show to headlining Broadway. Audiences suffering under the Depression were crying out for films where they too could imagine rising up from the factories and into the Park Avenue salons. The luxury lifestyle was the holy grail for working class girls just like Crawford, and female audiences could identify with her ambitions. 'I think a million or so girls

with nothing in their pocketbooks and a head full of dreams paid to see a Joan Crawford picture because, let's face it, between MGM publicity and the parts I played I was the rags-to-riches girl and if they were lucky they could make it too,' said Crawford.[7]

In *The Dancing Lady*, when millionaire Tod Newton (Franchot Tone) takes his friends on a slumming trip to a burlesque show, he notices stripper Janie Barlow on stage. The club is raided by the police and the dancers are rounded up for performing indecently. Tod goes to the station to witness the entertainment, bails Janie out and takes her to dinner. He gives her $50 and a note: 'Don't buy shoes with ribbons on 'em. Don't forget that striptease on Second Avenue is art on Broadway. The $50 is to buy yourself a dress without a zipper.'

It's the chance she needs to move uptown to try out for a new show directed by Gable's producer, Patch Gallagher. In plucky Crawford fashion, Janie announces: 'I'm through dreaming. I'm gonna start doing. I'm going up where its art. Uptown.' Janie uses the $50 to buy a smart black silk crepe dress with white organdy ruffled collars and without a zipper. She removes the bows from her shoes and secures an audition with steadfast determination.

The dazzling musical finale opens with *Heigh Ho, the Gang's All Here*. Signifying the end of prohibition, a bar opens up to reveal Crawford and Fred Astaire waltzing. She wears a frilled organdy gown with gold sequins and ostrich feathers on the sleeve very much in the style of the dress she wore in *Letty Lynton* (1932), one of the most successful of her movie costumes.

The Adrian gown for *Letty Lynton* was a white full-length pleated organdy confection with voluminous ruffled sleeves, Buster Brown collar and a fitted waist. Macy's claimed to have sold 500,000 copies of the dress from its cinema shop, some even in plaid. *Vogue* in February 1938 wrote that every girl 'felt she would die if she couldn't have a dress like that, with the result that the country was flooded with little Joan Crawfords.'[8]

Its popularity was perhaps due to the ideals of a working girl making it in the world. The dress represented hopes and dreams of millions of women that perhaps they too could empower themselves.

Joan Crawford received thousands of letters a week from women, who 'told me that in one way or another I fulfilled their dreams . . . they liked to read about the way I dressed when I went out. My silver service, my china, my parties, my husbands, my children, my escorts. I realised very early on that Mayer was right; I was obliged to be glamorous.'[9]

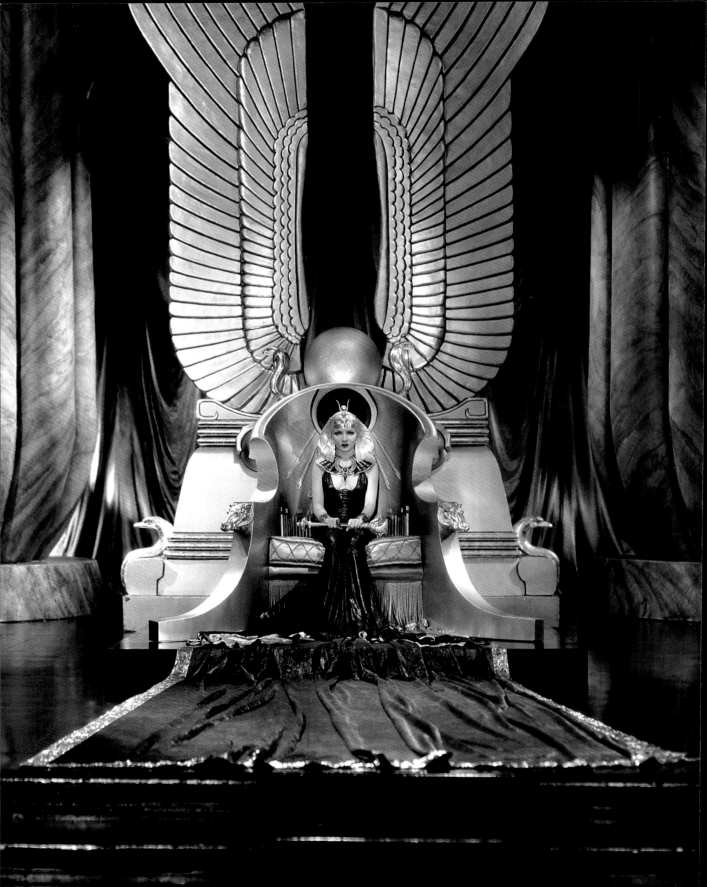

CLEOPATRA 1934

Cecil B. DeMille's *Cleopatra* was an Orientalist, Art Deco vision of ancient Egypt with Claudette Colbert's fringed pageboy hairstyle, pencilled in eyebrows and sleek, shimmering 1930s bias-cut gowns.

DeMille was one of the first directors to place great importance on costume and set designs to create a visual wonder on screen. He was also one of the first filmmakers to use merchandising tie-ins with his movies. Women were urged to buy replicas of Gloria Swanson's gowns so that they too could own some movie magic. In *Male and Female* (1919) DeMille explored his fascination with Orientalism, and Gloria Swanson's costumes, designed by Mitchell Leisen, were some of the most extravagant on screen at that point. One gown made entirely of pearls and white beads was so heavy that it had to be carried by two maids.[1]

When casting Poppea, Neros's wife for *Sign of the Cross* (1932), DeMille stopped Claudette Colbert on the Paramount lot one day, asking how she would like to play 'the wickedest woman in the world'.[2] It was an enticing opportunity, and a break from the comedy roles she had become known for, and so she immediately said yes. In *Sign of the Cross*, Colbert would be nearly nude in some scenes, and it provided spectacle, gore and torture for thrill-seeking audiences. A Christian girl is stripped and mauled by a gorilla, another is chained up and gorged by alligators, and Colbert takes a foamy bath in asses' milk. After this femme fatale performance Colbert was first choice for *Cleopatra*. 1934 proved to be a very successful year for Colbert; as well as the success of *Cleopatra*, she starred in *Imitation of Life*, and screwball comedy *It Happened One Night*, for which she won an Oscar.

Cleopatra was shot quickly, in eight weeks, but Colbert was unwell throughout the shoot. She was recovering from appendicitis and found it painful to stand for long periods of time. The weight of the costumes, one beaded gown

The bold geometric Art Deco lines of the 1930s suited a film with an exotic Oriental style, and Cleopatra's throne compliments the elaborate headdress. Her revealing costumes were created in shimmering lamé, with fishtails and extensive trains, and worn with thick jewelled necklaces, which became known as the Cleopatra collar.

weighing 75lb, would be tiring for her, and temperatures on set were kept low to preserve costumes made from feathers.

DeMille invited his niece Agnes DeMille, who would become an accomplished dancer and choreographer, to create dance sequences he could use in one scene. She had an awkward, un-comfortable time in the make-up department when they 'greased her hair and plucked her eyebrows; jewels were applied then wrenched off her living flesh'. DeMille sat on Cleopatra's throne to watch her do the dance, and then shook his head. 'This is noth-ing … it has no thrill, no suspense, no sex,' he told her.[3]

DeMille's ancient and biblical epics were filled with extravagant set pieces, exotic animals and glittering, risqué costumes. In *Cleopatra*, girls in leopard skin fight one another and flip through fiery hoops, to entertain Cleopatra and Marc Anthony as they get drunk.

DeMille had problems with finding a costume designer for *Cleopatra*. Mitchell Leisen, who formed a successful visionary team with DeMille after designing the costumes for *Male and Female*, dressed Claudette Colbert in *Sign of the Cross*. 'Making the costumes for Claudette was a real pleasure,' he said. 'She has just about the most beautiful figure I've ever seen. I slit her skirts right up to the hip to show her marvellous legs. She didn't have a stitch on underneath.'[4] But Leisen had decided to concentrate on art direction, and so at first DeMille used a team of costume designers, including Ralph Jester and 22-year-old Natalie Visart. She was given an apprenticeship as designer for *Cleopatra* after impressing DeMille with a large collection of Egyptian cos-tume sketches she had created, after hearing he was preparing a new produc-tion.[5] But when Claudette Colbert kicked up a fuss over her costumes and re-fused to wear them, potentially costing the studio for every minute she refused to be on set, Travis Banton was called in to whip up an entire new wardrobe.[6]

Colbert knew exactly how she wanted to look in the film, which was to have her breasts on display as much as possible. She had insecurities over her body, thinking her waist was not slim enough and her neck was too short, so she wanted to distract from her perceived problem areas.[7] Because Colbert demanded she was always photographed on her left profile, the right side of her face was referred to as 'the dark side of the moon' by colleagues.[8] 'She always was a bitch,' said DeMille.[9]

Colbert, who had been a fan of Banton's designs, did not like the sketches he presented to her for *Cleopatra*. When he showed a second, revised set, she returned them to him scrawled with insults about how ugly they were. Banton was incredibly insulted and stormed over to her dressing room. He told her he would send her one more set, and if she didn't like it then she could slash her wrists for all he cared. He stayed until midnight to create new sketches, had

Get the look with plunging, bias-cut gowns, metal Cleopatra collars, jewelled headbands and thick cuffs wrapped around wrists.

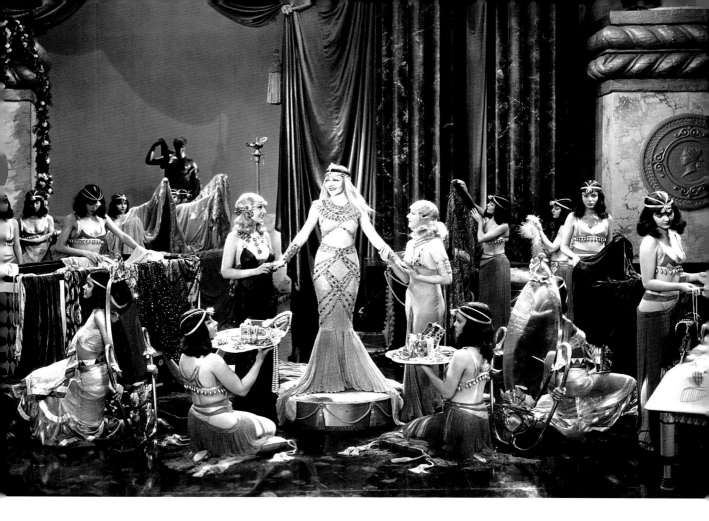

Claudette Colbert and her Egyptian handmaids were more 1930s in style with pencilled in eyebrows and bias-cut gowns, but it was a look of exotic Art Deco excess with jewelled headbands, heavy necklaces and gold arm cuffs.

them submitted to Colbert and awaited her reaction. She duly returned them to him, and when he opened up the folder, he saw that dried blood had been smeared all over them. Colbert had deliberately drawn blood from her finger and rubbed it over the sketches. Banton fled to Palm Springs for three days for a heavy drinking session and did not return until the studio straightened the situation out with the temperamental actress.[10]

Colbert was as close to naked as the censors would allow, with midriff-revealing gowns and bikini tops. Because the Hays Code had only recently been implemented, DeMille got away with more risqué costumes than he would be allowed once the code was fully enforced. The film even opens with a naked slave girl, only partially discovered by strategic lighting.

Costumes laden with feathers were a particular favourite of DeMille's, most famously in Hedy Lamarr's extravagant peacock cape in *Samson and Delilah* (1949). For *Cleopatra,* it was reported that the feathers of 6,000 pheasants were used to make up the fans of the Egyptian dancing girls in one scene, and 600

ostrich feathers to make up a solid feathered arch under which was Cleopatra's throne. The press office also made the extraordinary claim that it 'took the hair of 700 European peasants to make up the wigs, curls, switches and hair-pieces used by principals and extras'.

The gilded look of *Cleopatra* formed part of Paramount's huge merchandising campaign. Macy's carried what was claimed to be the 'most gigantic tie-up in cinema history', with a range of clothes with a Cleopatra theme. They sold dresses with Egyptian motifs, sandals, hats and chunky jewelled collars.[11]

Claudette Colbert was billed as Queen of Glamour, dripping in exoticism. A press re-lease declared, 'The style conscious Miss of today will be "Cleopatra conscious" from the tips of her jewelled sandals to the top of her sleek and glossy coiffure.'[12] Cleopatra sandals were high-heeled, gold and strappy, although more a thirties version than authentic Egyptian. Claudette's fringed pageboy hairstyle was also much imitated and the studio press office pro-claimed, 'Cleopatra had bangs – so modern women follow suit!'

Jewellers created wide, chunky bracelets with elaborate Egyptian designs including the lotus and scarab. Even make-up was Cleopatra inspired. Women were advised to use dark powder, a dark green eye-shadow and mid-night blue mascara, to 'give them a deep and searching but very alive look'.

'Already DeMille's *Cleopatra* opus is start-ing fashion trends,' said *Shadowplay* maga-zine in 1934. 'Around Hollywood, clips of bur-nished gold in Lotus flower motifs are worn on flimsy lace evening gowns. An Egyptian collar effect is seen here and there. And most inter-esting of all, the winged bandeaus worn by Claudette Colbert promise to replace the tiara as an evening headdress.'[13]

Below This Travis Banton design was sketched by one of his artists, Paloma Gibson. The purple and silver costume was for 'Cleopatra at the poison dinner scene' and written beside it is 'Purple stones – silver cloth – violet velvet – chiffon with silver metal'.

Right The pale blue chiffon gown was worn with a collar and bracelet constructed from layers of thin beaten gold chips. The golden wings were predicted to 'cause a revolution in the tiara'.

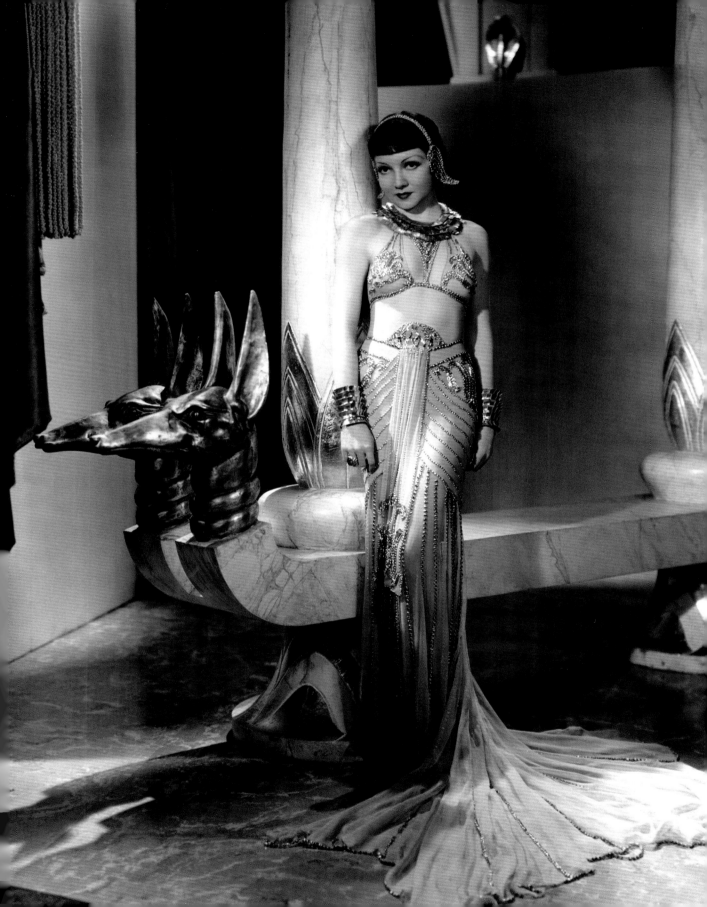

JEZEBEL 1938

It was a classic 1930s drama about a tempestuous southern belle in the years before the Civil War, 'heavily scented with magnolia blossoms, mint juleps, and the soft, courteous accents of the pre-war South.'[1] 1938's *Jezebel* came a year before *Gone with the Wind*, and starred Bette Davis, an early contender for the role of Scarlett O'Hara.

David O. Selznick was concerned when he found out Warner Brothers were releasing their own Southern drama first. He told Jack Warner, 'The picture throughout is permeated with characterisations, attitudes and scenes which unfortunately resemble *Gone with the Wind*.'[2] It didn't help when the *New York Sun* reported that Warner Brothers had 'sensed a trend and became the first to present a picture which should be a pacemaker for any old South drama'.[3] But the director, William Wyler, insisted that *Gone with the Wind* was not in his mind when making *Jezebel*. 'It was an entirely different sort of story, although there were similarities in the character of Jezebel and the character of Scarlett in so far as they were both attractive Southern belles, very headstrong, and that their headstrongness sort of did them in in the end.'

The red dress shocks the guests at the ball, and the girls' white crinolines move from the dance floor as if being contaminated by the brazen gown. The dress was worn with black lace fingerless gloves and a black hooded cape, which when removed made the bare shoulders and red fabric appear even more sleazy.

59

Julie Marsden is a woman who likes to shock and be daring, and makes no apology for it. She drinks whisky, flirts with men and breaks the rules of the day. Until she wears the wrong dress, and her world collapses. Screenwriter Louis Edelman told producer Hal Wallis, 'We are trying to tell the story of a bitch, and we're going to make you hate her for her viciousness and weakness, and then love her for her courage and the fight she puts up to get her man.'[4]

Bette Davis had sixteen costumes changes, charting her progress from strong and wilful to repentant. Each gown, designed by Orry-Kelly, cost over $500, a large sum in those days, and the pivotal red satin gown cost $850. Seventy-five seamstresses worked for a month on the costumes and used 3,000 yards of silks and satins and 2,000 yards of lace.[5]

Australian born Orry-Kelly was appointed head of Warner Brothers costume department in 1932. Choosing to go by the hyphenated name Orry-Kelly, the designer would find that he received letters addressed to 'Messrs Orry and Kelly'. He said, 'I wish they'd run a brief, dignified announcement to the effect that I'm just one person – not two!'[6]

It was his costumes for Bette Davis that were his most successful, partly because she liked to change her image for each character but also because she was not that easy to dress.[7] He shaped her with specially designed corsets for period films like *Jezebel* and *The Little Foxes* (1941), when she would put her own comfort aside for period accuracy. But for modern films she would kick up a fuss over having to wear these structured undergarments and so Orry-Kelly would design costumes with subtle draping and hidden support. But she came to depend on him and when Orry-Kelly left Warner Brothers in 1944 to start his own business, Davis said 'it was like losing my right arm.'[8]

Film historian Jeanine Basinger calls *Jezebel* 'a story of four very important costumes'.[9] Her first costume, the riding habit, defines her character, the scarlet gown is the catalyst that changes her fortunes completely, her white dress is the dress she should have worn to the ball and the plain grey cape is redemptive, worn as she ventures through the swamp.

The key dramatic moment in *Jezebel* concerns a red satin ballgown. In the dress shop, Julie is first seen being fitted for a white lace gown, but she catches sight of the brazen scarlet gown. 'Saucy isn't it,' she says. 'This is 1852, dumplin', 1852. Not the dark ages. Girls don't have to simper around in white just because they're not

Right Late for her own party, Julie makes a dramatic entrance on the back of a wild horse that no one can control but her, in a riding outfit with long leather boots and a feathered cap. With her riding crop she coolly hitches up the back of the skirt, a move which took Bette Davis forty-five takes, according to William Wyler. Julie's riding outfit is not a proper party gown, especially in a society where rules and customs are everything.

Below The gown worn in the final scenes was covered in netting and pearls. She throws a cape over it and ventures through the swamp to rescue Henry Fonda. Once back at the plantation, the delicate gown has been ripped and muddied from the journey.

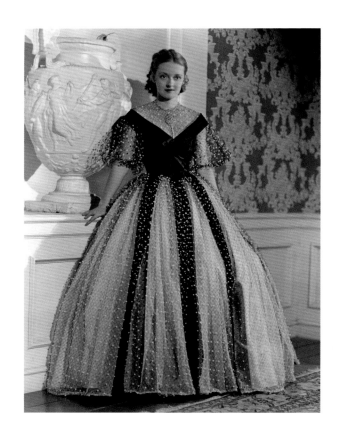

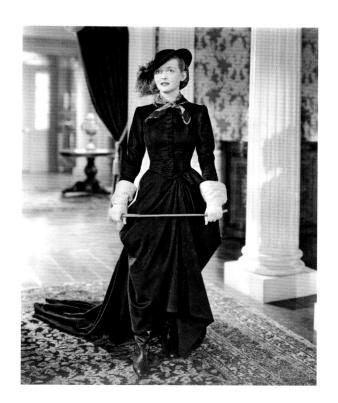

married.' Julie defiantly arrives at the Olympus Ball in the shocking scarlet dress, despite the protests of her mother and her fiancé Pres (Henry Fonda). Ladies are expected to only wear white to the ball, and she draws gasps and looks of horror as she walks into the ballroom. The shock of the red dress had to be conveyed in black and white. But even if Technicolor had been a consideration, Wyler was never keen to use it. He said: 'I was not eager to do films in colour, because the colour was very artificial in those days. I thought that particular scene would be striking in colour, and would, of course, be much more effective, but I think we got around that.'[10] The red satin gown was in fact created from a bronze fabric, because red would photograph as grey, rather than the deep colour that indicated vivid red. 'We tested the dress to try to give it a shade that was sort of shiny, but it was bound to come out dark. I think the scene got over very well, all the same,' said Wyler.[11]

The most expensive of Bette's costumes was the frothy lace gown, first seen in the dress shop, with its skirt created by hundreds of small veils. When Julie hears Pres is arriving back from the North, she changes into the white lace to show him she has redeemed herself and that he should take her back. But it's too late. He's already married.

Each version of the white organdie gown lasted less than a week, despite two wardrobe women giving the dress constant care. One cleaned it each night in solvent and the other pressed it and mended it in the morning, replacing the veils that had been torn off the day before. 'It was imperative for Orry-Kelly to design this as a delicate, foamy lacy thing – which he did. However it was necessary to make three copies of the dress because the delicate lace veil snagged and became bedraggled almost as rapidly as the wardrobe department could turn out new ones,' said a press release.[12]

'The life of gowns averages one week of fairly continuous wear,' said Orry-Kelly. Wardrobe departments would often make duplicates of costumes to allow for wear and tear, especially if it was an active role. For *Jezebel* there were duplicates of every one of her gowns. The gowns that were only worn for a day or so were sent to the wardrobe department, where they could be recycled in other films.

Historical accuracy was more important to Orry-Kelly than some of his peers like Adrian and Travis Banton, who were more concerned with the theatrics on screen.[13] The research department examined New Orleans life around 1850

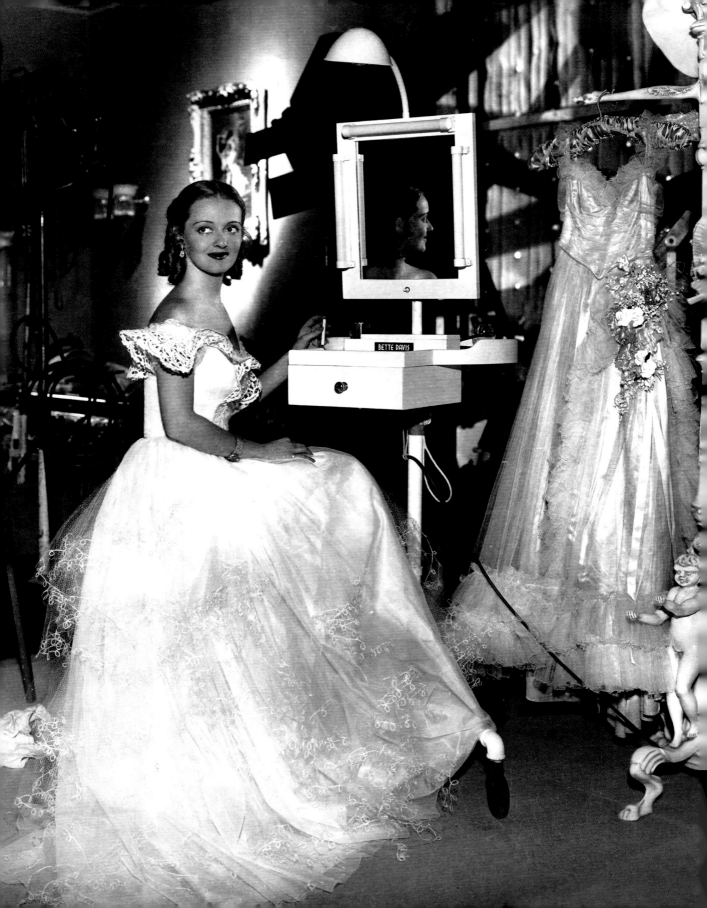

Left The white gown was what Julie should have worn to the ball. With little white flowers woven into her hair, a lace neckline falling from her shoulders, she shimmers and glows under the light, looking fresh and youthful.

to discover the costumes of servants and poor whites, womens' mourning dress and the badge of the Louisiana police, 'various masks that were used by the merrymakers' of the Mardi Gras, and the 'kind of costume worn by the men in the orchestra that played at the various balls over the city.'

To get the hotel just as it would have been, Herman Lissauer, head of research, spoke with John O'Leary, vice president and manager of Drinkler Hotels about what the old St Charles bar and grill would have been like in 1851. 'In talking to some of the real "old-timers" around here who worked around the hotel fifty to sixty years ago, the nearest I can find out is that all the bartenders wore "handle bar moustaches", they did not wear jackets – just worked in their shirt-sleeves with an apron. They all wore sleeve-bands or "garters" with rosettes,' Mr O'Leary replied. A sprawling New Orleans plantation home was built on the Warner Brothers lot, as well as a recreation of a New Orleans street with its wrought iron balconies, and the murky swamp that leads to the yellow fever camp. The great detail of the bustling streets, the Spanish moss hanging from oak trees, the magnolias around the plantation, the misty bayou swamp, all add to the romance of nineteenth-century Louisiana. And, according to a press release, to get into the spirit of the South, a fresh supply of mint arrived everyday for the mint juleps.

Henry Fonda had to be finished by 14 December, so he could be back in New York for the expected birth date of his daughter, Jane Fonda, on 16 December. Bette Davis would later in life recount the story on a TV show with Jane. 'Hank's contract for *Jezebel* said we must finish him on a certain date because he was going to have a child. So we got through with him in time, which meant all my intimate scenes with [Jane Fonda's] father, I had to keep all my close shots for after he left. I was looking into a blank space pretending. It really was murder. But any actor who causes me this much trouble and can produce a Jane Fonda, I'll go through it all over again.'

One of the directions Wyler gave Bette was to smile during a scene when she had been 'raising hell' with Henry Fonda. He asked her to try it smiling, even though her style of acting was to come on strong. 'It was a little less ordinary than that type of scene played, and just as bitchy, in fact a little more, where she was giving him hell but with a smile on her face, and rather than in an aggressive voice, with kind of a sweet voice. Well, after we did it, she liked it.'[14]

Marketing the glamour and costumes of Bette Davis would be important to promote the movie and they got a 'tremendous break' by securing a cover issue of *Cosmopolitan* for their star.[15] 'For Bette is not a beauty,' said *Chicago Daily News*, 'but seeing her as the vixenish New Orleans belle of 1852 . . . she packs glamour galore!'[16]

GONE WITH THE WIND 1939

Gone with the Wind was by far the most ambitious and astonishing film that Hollywood had ever attempted to make. It took three years and a budget of $4 million to bring the American South and the ravaging of the Civil War to life in the eagerly awaited adaptation of Margaret Mitchell's best-selling novel. It closed the decade in spectacular style when it opened in Atlanta in December 1939, and would become a film of gigantic proportions – the biggest, most popular movie of all time and winner of eleven Academy Awards.

Mitchell's dreamy novel was essential reading in the latter part of the 1930s, a time when those suffering under the Depression and a threat of war looked nostalgically to a once glorious era.

Every young starlet had her eye on the part of tempestuous heroine Scarlett O'Hara and over the course of two years 1,400 actresses were tested, including Bette Davis, Katharine Hepburn and Paulette Godard. Movie fans wrote in with their suggestions, but it was of course 25-year-old Vivien Leigh, a 'Scarlett dark horse', who won over producer David O. Selznick.

Leigh possessed the same dark hair, magnolia skin and pointed chin as Mitchell's heroine, and the author expressed her delight at the casting. 'Naturally, I'm the only person in the world who really knows what Scarlett looks like, but this girl looks charming. She has the most Irish look I've ever seen, with a "devil" in her eyes. She looks like she has plenty of spirit and fire. Not at all like a languid Hollywood girl.'[1]

Selznick sought historical accuracy as well as spectacle. The costumes, designed by Walter Plunkett, were to reflect a romantic vision of the pre-war South with flouncing frills and hoop skirts, the makeshift costumes of the Civil War and then the bustles of the reconstruction period. They wowed audiences with eye-popping Technicolor, enormous hoop skirts and luxurious velvet gowns.

In the restoration period, Scarlett wears extravagant, fashion-conscious gowns with ermine collars and cuffs, candy-striped taffeta, butterfly sleeves, velvet dressing gowns and chiffon peignoirs. The vertical striped gown with butterfly sleeves she wears after marrying Rhett, worn with a John Frederics hat, cost $4,000.

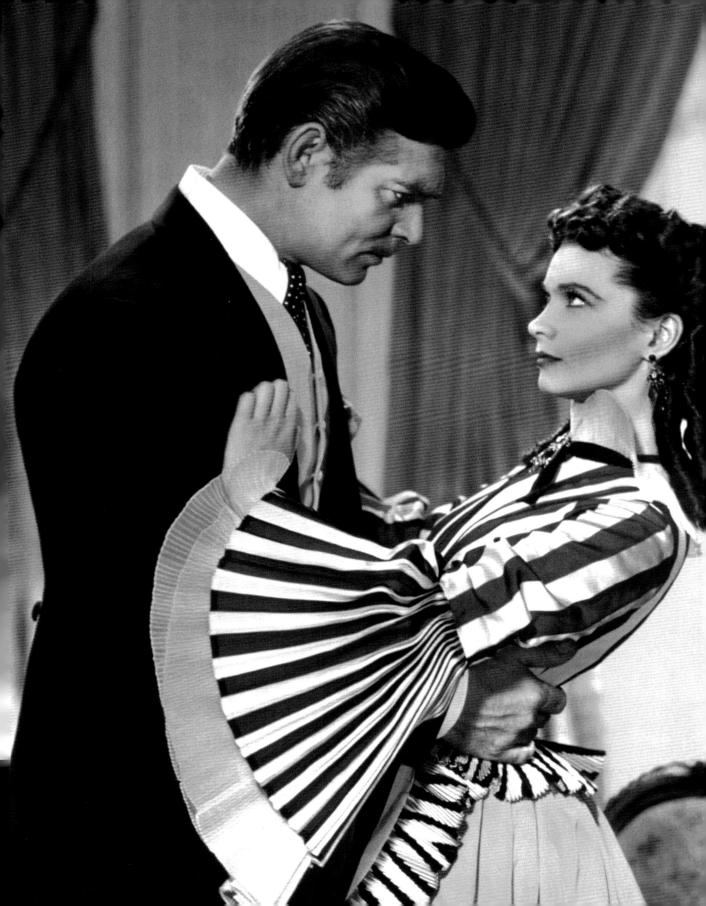

Walter Plunkett was the chief designer at RKO from 1926 until 1939, with a speciality in period costume. Plunkett left Hollywood in 1935 to design women's clothes in New York, but when he heard about the production of *Gone with the Wind*, he personally wrote Selznick a letter asking to design the costumes. He said in a 1981 lecture: 'I had done for Kate Hepburn *Little Women*, which was one of his pictures. So he knew me and immediately – in fact the day after my note was delivered – I got the message to come and do it.'[2]

He created more than 5,500 costumes for the fifty cast members and thousands of extras, using 35,000 yards of fabric for the women's costumes alone, employing a team of expert weavers, seamstresses, milliners, shoe-makers and corset makers. Plunkett was determined that the costumes be as authentic as possible and spent months researching the fashions of Atlanta in the Civil War period. The women who ran the Daughters of the Confederacy museums in Savannah and Charleston gave him fabric samples from skirt hems, and described how war rations meant that buttons would be made from walnut seeds, stones and even thorns.

But when Selznick first saw Plunkett's sketches for Scarlett, he felt they did not make a big enough impact for such an important production. Selznick told the wardrobe and production departments that they needed to 'correct the common fault of all American pictures', that costumes look 'exactly what they are – fresh out of the costume department' instead of looking worn and lived in.[3] Selznick considered replacing Plunkett if he didn't improve, but he

Scarlett wears extravagant, fashion-conscious gowns in candy-striped taffeta, dark velvet or with huge hooped skirts covered with frills.

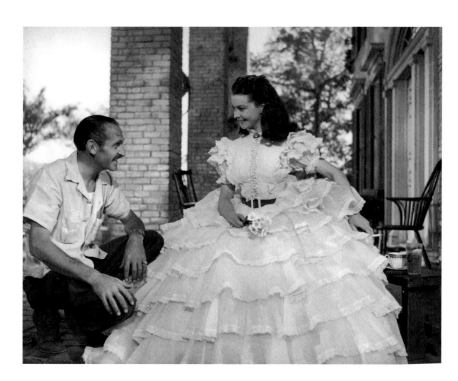

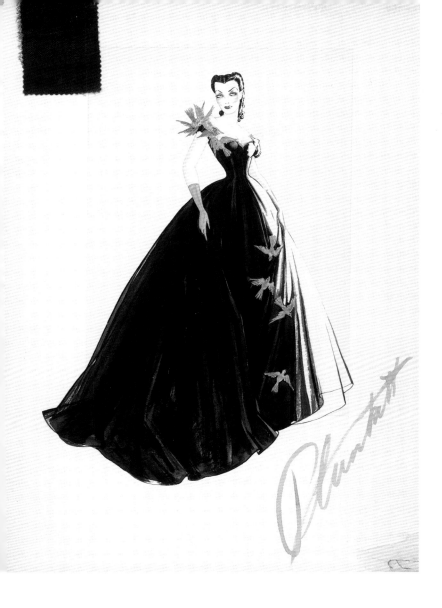

told his assistant Katherine Brown, 'Plunkett has come to life and turned in magnificent Scarlett costumes so we won't need anyone else.'

It wasn't an easy shoot. Director George Cukor, considered a woman's director for his touch in directing actresses, was replaced two weeks into shooting by the tougher Victor Fleming. After seeing wardrobe tests of Vivien Leigh, Selznick had concerns over how flat-chested she was. Cukor had been more sympathetic to this problem than Fleming, who bellowed from behind the camera, 'For Christ's sake, let's get a good look at the girl's boobs'! Plunkett was instructed to bind Leigh's breasts together with adhesive tape to push them up, particularly for the plunging red velvet gown worn to Ashley's birthday.

Leigh was in make-up at 7a.m. and often stayed until midnight. Ann Rutherford, who played Scarlett's sister Carreen, said of Leigh's dedication: 'She burned herself, she was such a hard worker. We watched her lose weight. In a break she'd take her costume off and the wardrobe girls would put more seams in what once had been a tightly fitted dress.'[4]

Above In the New Orleans restaurant she wears dark blue satin with black net and sequins, and three white and yellow stuffed doves on the right shoulder, as shown in this Walter Plunkett sketch.

Left Vivien Leigh with Walter Plunkett. The green barbeque gown was to originally appear in the opening scenes, but Selznick thought it was featuring in too many scenes. So Scarlett was given a white puffed sleeve muslin prayer dress with red velvet sash.

The hats, designed by John Frederics, were a troublesome issue for Selznick. He discarded sketch after sketch much to the frustration of Frederics.[5] Margaret Mitchell was also unhappy with the hats, particularly when Scarlett tries on a high-perched purple velvet hat while in mourning. The bonnet with veil would have been a fashion faux pas at an evening party, but technical advisor Susan Myrick wrote to Mitchell: 'Walter Plunkett and I are plotting to get the bonnet off but we are doubtful. You see, the fools paid John Frederics of NY a hundred bucks for that bonnet and they are bound she'll wear it.'[6] They may not have been historically accurate, but *Picture Play* noted that the Scarlett O'Hara hats 'promise to be sensational fashion forecasts'.[7]

Despite the historical accuracy, there was still a 1930s influence in the costumes. Crinolines were exaggerated in size and the men's lapels were more modern with broader shoulders. These touches made the costumes more appealing for the audience, sparking trends with *Gone with the Wind* style fashions.[8] Publicity centred around Scarlett's many spectacular dresses and hats and female cinema-goers would watch the film over again to determine their favourite dress.

Selznick claimed that *Gone with the Wind*'s costumes were responsible for fifty per cent of fashions at the end of 1939. As well as a return to corsets, 'The nation is now burdened with snoods for women's hair as a result of the Scarlett and Melanie snoods,' he said. 'All of this is trivial and laughable in a world that is shaken by war, but women being what they are, I think it could make for excellent publicity.'[9]

For Scarlett's gowns, Plunkett conveyed not only her personality in the costumes, but the journey she makes as a survivor of war. There are two phases to Scarlett, divided by the intermission in the three hour film. In the first phase she is a frivolous and carefree Southern belle in organdy and tulle. In the second phase of her journey as she struggles during the Civil War she wears velvet, a stronger, hardier material that also reflects her maturity.

In the novel, every costume of Scarlett's was green, partly because it was Mitchell's favourite colour. While Plunkett sought to vary the colour scheme, Scarlett would still wear several green dresses, from the flighty Southern belle in green-flecked frills to survivor in a green velvet dress made from curtains.

Mitchell first describes Scarlett in a 'new green-flowered muslin dress spread its twelve yards of billowing material over her hoops', and this was the basis for the Twelve Oaks silk organza barbeque gown, with its ruffles and interlaced green ribbon. The screen printed green sprig design was copied from an authentic 1861 fabric, but Plunkett doubled the size of the sprigs so they would be visible on camera. It proved a popular dress and was replicated and sold in high numbers in department stores across America.

Scarlett's golden cream satin wedding dress also launched a bridal trend. It was a little too long and loose on Vivien, to give the impression she was wearing her mother's wedding dress in her haste to get married, and was in fact fitted to Barbara O'Neill, who played Scarlett's mother. As a luxurious, fashionable dress for 1834, it had long mutton sleeves, creating the illusion of a smaller waist, and was covered in silk and lace maple leaves. The dress was used the following year for Joan Fontaine's screen test for *Rebecca* (1940).[10]

For the war scenes, Plunkett created twenty-seven copies of the lavender and brown print calico dress worn in the hospital scene. Each copy was aged to show different stages of wear, and Scarlett's decline over a timespan of two years.[11]

Above Vivien Leigh in a red and white gown designed by Walter Plunkett.

Right As described in the novel, Scarlett needed a gown to impress Rhett, but without the money or materials, Mammy made it from the green velvet dining room curtains with the drape ties forming a belt. The green hue was chosen to compliment Leigh's eyes, and was faded to realistically look as if it had been made from old draperies faded by the sun. Frederics designed a hat with a gold chicken claw and feathers to go with the curtain dress; the idea being that it was from the last chicken that had been used in the soup.
Hattie McDaniel won an Oscar for her role as Mammy. 'I'd rather play a maid and make $700 a week, then be a maid for $7,' she famously said.

When Selznick saw the costume tests for Clark Gable as Rhett Butler, he was adamant they wouldn't do for such an idol as Gable. The suits were too tight around the neck, causing his flesh to bulge out. 'A more ill-fitting and unbecoming group of suits I have never seen on a labouring man, much less on a star,' he said. 'It's disappointing indeed to have the elegant Rhett Butler wandering around with clothes that look as though he had bought them at the Hart, Schaffer, and Marx of that period.' Gable normally would take charge of his wardrobe and have input in the sketches. But he had not been allowed to use his own tailor, who he had been using to create his wardrobe, onscreen and off, from the start of his career. When Selznick heard about this 'insane order', he insisted Gable's tailor be brought in to fix the costumes.[12]

Gone with the Wind swept through the Academy Awards and on receiving the Oscar for best film Selznick said: 'It's too bad there isn't an award for costume designing, too, because Walter Plunkett would have received it.' The Academy Award for Best Costume in Black and White and Colour was not introduced until 1948.

THE PHILADELPHIA STORY 1940

Katharine Hepburn was a woman who liked to do things her own way. She was athletic, fiercely independent and prone to striding around the movie lot in slacks and shirts at a time when that was seen as unfeminine. 'I came along at a point in the movie industry when nothing like me had ever existed, with a loud voice and a very definite personality and a rather belligerent look. Show me an actress who isn't a personality and you'll show me a woman who isn't a star,' said Hepburn.[1]

But Hepburn's career in the late 1930s was suffering. Her latest Hollywood movies had been flops and after she was dropped by RKO and named box office poison she needed a hit. The role of Tracy Lord in *The Philadelphia Story* on stage and screen completely revived her fortunes. When the Broadway play opened in March 1939 it was a critical and commercial success. Howard Hughes had given Hepburn some savvy business advice that she should snap up the film rights to the play before it opened, and he gave her the $30,000 it would cost. 'I slept with Howard Hughes to get *The Philadelphia Story*,' she once joked.[2]

In the run up to her second marriage, Tracy Lord battles with her ex-husband, C.K. Dexter Haven (Cary Grant) and two journalists, Macaulay Connor (James Stewart) and Liz Imbrie (Ruth Hussey), who turn up on the doorstep of her Main Line Philadelphia home. Because writer Philip Barry had based Tracy Lord on Katharine Hepburn, a good friend of his, it was a part she was born to play. They were both stubborn, independent and from wealthy families, as could be heard in Hepburn's clipped Bryn Mawr accent. Owning the film rights meant she got to carry the role on to screen, which would otherwise have gone to Ann Sheridan or Joan Crawford. 'I played Tracy Lord for a year on the stage, but no one made me any offers for a part in the Hollywood film. No one realised I owned it.'[3]

Katharine Hepburn as Tracy wears an Americana styled gingham dress, overly fussy as she puts on affected manners to scare the journalists. Cary Grant as Dexter was given a wardrobe with more style and flair, with checked suits and pink shirts, sports clothes and flannels, while Jimmy Stewart, as a reporter, wears brown striped suits and hats.[12]

With the rights she also had control over the casting and director, choosing George Cukor to direct, and at first Clark Gable and Spencer Tracy as her co-stars.[4] But when they weren't available, she got Cary Grant as Dexter and Jimmy Stewart as reporter Mike Conner. Cary Grant said of Hepburn, 'You had to look at her, you had to listen to her, there was no escaping her; but it wasn't just the beauty, it was the style.'[5]

Adrian, as MGM's head costume designer, was given Hepburn to dress for the first time on *The Philadelphia Story*. She had played rich, icy stubborn characters in 1930s comedies, had earned the nickname 'Katharine of Arrogance' by crew members and he strove to 'counter the perceived haughtiness that was sinking her popularity'.[6] She had an athletic sinewy figure, like Garbo's, who was his favourite to dress, and gave her elongating floor length classical styled gowns. He also accentuated her long neck with high collars and open necklines.[7] 'Adrian was my favourite designer. He and I had the same sense of smell about what clothes should do and what they should say,' Hepburn said.

Throughout the script, Tracy is compared to a goddess and her costumes reflected this. 'You have the withering look of a goddess,' Dexter tells her, as she stands by the pool in a long white robe. She is called a 'virgin goddess', and has 'beautiful purity like a statue'.

Russian fashion designer Valentina dressed Hepburn for the Broadway play. For the evening party she designed a white silk crepe evening dress with pleats to the floor, like the Grecian goddess she is compared to. 'At last I made her look like a woman,' Valentina reportedly said. Adrian adapted this dress by removing the pleats and placing gold braid around the collar, down the sleeves and around the waist.

In the opening scene, Hepburn wanted to wear slacks to show Tracy's independent spirit, but instead Adrian talked her into wearing a long white gown. It gave her a soft, feminine appearance which contrasts with her violent behaviour as she snaps Dexter's golf clubs in half.

While trousers on women weren't as shocking in the 1940s as they had been in the decade before, MGM's head Louis B. Mayer needed some persuading. Mayer was shocked by a pantsuit that Adrian had designed for Hepburn – he felt it was

Below Katharine Hepburn rehearses with director George Cukor in her favoured tailored slacks, shirts and flat shoes. She blazed a trail for strong, feisty women by rejecting petticoats and girdles for a traditionally male wardrobe.

Right For the evening party, Hepburn as Tracy wears a classical white chiffon gown with gold braiding. It suits the praise heaped on her. Mike declares: 'You are lit from within, Tracy!'

too racy for America. The black pantsuit, worn with a white shirt and a short jacket, was brought to his attention by producer Joe Mankiewicz when he saw the sketch. He asked Hepburn, 'Are you sure these too should be slacks? Fine by me if fine by you.'[8]

In the library, Tracy wears a quirky knitted cap with a tassel, worn with a cream striped suit. It shows a softer, intelligent and childlike side to her, which surprises Mike Connor, after only seeing her at her most affected. Hepburn said: 'When Adrian showed me the sketch, I laughed. It looked like a hat for a very young girl, and it didn't seem to go with the suit. Then he explained to me how he saw Tracy's character . . . she wants to defy convention, and she won't take advice from anyone. But inside there's a frightened young girl. He thought the hat would help show that Tracy wasn't as stiff as she seemed on the surface, and also give a glimpse of the girl inside.'[9]

Another costume, a gingham layered skirt with a white blouse and gingham collar and tie, is very pastoral American. The skirt was made from red and white fabric which Adrian had bought on a trip through the Appalachia. He used a blue and white version for Dorothy's dress in *The Wizard of Oz* (1939), perhaps the most 'American' of movie costumes.

In the final scenes, Tracy's *mousseline de soie* wedding dress is a departure from the sleek flowing gowns, and has more of a country girl look with its ruffles around the sleeves and neckline and a large picture hat.

The Philadelphia Story shaped Hepburn's image with the elegant Adrian gowns and also gave her the chance to show off her athleticism. In one scene she performed a dive into the pool, which she was proud to say she did in one take.[10]

'Owning *The Philadelphia Story* was one of the best things that ever happened to me. I think I made a little money too. It was life-changing, what it did for my career.'[11]

KITTY FOYLE 1940

As one half of Hollywood's most famous partnership, Ginger Rogers was the all-American girl who danced across the screen in extravagant, frothy creations. But she wasn't just Fred Astaire's partner; Ginger Rogers in the 1940s was considered a gifted actress and comedienne in her own right. She played a series of working girls – a stenographer, a toy salesgirl, a soda jerker, a bookseller, a secretary and a telephone operator. In 1940 she won an Oscar for her first dramatic role in *Kitty Foyle*, representing the new demographic of women – the white collar girl.

For the Kitty Foyle look wear a long sleeved, dark tailored dress with contrasting white collar and cuffs, or a dark suit with a pale blouse underneath.

Ginger gave up the feathered gowns for simple white collar suits for her role as the everywoman heroine Kitty Foyle. These dark suits with their contrasting collars were known as the Kitty Foyle look, and became a wardrobe staple for the working woman. *Modern Screen* said her wardrobe was one 'that any stenographer or secretary might own'.[1]

Life magazine in March 1942 wrote: 'Ginger has become an American favourite – as American as apple pie – because Americans can identify with her. She could easily be the girl who lives across the street. She is not uncomfortably beautiful. She is just beautiful enough. She is not an affront to other women. She gives them hope that they can be like her.'[2]

The much anticipated adaptation of Christopher Morley's bestselling 1939 novel, *The Natural History of a Woman,* captured the imagination of young working women. Kitty Foyle was the 1940s Bridget Jones; a career girl torn between two men – the wealthy cad and the good, honest man. It dared to explore the racy subjects of babies out of wedlock and affairs with married men. The film is told in flashback as Kitty must make the decision to marry

This was the Kitty Foyle look – a black suit with ruffled white collar and cuffs, a triangular hat, and black shoes. Renie Conley was inspired by the Adrian dress worn by Joan Crawford in *Grand Hotel* (1932, pictured right). The fitted black tailored dress with buttons down the front had contrasting asymmetrical collars and cuffs, a fresh take on a French maid's outfit.

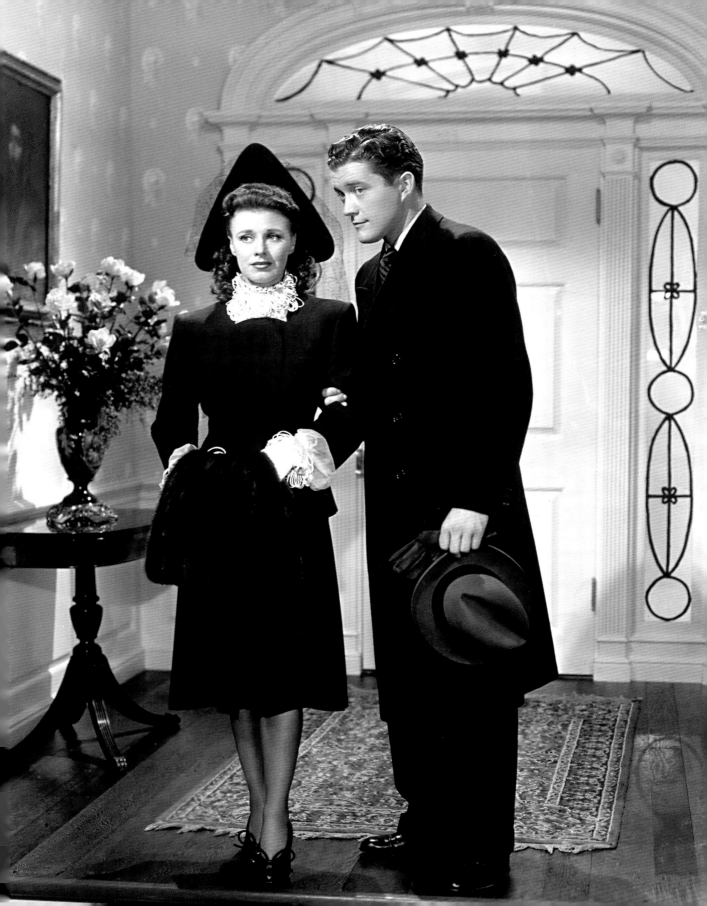

respectable doctor Mark Eisen (James Craig) or be mistress to Philadelphia blue blood Wyn Strafford (Dennis Morgan). We see her working class childhood raised by her rough widowed Irish father to her developing a career as secretary and counter assistant in a department store. It offered a social commentary on the early 1940s and the placing of a new social class of young white collar women, who earned their own money and lived independently. They wore clothes that were simple, smart and modest enough to stem off the possibility of sexual harassment in their workplace.

Ginger Rogers had at first rejected *Kitty Foyle* for being 'highly suggestive and too lurid'.[3] Producer David Hempstead sent her a copy of the novel, which had recently been purchased by RKO for a large sum. After a rewrite, and a softening up for the sake of the censors, Ginger accepted it and would later declare it to be one of her favourite roles, proving that she was more than Fred Astaire's dance partner. 'I just couldn't stand being typed or pigeon-holed as only a singing and dancing girl. I wanted to extend my range,' she recounted.[4]

Time magazine claimed women across the country were ecstatic with the news that Ginger Rogers would be playing their heroine. 'Ginger, with her shoulder-length tresses, her trim figure, her full lips, her prancing feet and honest-to-goodness manner, is the flesh and blood symbol of the all-American working girl.'[5]

Costume designer Renie Conley, under contract with RKO from 1939 to 1949, designed smart suits and dresses for Kitty, made from dark fabric contrasted with white collar and cuffs. It was an outfit that didn't flaunt wealth, and one that Coco Chanel would champion. Chanel created the little black dress with white collar, for a simple, elegant look. Renie was partly influenced by Adrian's designs for Joan Crawford in *Grand Hotel* (1932), as a morally ambiguous stenographer in a tailored black dress with asymmetrical white lace collar and cuffs. Renie also created Oriental detail in the neckline. One satin long sleeve dress had a Chinese style neckline fastened with two knitting needles, the dress was cinched at the waist with a buckle.

In tribute to the forthcoming adaptation of Morley's novel, *Life* magazine printed a photo spread with sugges-

tions of how Kitty Foyle should look on screen. 'Neither too grubby or too glamorous,' they suggested. Director Sam Wood told *Life*, 'Renie's costumes for Ginger might well be within a White Collar Girl's budget. Neat but not gaudy.' *Life* also showed images of possible locations for the Philadelphia home were Pop Foyle raised Kitty, the soda counter, the cramped apartment in the hotel for girls and the cheap-eats joint. The original 21 Club in New York was used as the model for Giono's Speakeasy.

To complete the transformation to Kitty, Ginger dyed her hair chestnut brown and dressed down to take on her first dramatic role. 'I concluded that Kitty couldn't possibly be a blonde,' said Ginger, 'She was the daughter of a proud Irishman and had to look and act like one. Dark hair, blue eyes, a quick wit and a stinging tongue.'[6]

The one expensive evening dress was made from gold lamé, imported from France at a cost of $24 a yard. 'Because the material used in the gown was the last of its kind to come out of war-torn France, Bonwit Teller, exclusive New York store, wired the studio asking for it. RKO refused to yield the cloth, preferring to gown their star in it.'[7]

Kitty Foyle was nominated for an Academy Award in five categories including Best Picture, Best Director for Sam Wood and Best Actress. Ginger saw off stiff competition that year – Joan Fontaine for *Rebecca*, Bette Davis in *The Letter* and Katharine Hepburn in *The Philadelphia Story*. When Ginger won her first Academy Award, after all the musicals she had starred in with Fred Astaire, he sent her a one word telegram as congratulations. 'Ouch!'

Above left Ginger Rogers, in Kitty Foyle's one evening gown, with director Sam Wood and costume designer Renie Conley looking over costume sketches.

Left A long sleeved check dress was given a little white lace collar, and was accessorised with black brimmed hat and black court shoes.

Above right Working women could relate to Kitty, who shares a cramped New York apartment with two other girls while selling perfume in a department store. Kitty wears a long black skirt with a ruffled high neck blouse and little belt.

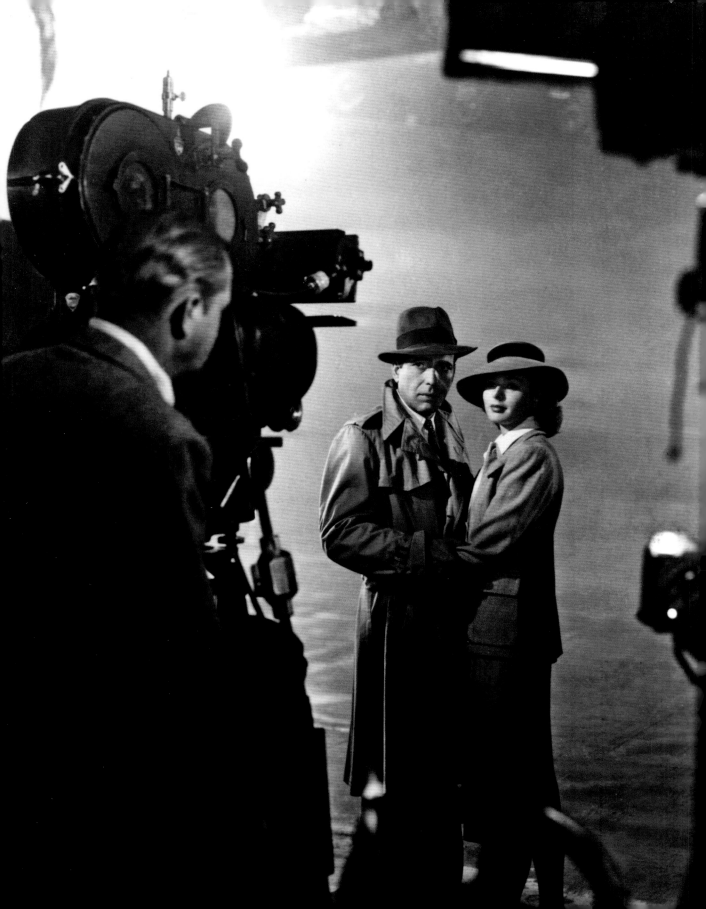

CASABLANCA 1942

If there's a film that represents the look of the 1940s, then it's *Casablanca*. Humphrey Bogart as hard-boiled cynic in trench coat and fedora; Ingrid Bergman as his romantic love interest in the stylishly efficient suits of the war years; the shadowy tilt of their hats in the final scene at the airport. And for Bergman and Bogart, *Casablanca* is their most remembered and loved film. It has become firmly entwined in culture from the sharp dialogue through to the tropical production design of an American café in exotic North Africa.

Casablanca, originally called *Everybody Comes to Ricks*, had been turned down by every studio before it arrived at Warner Brothers. When producer Hal Wallis found the script on his desk five days after the attack on Pearl Harbour, he embraced the 'colourful' and 'sophisticated hokum' with enthusiasm.[1] 'The story of a laconic American solving the problems of Europeans would have definite appeal in those troubled times,' he said.[2]

It fitted the bill as a project to support the war effort, while also capitalising on the success of *Algiers*, the 1938 exotic romance adventure starring Hedy Lamarr. Wallis changed the title to *Casablanca*, to cash in on the similar story and North African location. As Wallis saw it, 'Casablanca is a picture depending largely on its background, colour, locale and mood.'[3] A desert oasis was created on the Warner Brothers back lot, with the white washed walls, potted palms and ceiling fans of Rick's café, and the narrow alleys and archways of the black market. Wallis instructed cinematographer Arthur Edeson to ensure a deep contrast in lighting, with 'real black and whites with the walls and the backgrounds in shadow and dim, sketchy lighting'.[4]

One of the reasons why *Casablanca* has stood the test of time is the simplicity and realism of the costumes. Wallis was anxious that characters didn't look too dressy. 'I would like to have the feeling that these people are getting out of their country with just the clothes on their backs, and I don't want them to look too dressed up,' he said.[5]

Ingrid Bergman's look was simple, with a tailored jacket, knee-length skirt and white shirt, worn with a wide-brimmed hat. Her hair, jewellery and make up was kept natural.

Humphrey Bogart and Ingrid Bergman prepare for the final scene at the airport.

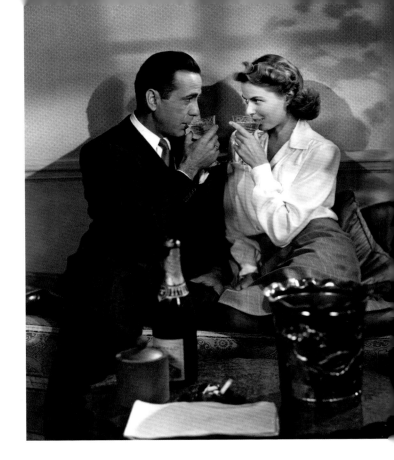

Warner Brothers research department gathered photos of Moroccan and Tunisian women to give to Australian-born costume designer Orry-Kelly. Researchers discovered the difference in dress between rich and poor Arabians, and that 'the Moroccan peanut vendor's white robe will be easily distinguishable from the multi-coloured outfit of the man who peddles water'.[6]

Bergman's wardrobe was dominated by white, incorporating the simple silhouettes of street suits, striped tops and wide-brimmed hats. The paisley patterned blouse, worn with a red sash and black skirt, is her darkest, most complicated costume, worn when Ilsa pulls a gun on Rick.

Bergman's classic look has stood the test of time, partly because she herself eschewed overly made-up glamour for a more naturalistic look. She was unconventional in that she was very tall, wore simple make-up and kept her prominent, natural eyebrows, at a time when women wore them plucked and pencilled in.

Hal Wallis was desperate to cast her as his leading lady, as she was 'the only actress with the luminous quality, the warmth and tenderness necessary for the role. But getting her was a major problem.'[7] That problem was David O. Selznick, the big shot producer who discovered the Swedish actress, signed her up and cast her in the successful *Intermezzo* (1939). Wallis eventually secured her, but on condition that all decisions about wardrobe and make-up were to go through Selznick. He was notoriously difficult when it came to protecting the image of his stars, and he wanted to make sure she looked as beautiful as possible on screen, while also maintaining the naturalism that audiences fell in love with.

In a BBC interview in 1980, Bergman recalled when she first arrived in Hollywood: 'I argued with [David Selznick] because he felt that I should look like everybody else, have my teeth straightened and my eyebrows plucked. One day he said, "I have an idea", and he was looking at me. "I'm not going to change anything. You're going to be the first natural actress in Hollywood." And he left me the way I was and that was how my publicity was built up. I was the first natural person that ever came to Hollywood.'[8]

Finding the right costumes for Ingrid Bergman proved to be a challenge –

Humphrey Bogart's white dinner jacket worn with a black bow-tie was the gentleman's evening wear of the 1940s.

balancing the opinions of Hal Wallis, director Michael Curtiz and Selznick. While it was important Bergman looked glamorous for female audiences, Wallis was concerned that she would look too elegant and smart. Wallis also made it clear to Warner's hairstylist Perc Westmore that Bergman should wear her hair down the entire time, in keeping with the image that was so successful in *Intermezzo*.[9]

After viewing wardrobe tests for Ilsa's first costume, worn in Rick's café, Wallis expressed his concerns to Curtiz that the evening gown was far too dressy. 'We should think seriously about whether this girl should ever appear in an evening outfit,' he said. 'After all, these two people are trying to escape from the country. The Gestapo is after them, they are refugees, making their way from country to country, and they are not going to Rick's café for social purposes. It seems a little incongruous to me for her to dress up in evening clothes as though she carried a wardrobe with her.'[10]

Orry-Kelly ran up a number of gowns, all rejected. Of the original gown Wallis said to Curtiz, 'Let's throw out the entire outfit. It is very unattractive. Kelly will have to make-up something else to replace this.'[11] Another gown, to be worn with long white gloves, was 'much too dressy'. He told Curtiz that it

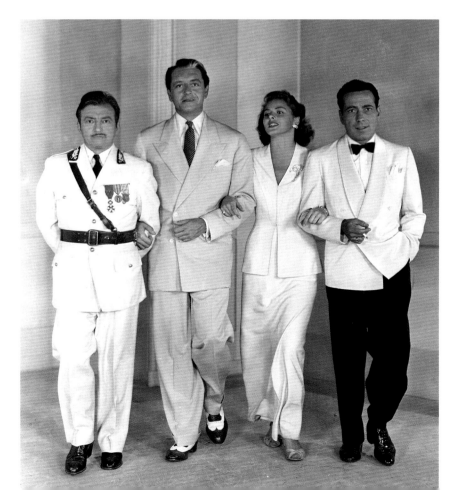

Above left For this scene set in Paris, Bergman wore a simple white long sleeve open-necked shirt, worn with a pale grey pinstriped A-line skirt. Her hair was kept simple with minimal jewellery, make-up and natural eyebrows.

Right Claude Rains, Paul Henreid, Ingrid Bergman and Humphrey Bogart pose together for studio publicity shots.

would be better to go with 'just a plain little street suit. Somehow or other these evening costumes seem to rub me the wrong way.'[12] He was also not keen on Bergman's most glamorous costume in the film, worn during the Paris flashback. He said he didn't 'particularly like that satiny affair which was to work in the interior of Ilsa's apartment, but I believe that it is shooting today and it is too late to do anything about it.'[13]

When David O. Selznick saw the costume tests for Ingrid Bergman's wardrobe a few days into production, he wasn't pleased. He wrote in a memo: 'In order for her to look smart she doesn't have to be dressed up like a candy box.' He thought white shoes made her feet look enormous, and the striped skirt and sheer blouse made her rear look too big.[14]

According to studio press releases, she wore 'a rare combination of glamorous and practical gowns'. The exotic setting called for 'almost tropical clothing' but 'Orry-Kelly has used style and cuts that, copied in fall or winter materials and colours, would suit the most fastidious woman.'[15] It was even noted that a new shade of pale blue had been created by Orry-Kelly for Bergman, called Casablanca Blue, inspired by the reflection of the deep blue Mediterranean Sea on the white washed walls of North Africa. The publicity material noted that Orry-Kelly predicted its popularity during the war years because 'it is made from American dyes, so there is little likelihood of any shortage and it is particularly effective on cotton fabrics.'[16]

As Rick's spurned lover, Madeleine LeBeau was given a flashier wardrobe, with a shimmering, midriff revealing gown; Hollywood's costume for bad girls. The actress was a 19-year-old French refugee who was 'thrilled to have been part of *Casablanca*'.[17]

The role of Rick Blain cemented Bogart as a romantic leading man and became the archetype of his persona – the cynic who professes to never sticking his neck out for anyone, but then reveals a softer, honorable side. The image of Bogart in white evening jacket and bow-tie, cigarette in mouth, has become the indelible image of *Casablanca*. And Bogart would also be forever linked with his trench coat and fedora hat, even though he only wore them in a couple of scenes.

But, in fact, Hal Wallis wasn't keen on Bogart wearing a hat at all. He told Curtiz, 'Please be

careful about the kind of hats you have Bogart wear. As far as I am concerned, I would just as soon see him go through the whole picture without wearing a hat.'[18] He rejected the use of a hat in the car in Paris, 'We might give him one in the railroad station in Paris, and perhaps a Panama hat worn with costume 10, Martinez' café and exterior bazaar. Otherwise, I would play him without a hat.'[19]

In the wardrobe plans created in May 1942, just before filming, Bogart's first suit was described as a tropical dinner jacket. It was also indicated that he would need a tuxedo for the Paris flashbacks, a raincoat and soft hat for the Gare du Lyon, and a light suit and Panama hat for the bazaar. All of these would be provided by Bogart himself – men's wardrobe was rarely custom-made for film.

Austrian born actor Paul Henreid was reluctant to play resistance leader Victor Lazlo. He thought 'the role of an underground leader who appeared in a white tropical suit and hat in a famous nightclub and talked openly with Nazis was ridiculous and redolent of musical comedy.'[20] Wallis was concerned with Paul Henreid's wardrobe, after difficulties with his clothes in his recent production of *Now Voyager* (1942), so he made sure he received still pictures of every wardrobe change.[21] After viewing Henreid in a white tropical suit for scenes in Rick's café, Wallis instructed his costume to be changed to a 'plain sport outfit.'[22] 'We do not want him to wear the tuxedo at any time in the picture. He is always to be dressed informally.'[23]

It wasn't until production of *Casablanca* wrapped, that Warner Brothers realised they may have a hit on their hands. Bergman, who had been more concerned about winning the part of Maria in *For Whom the Bell Tolls* (1943), would be surprised later in life that Ilsa would be her most famous part. She had even cut her hair off to play Maria as soon as shooting ended. This meant that a plan to cut *As Time Goes By* and replace it with another number was made impossible because of the lack of continuity between her hairstyles.[24]

Left Bergman's tailored suit with knee-length skirt and white shirt, worn with a wide-brimmed hat was a simple look for women to replicate during the war years.

Above For the 1940s tropical look, Bergman wore a black and white striped short sleeve top underneath a knee-length white sleeveless shirt-dress, tied at the waist with a simple belt, and accessorised with a matching hat and pale low-heeled sandals with ankle-straps.

COVER GIRL 1944

Cover Girl has all the ingredients for a stirring war-time musical: forties chorus girls with shoulder length waved hair and revealing two-piece costumes, musical numbers by Jerome Kern and Ira Gershwin, snappy choreography from Gene Kelly, a supporting role for Phil Silvers and of course redhead Rita Hayworth, the armed forces' favourite pin-up, in glorious Technicolor.

As well as being one of the most popular musicals of the time, it is also considered one of the first, along with *Meet Me in St Louis* (1944), to combine songs within the narrative. While some musical numbers take place on stage, others happen as if off the cuff, expressing the emotion of the characters. It was also the first film in which Gene Kelly choreographed his own dance moves, showing what he was capable of, with his ballet and tap style and the innovative shadow dance. There were eight dance routines for Hayworth and songs included the classic *Long Ago (and Far Away)*, which hit a note with those pining for their loved ones during the war.

Fred Astaire once declared that Rita Hayworth was his favourite dance partner when they starred together in wartime musicals *You'll Never Get Rich* (1941) and *You Were Never Lovelier* (1942), but it was her pairing with Gene Kelly in *Cover Girl* that made her a huge star. Gene Kelly was borrowed from MGM despite head of Columbia Harry Cohn's concerns about his 'tough Irish face'.[1] Like Astaire, Gene Kelly was worried about Rita's tall frame, so 'Rita took off her shoes and let Kelly sweep her off her feet.'[2]

The dancers wear Latin inspired showgirl gowns with gold sandals, Eve Arden in an elaborate hat that looks like a crow has landed on her head, Gene Kelly in a bellhop costume, Rita Hayworth in a pale green chiffon gown, and Lee Bowman as theatre impresario Noel Wheaton.

Left 'I've just seen the golden wedding dress for the cover. It's a dream,' says one of the models at *Vanity* magazine. 'If you whipped me up a dress like that, I'd get married tomorrow. To anyone.'

Opposite *Cover Girl* was Rita Hayworth's first Technicolor film to showcase the auburn hair which made her the GI's favourite all-American pin-up. She wore a lemon yellow shirt and black shorts for backstage dance rehearsals.

Rita Hayworth had been on the stage from a young age. She danced in Tijuana dives with her father from the age of 13 and was given small roles in Hollywood as the exotic, Spanish type under her original name Margarita Cansino. But it was when she was marketed as the all-American Rita Hayworth, with her hair dyed strawberry blonde, and her hairline pushed back with electrolysis, that she became known as the love goddess.

The war years were the era of the cheesecake pin-ups, of voluptuous, straight-up 'sweethearts' representing the girls left behind and Rita was the second most popular pin-up after Betty Grable. After *Life* magazine published a photograph of Hayworth kneeling on a bed in a satin negligee in 1941, 5 million posters were ripped out and stuck up on the lockers and walls of GIs fighting in the war. 'Rita seemed so much to personify all the good things of life worth fighting for,' wrote John Kobal. Rita was adored by servicemen and

Rita Hayworth wore the look of a 1940s chorus girl with her red waved hair pulled into a pompadour, with high-waisted shorts and short sleeved blouses.

her movie musicals were morale boosters, including *You'll Never Get Rich* and Technicolor extravaganza *Tonight and Every Night* (1945). Columbia head Cohn hired writer Virginia Van Upp to perfect the script for *Cover Girl*, and after becoming good friends with Rita Hayworth, she had input into the wardrobe and other aspects of production to really make the star shine on screen. They would work together on several more productions. On the set of *Cover Girl*, Harry Cohn found out that Virginia had thrown away $50,000 of costumes when she didn't think they looked right. When he confronted her, she invited him to come and have a look for himself. He saw that she was right about the costumes, and trusted her for his most valued star.[3]

In *Cover Girl* Danny McGuire (Gene Kelly) owns a Brooklyn nightclub where his girlfriend Rusty Parker (Rita Hayworth) performs as a chorus girl. When she wins a competition to become the new face of a fashion magazine,

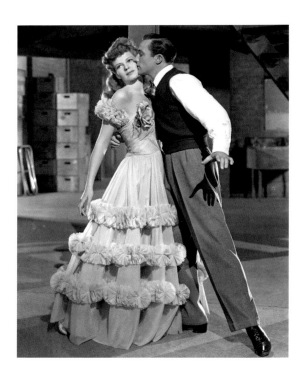

she is suddenly pushed into stardom with a chance to perform on Broadway. The owner of the magazine was in love with Rusty's grandmother, and Rusty's resemblance to her captivates him.

Little touches in the script indicated its place and time. In one brief conversation it is revealed that Gene Kelly's character isn't at war because he was shot in North Africa; a chorus girl calls out, 'Who stole my nylons, ye gods!'; there are uniforms in the audience and talk of the shortage of men; and Phil Silvers sings in *Who's Complaining*, 'I'll feed myself on artichokes, until that Nazi party chokes, so as long as they don't ration my passion for you.'

As part of a large publicity campaign, fifteen winners of national cover girl competitions were used to model for magazines of the day. Models Anita Colby and Jinx Falkenburg made cameos and *Harper's Bazaar*, *Cosmopolitan* and *Vogue* lined up to have their magazine covers featured in a Columbia musical.

Eve Arden, who would play the headteacher in *Grease* (1978), is the editor of *Vanity* magazine, played in her typical wise-cracking, punchy style. She looks the part in dazzling suits, broaches, furs and elegant gloves.

Rita played two characters; Rusty Parker, a modern day dancer dressed in Travis Banton's contemporary designs, and Rusty's grandmother Maribelle, a turn of the century singer and dancer in gowns by Gwen Wakeling, who had extensive knowledge of period costume. Kenneth Hopkins designed fabulous, creative hats which perch at angles on top of smooth, glossy hairstyles.

Above left For the *Long Ago (and Far Away)* number, Travis Banton designed an extravagant off-the-shoulder tiered aquamarine gown with a pink rose on the bodice to break up the colour. Hair in the 1940s was worn shoulder length and rolled, often with a pompadour, which was a pouf of hair at the crown, creating a fringe effect.

Above Rita rests on a leaning board during the production, which allowed stars in period costume to take the weight off their feet, without crushing their gown.

Above right Gwen Wakeling's costume sketch of the 1890s flouncing black and white stage gown for Maribelle Hicks, with a burst of red on the cress and in the hat.

Muriel King provided costumes for the supporting cast including tailored day-wear for the models and backstage dancer's costumes of shorts and shirts. The same year as *Cover Girl*, King designed the Flying Fortress Fashions for female factory workers at Boeing and other west coast aerospace firms. *Life* reported that these safe, practical fashions had become a fad for 1943.

Technicolor showcased Rita's diaphanous stage costumes in lime greens, aquamarine, pale pinks and gold. For daywear she wore a houndstooth coat with thick black collar, and a pale pink two-piece tailored suit worn with a flat black hat, which perfectly offset her red hair. She wears draping layered skirts that fly up to reveal her legs as she dances and for the title musical number, Rita runs down a staircase and on to the huge stage, in a billowing gold dress that exposes her shoulders.

The flashbacks depicting Maribelle also served to satisfy audiences who had loved Rita in *The Strawberry Blonde* (1941) and *My Gal Sal* (1942), where she was also dressed in late 1890s Victorian costume. The flashbacks were very much a fantasy of turn of the century New York, with merry-go-rounds, boating outfits and women with parasols and bustles. One of the musical numbers was *Poor John*, a popular English song from the late nineteenth century. The 'costume for this entertaining number is a copy of the famous London costermonger costume for which almost two thousand pearl buttons were used,' said a press release. She wore a black knee-length skirt with a red jacket, decorated with pearl buttons, the heart and starburst patterns matching the blue suits worn by the accompanying male dancers.

The dance numbers between Rita, Gene Kelly and Phil Silvers on a studio-built New York streetscape are highly animated and pure joy, demonstrating how happy she was at that time in her life. Rita had a whirlwind romance with Orson Welles during production, and the couple, dubbed 'beauty and the brains', got married in secret in September 1943. No one on set had any idea until they read about it in the papers. Lee Bowman, who played theatre director Noel Wheaton, remembered when she arrived to film the wedding scene. 'She looked very lovely sitting there in her wedding dress while the crew were setting up. Rita sat there with her hands in her lap, her eyes very big and a lovely big smile on her face. When any of us asked, "What is it, Rita?" she'd just shake her head and say, "Mmm, I've got a secret." Wouldn't say anything else. The first we knew what it was came during the lunch break when somebody brought us the papers with the headlines.'[4]

TO HAVE AND HAVE NOT 1944

When Lauren Bacall slinked panther-like on to the screen in Howard Hawks' *To Have and Have Not*, a starlet had never made such an impact in her first movie role.

Bacall was hyped as 'an American Dietrich', a 'tall Veronica Lake', and 'what most men expect their favourite girl to look like'.[1] The actress, born Betty Joan Perske, was given the nickname 'the Look', in tribute to the way she tilted down her chin and glanced up through the side sweep of blonde hair.

> Lauren Bacall's cool look was elegant and strong, with structured shoulders, stylish houndstooth suits and a side sweep of long blonde hair.

Lauren Bacall was the perfect partner for Humphrey Bogart, as she could match him with toughness and wisecracks. They famously fell in love during the making of *To Have and Have Not*, and because the film was shot in sequence, the offscreen love story unfolds before our eyes.

Hawks told Bogart, 'We are going to try an interesting thing. You are about the most insolent man on the screen and I'm going to make a girl a little more insolent than you are.' Bacall dropped biting one-liners, gave Bogart the brush off until the end, and slinked in tight fitting suits, shirts and dresses that highlighted her cat-like poise.

When she first saw Bogart, Bacall said 'There was no clap of thunder, no lightning bolt, just a simple how-do-you-do. Bogart was slighter than I imagined, five feet ten and a half, wearing his costume of no-shape trousers, cotton shirt, and scarf around neck. Nothing of import was said, we didn't stay long, but he seemed a friendly man.'[2]

While Hawks' film was based on the Hemmingway novel and the central characters of the book were retained, the plot of rum-running and pre-war revolution was cut, and instead Bogart was involved in the Vichy French struggle for

The midriff revealing black gown Bacall wears as she sings in the Café de France has a Latin American feel, with a hoop that links the top to the draped skirt. Like all her costumes, it had structured shoulders, and she wore it with a pair of black peep toe shoes.

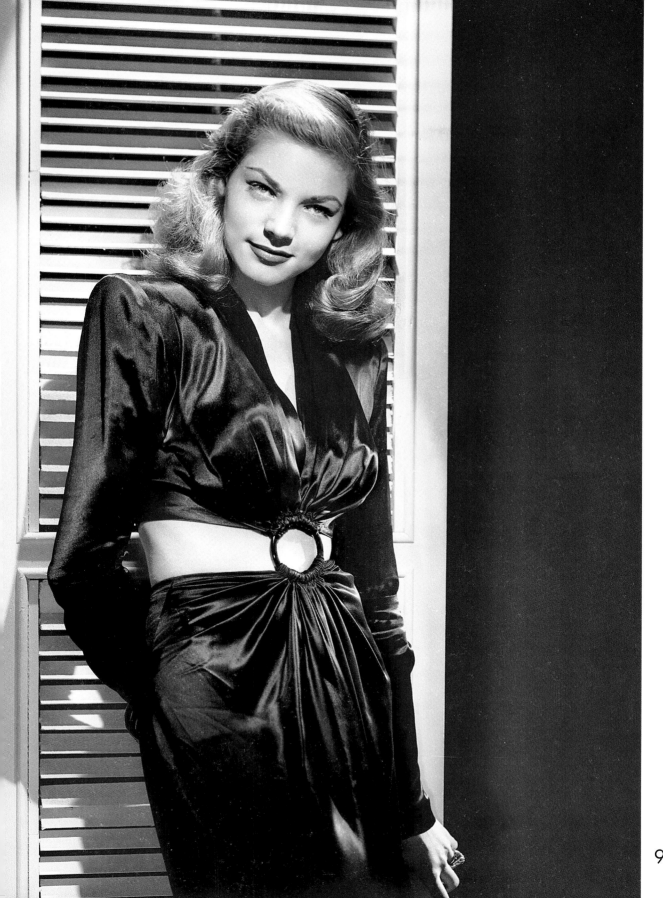

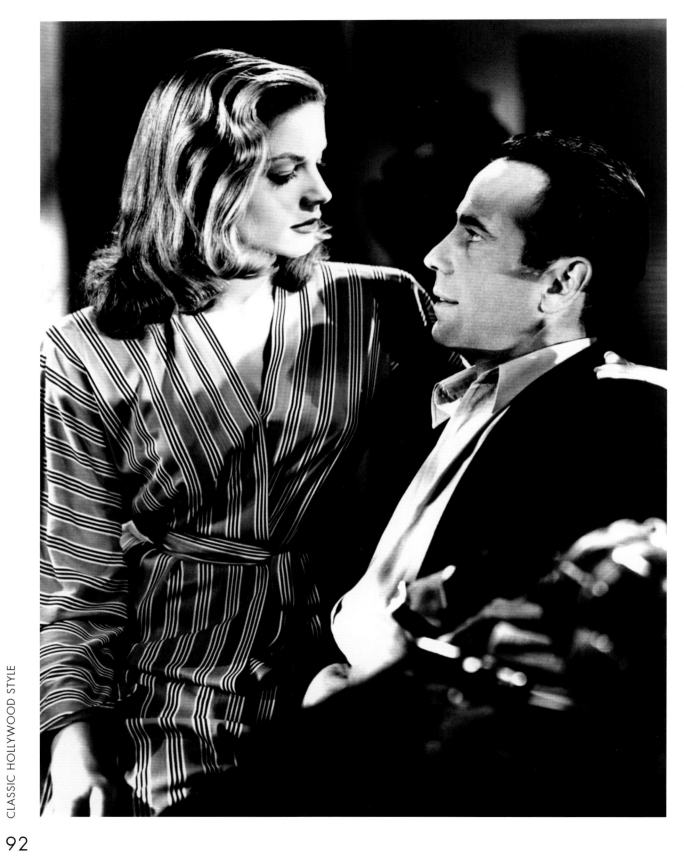

control of Martinique. 'Martinique is in the tropics. The tropics are sultry. And so is *To Have and Have Not*,' said *Motion Picture Daily*. 'Bacall's voice is deep and interesting. Her deportment has a decided come hither look and her brand of acting is purring in the slow-cooked manner . . . There are far prettier actresses in Hollywood, but not many that leave the Bacall kind of impress.'[3]

Bacall was Howard Hawks' protégé; the young model who his wife, Nancy 'Slim' Hawks, had seen on the cover of *Harper's Bazaar*, and told her husband that this was a star in the making. Bacall told *Vanity Fair* that Hawks' 'one ambition was to find a girl and invent her, to create her as his perfect woman. He was my Svengali, and I was to become, under his tutelage, this big star, and he would *own* me. And he would also like to get me into his bed, which, of course – horrors! It was the furthest thing from my mind. I was so frightened of him.'[4]

Hawks changed the heroine's name in the film from Marie to Slim, in tribute to his wife. He also ensured Bacall's Slim wore a houndstooth suit exactly like the ones his wife liked to wear.[5] She would wear a similar suit with beret in *The Big Sleep* (1946), reteaming with her new husband, Bogart.

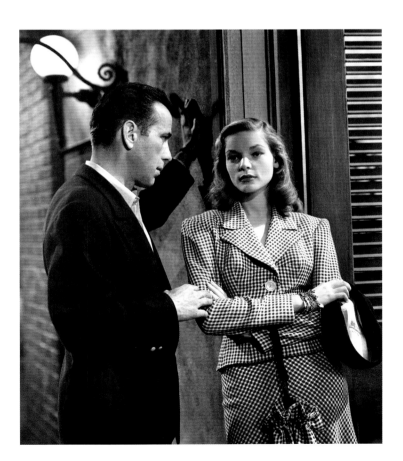

The make-up department tried to strip back Bacall's hairline and straighten her teeth, but she resisted and insisted on keeping her hair the way she liked it. 'The wave . . . on the right side – starting to curve at the corner of my eyebrow and ending, sloping downward, at my cheekbone.'[6]

Slim is first seen leaning on a piano in a Martinique hotel bar. She is a drifter who needs money, and charms Bogart's fisherman when he watches her pick the pockets of a man who is buying her drinks. 'That girl's an expert on slow motion,' said Hoagy Carmichael, who wrote songs for the film and played piano player Cricket. 'Slow motion, honey, that does it. Just like in a good, low down tune.'[7]

In her deep sultry voice, she asks: 'Anybody got a match?' Steve throws her a box of matches and she coolly catches it in one hand. It was the first scene to be shot and in reality, instead of being the 'know-it-all experienced sex pot', the

Left Bacall wears a simple striped dressing gown, with shoulder pads of course, when she plants herself down on Bogart's lap, gives him a lingering kiss and delivers her most famous line. 'You know how to whistle, don't you, Steve? You just put your lips together and blow.'

Below The houndstooth wool suit emphasised Bacall's lean figure, and was inspired by a similar one worn by Howard Hawks' glamorous wife, Slim. Bacall wore it with a matching bag and with a black beret in her hands.

19-year-old was a 'true innocent'.[8] She was shaking so much that it took take after take to get it right. The only way to stop her head trembling, was 'to keep it down, chin low, almost to the chest, and eyes up at Bogart'.

The Look was 'something she learned in modelling for *Harper's*' said Bogart in a 1944 interview. 'Never does it off screen except for a gag. I say "give us that from-down-under look". She goes into it and breaks herself up, laughing.'[9]

On reading the script, Joseph Breen from the censor's office criticised its 'low tone', he said characters needed to be softened to get away from 'scummy flavour' and 'the story has, in addition to the flavour of prostitution, a kind of flavour of pimpery'.[10] While the Hay's office tried to tone down the story, Bacall said, 'we get away with a lot. Like in *To Have and Have Not*. It's all according to how you do things. Now if I'd worn black satin and gone slinking around . . . but we dressed against it and threw our lines away.'[11]

'Women are sexy when they're covered up,' said costume designer Bill Travilla. 'Lauren Bacall in *To Have and Have Not* was completely covered in an oversized man's black robe. When she turned around to utter her famous line . . . she turned the world on and they literally undressed her.'[12]

She was not a girl who felt comfortable doing pin-up shots. 'Anyway my idea of sex is that it's mostly in the face.'[13]

Orry-Kelly researched the costumes of Martinique and Cuban women and

The silver fox director Howard Hawks with his protégé Lauren Bacall, in a smart utility dress. His society wife, Slim Hawks, took the young actress under her wing and showed her how to dress stylishly.

voodoo priests. Warner Brothers' researcher Herman Lissauer told him there was no particular native dress in the 1930s. Native woman wore cotton blouses, skirts and organdie dresses, 'imported from the United States and would be of the Sears Roebuck Montgomery ward catalogue type'.[14]

It was the mix of local colour that gave the film its rough but tropical feel. There was piano player Cricket, always with a match hanging from his mouth, Bogart in fisherman's hat, open-necked shirt and blazer and a rough down-at-heel bar filled with shady locals and the French Resistance.

Bacall's cool look particularly struck a chord with women who saw the film and the publicity photos in magazines. 'Even the high school girls are trying to copy her striped hair, aidling walk and guttural wheezes,' reported one newspaper. 'Corset departments report un-meetable demands for the up lifted, Bacall type of brassiere.'[15]

Jack Warner had not been convinced about the star quality of Bacall at first. Producer Steve Trilling told Warner that Howard Hawks 'is going over the tests of our various young people and will try, as much as possible, to talk him out of Betty Bacall – the girl he has under personal contract and was willing to share with us if she played the part.'[16] But Warner Brothers' publicity department declared on the film's release: 'We believe that, with the release of this enormously dramatic film, Lauren Bacall becomes one of the most exciting discoveries in the history of motion pictures.'[17]

London's *Daily Express* was less flattering. 'She is not very pretty. She has an ugly mouth, a nose that means nothing, tawny hair with a fashionable white streak in it. All the magnetism is in the eyes which are extraordinary, and in her slow contemptuous voice, her bored, cat-like movements.'[18]

Howard Hawks' discovery was a huge hit with GIs on the film's release, and publicity campaigns took full advantage. There were proposals to name a small volcanic island near Guam 'Bacall Island.' Boys on Kwajalein 'went for Bacall in a big way', and put out a request to interview her by recording questions onto vinyl. 'I believe this can be a swell publicity stunt. Should produce some nice yarns,' said a publicity man.[19] Soldiers sent her cartons of cigarettes ever since 'that thing in *Life* where I said I'd go mad if the cigarette shortage doesn't let up soon. Those boys are wonderful – they write, "we don't want you to go mad, honey."'[20] A letter from a United States Marines said, 'Damned but it was good! To give you an idea how good it is the boys are still talking about it and when that happens its good! This "Slim" that played opposite Bogart was a typical college gal if ever I saw one – course I'm talking of the best kind and I really enjoyed her! Reminded me of a good level drinker with whom you could really have a good time. The kind I miss most here at "Paradise Island".'[21]

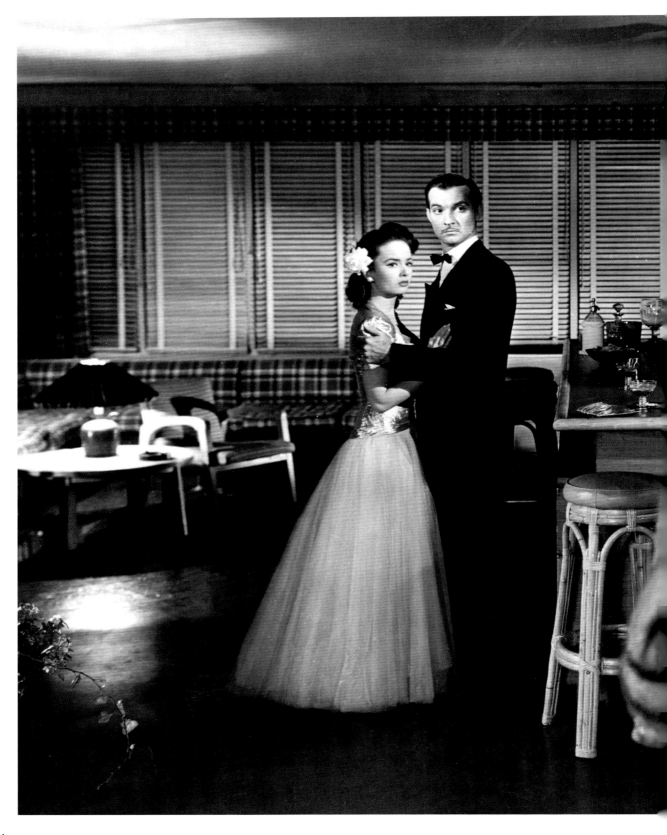

MILDRED PIERCE 1945

It was the shoulder pads that became a character in their own right. Joan Crawford in a halo of mink as she walks desperately down a dark and foggy pier, illuminated by the streetlights overhead. As a studio press release put it at the time, if Mildred's suicide bid had worked, without interruption of a police officer, she would have been the 'best dressed suicide in pictures'.[1]

As film noir heroine Mildred Pierce, Crawford was the ultimate power dresser, forty years before Joan Collins cattily strutted in high heels and business suits. Mildred is a housewife who transforms herself into an entrepreneur with a chain of successful restaurants, after her husband leaves her for another woman. She works hard to give her spoilt daughter Veda the wealthy lifestyle she desires, even if that means sacrificing her own happiness.

By 1940 Crawford's stardom had dwindled and her MGM contract was terminated, after almost two successful decades. In 1943 she signed with Warner Brothers for a $500,000 three-picture deal and her first lead role was *Mildred Pierce* in 1945, an adaptation of the James M. Cain novel.

Director Michael Curtiz was very reluctant to take on Crawford and told Jack Warner, 'She comes over here with her high-hat airs and her goddamn shoulder pads . . . why should I waste my time directing a has-been?'[2] But

Mildred Pierce wears a mink hat and coat with imposing shoulder pads when she discovers her daughter Veda in a clinch with her husband Monty. In a gown with a shimmering bodice, full tulle skirt and flower in her hair, Veda is a picture of innocence.

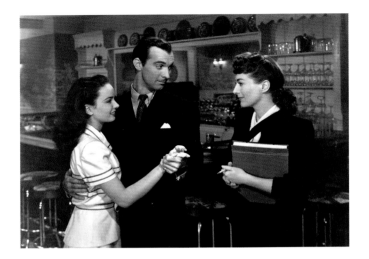

Left On the night of her restaurant opening, Mildred impresses in a smart black suit with white necktie, while Veda wears a little cream sports suit with stripes on the collar and cuffs.

Below Joan Crawford poses with Ann Blyth between takes of the mother and daughter slapping showdown. In the now famous scene, Joan wore a two-piece navy dress, Ann a red polka dot dress with a lace frilled collar.

Right With her housemaid Lottie, played by Butterfly McQueen, Mildred sets up a pie making business. Her checked shirt-waist dress with rolled up sleeves and braces is worn with a floral apron, and is very similar to her waitress uniform.

when Crawford was forced to do a screen test, she eventually convinced Curtiz she could do it. The film not only won her an Academy Award for Best Actress, but relaunched her career in melodrama. 'The role of Mildred was a delight to me because it rescued me from what was known at MGM as the Joan Crawford formula,' said Crawford. 'I had become so hidden in clothes and sets that nobody could tell whether I had any talent or not.'[3]

But Crawford would also complain to a journalist, 'No Adrian. I looked crummy through the whole thing.'[4] Curtiz insisted on simplicity with her wardrobe and make-up, avoiding the painted on look that Crawford had become well known for. She was often ridiculed for her exaggerated eyebrows and the way that she changed the shape of her mouth with heavy lipstick. Acerbic columnist Hedda Hopper, not generally a fan of the actress, even praised her look in *Mildred Pierce*. 'In this you'll see Crawford as she is, without false eyelashes or layers of grease paint and with a mouth that doesn't look like a double-breasted evening coat.'[5]

In preparation, Crawford underwent a 'de-glamorising' process, with a series of make-up and wardrobe tests over six weeks until they perfected her look.[6] Crawford said that she and Curtiz wanted to create a different character 'from the woman I had been on the screen before. We sought a new maturity, a new stable quality that would give a solid background for the almost violent emotionalism demanded by the role.'[7] But producer Jerry Wald confided to studio

manager T. C. Wright that 'the biggest problem we face is to make sure that whoever is to be cameraman can do a good job with Crawford.'[8]

Warner Brothers chief costume designer Milo Anderson had a tumultuous working relationship with Curtiz and Crawford when designing costumes for the movie. 'Mike was rather hard on poor Milo Anderson,' said Joan.[9] 'One of our common problems was the clothes Mildred Pierce should wear. Mike was convinced they should be simple and not "a clothes horse" as he disliked scenes in which the clothes a woman wears attract more attention than they ordinarily would in real life.' One dress which featured a large bow was rejected because 'everybody concerned feels that the bow on the dress will distract attention in the scene.'[10]

There were twenty-nine costume changes which chart her growth from housewife to waitress to business woman in an 'ultra-spectacular evening gown one expects of a newly rich attractive, young business woman.'[11]

As a housewife, Mildred lives in the kitchen, baking cakes for the neighbours and dressed in feminine cotton skirts, blouses and floral apron. In notes on the script, the early costumes were merely described as house dresses,

and Crawford and Anderson worked hard to find the perfect ones. 'Milo had ideas of dressing me in lovely, glamorous fashion but Mike would have none of them. So I went to a Sears and Roebuck store and tried on several of their $3.95 and $7.95 dresses. But when we showed them to Mike he ruled against them too. He said they were still 'too chic'. So we went back to Milo and a new set of originals he had made, based on Mr Curtiz' mental picture of what Mildred Pierce would wear.'[12]

The waitress uniform highlights her working class origins. On the opening night of her first restaurant she wears an apron over her black suit and in one scene Mildred's checked collar links her to the table cloths in her restaurant. 'I cook food, I sell it and I make money from it,' she tells her new husband when they argue over money.

Her success is demonstrated as her suits become more structured and businesslike, and the fur coat is a final symbol of her success, before her power is about to crumble. In costume notes for the first scenes, the imposing fur coat over evening dress was planned out to be 'an evening dress with coat or wrap of some kind.'[13] The colour was 'Kelly Green' and 'the wardrobe department said the fur was Fitch and that they were the most expensive items of the wardrobe.'[14]

It is when she is introduced to Monty Beragon that Mildred's attractiveness is revealed from underneath those work clothes. A dress 'that shows her legs' was required for a scene when she is cleaning at her new restaurant,[15] and at Monty's Malibu beach house she is ultra feminine in a white polka dot dress and two-piece bathing suit. These were considered racy enough to draw comments from the censors. Joseph Breen wrote to Jack Warner: 'In view of the fact that the couple are scantily clad in bathing suits, please change this close embrace at the ending of scene.'[16]

As Mildred becomes more successful, her shoulders become bigger, her hair more structured and she dresses in dark suits.

Joseph Breen had already told Warner, that the 'story contains so many sordid and repellent elements . . . suggestions of illicit sex and blackmail on the part of a 16-year-old, and the very distasteful situation of a man making love to both mother and daughter at the same time.'[17] There was also concern over how teenage daughter Veda (Ann Blyth) would be represented. 'Please watch the costuming of Veda. She should not be shown in less than a slip,' wrote Breen.

The three men in Mildred's life were all to have distinctive looks. Old friend Wally's wardrobe was to be 'a trifle loud', first husband Bert's suits were to be 'a little tired looking' and 'Monty's clothes at all times should be in very good taste'.

The first tests for Zachary Scott, who played Monty, caused problems when Jerry Wald saw them as being 'completely wrong'. He told T. C. Wright, 'For your information, Mr Scott is playing a character that is supposed to have some culture and background . . . It is not my job to make deals with actors regarding clothes, but I do know what the character should wear in the picture, and certainly the clothes that Mr Scott wore in the test were not right in any way and in no way were even a reasonable facsimile.'[18] T. C. Wright was not happy when he heard that additional wardrobe would have to be made up, as men's wardrobes were usually provided by the actor himself, but Wald reassured him that once he saw the wardrobe stills, 'you will agree that they are not right'.[19] The studio sent him to a good tailor to get the clothing problem fixed.

Filming began in December 1944. There were four different restaurant sets, all equipped with operating kitchens, but with war rationing, they had to be inventive on how to represent rationed food. Lemon peel was used to simulate patties of butter found in pre-war restaurants, and the smell of pastry 'brought visitors from every corner of the lot'.[20]

Because Joan Crawford had been off screens for a few years, and her popularity was not as it had been in the 1930s, it was difficult to predict how *Mildred Pierce* would be received. So when the first reviews came back, buzzing about the production and Crawford's performance, producers were very excited.[21] Jerry Wald sent a telegram to Crawford's apartment in New York as soon as he read the great reviews in the *Hollywood Reporter* and *Variety*: 'Both papers say it's the best picture you've ever had and puts you right back on top where you justly belong.'[22]

Wald also sent congratulations to Milo after his name check in the review. 'I was delighted to read in this morning's *Reporter* that a film critic finally took recognition of a designer's work in a film,' Wald wrote. 'It was well earned praise and these few lines are to thank you for the excellent job you did for us on Pierce.'[23]

GILDA 1946

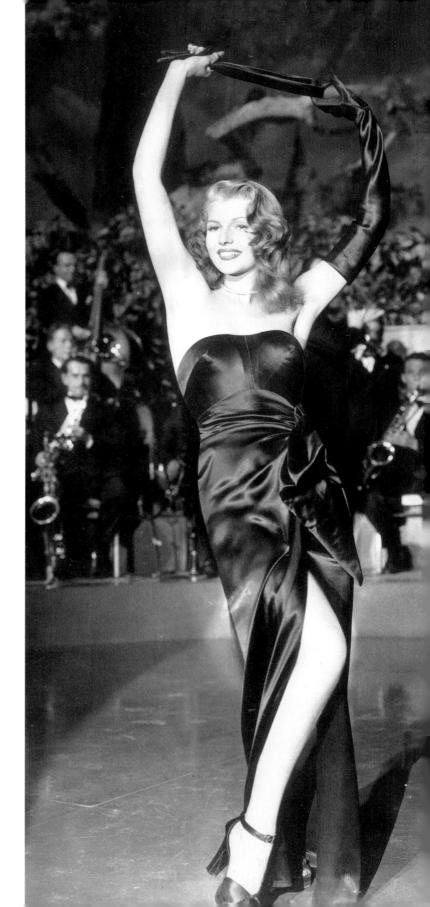

'There never was a woman like Gilda', declared the posters, and 1940s audiences had never seen such a bold femme fatale as Rita Hayworth in *Gilda*. Her image is the epitome of seductive woman; wrapped in black satin, voluminous hair cascading around her bare shoulders, head tilted back as she leaves a trail of smoke from the cigarette in her hand.

This image of Gilda has been used as a trigger for dramatic purposes – in *Bicycle Thieves* (1948) Antonio's bike is stolen while he is putting up a poster of *Gilda*; in *The Shawshank Redemption* (1994), Andy uses the same languorous shot of Hayworth to cover up the escape tunnel in his prison cell. In one scene the prisoners watch the film, cheering at Hayworth's entrance; that moment when she flicks her glossy mane, pulls up the strap of her nightgown, and says 'Me, decent? Sure, I'm decent.'

'The fashion trend I set was the strapless gown with Rita Hayworth in *Gilda*. We had censor trouble with that picture but got away with it,' said Jean-Louis. The black satin gown had a huge bow at the hip, and was worn with long satin gloves and high sandals.

Get the Gilda look with voluminous hair, a luxurious shoulder-exposing satin gown, and long, elegant gloves.

In the most famous scene, Hayworth, dressed in a strapless black satin gown designed by Jean-Louis, suggests a striptease to *Put the Blame on Mame* as she playfully peels off a glove and throws it into the appreciative crowd. Audiences wondered how the dress stayed up as she danced an energetic, burlesque routine.

This dress was a pinnacle of the working relationship between the Columbia Pictures star and the Parisian-born designer, who designed for ten of her movies. His daring, sensual creations turned the shy Rita into the love goddess on screen, matching legendary pairings of Adrian and Greta Garbo or Travis Banton and Marlene Dietrich.

Jean-Louis built a career on designing revealing, provocative gowns for some of the worlds most iconic women. When Marilyn Monroe breathed *Happy Birthday* to JFK, she wore a Jean-Louis creation that gave the impression she was almost nude, save for some well-placed rhinestone. He also gave an ageing Marlene Dietrich the body of a woman much younger when he created skin tight soufflé gowns for her cabaret performances. Jean-Louis once proclaimed: 'I get lots of fan mail. I used to get mail from soldiers – they thought Jean-Louis was a woman and wanted me to send them my picture.'[1]

But the *Gilda* gown, he believed, was the one that set fashion trends because he kept the lines simple. 'Since pictures are sometimes held for a long time, you must keep the designs simple so they won't be dated.'[2] He told *W* magazine in 1981 that Rita was 'the most fun and so beautiful. There was nothing common about her. Her nose, her chin were extraordinary – and those long, long legs. When I did the *Gilda* dress it was bolder and sexier than film designs of the time, but on Rita it was not vulgar.'[3]

Gilda was the classic Hayworth role; sexually alluring but cool and remote, like her roles in *Blood and Sand* (1941) and *The Lady from Shanghai* (1947). Audiences were said to gasp at that first sultry sight of her, with her shoulders bare, the straps of her negligee having slipped away, whipping her hair as she looks up. It was the most popular film of 1946, despite being lambasted as 'high-class trash' by critics, and launched Hayworth as the most sought after woman in the world. She was at her most lustrous as Gilda, her skin creamy perfection and her cheekbones and eyes sharpened on monochrome film. As John Kobal commented, few actresses have had their hair used so deliberately as a sexual metaphor.[4]

Typical of postwar film noir, Gilda is the bad girl who is slapped, abused and kissed by the male protagonist, a reflection of the paranoia felt by men as they came home from war to find women had coped quite well without them. The plot was convoluted at times – we are led to believe Gilda is a heartless seductress, but it turns out she was only pretending – but with the presence of Hayworth dressed in shimmering, tactile gowns, all would be forgiven. *Variety* wrote: 'When things get trite and frequently far-fetched, somehow at the drop of a shoulder strap, there is always Rita Hayworth to excite the filmgoer.'

Hayworth got some choice dialogue. Gilda quips, 'Didn't you hear about me Gabe? If I'd been a ranch they'd have named me "The Bar Nothing".' But Hayworth's sizzling turn as the ultimate femme fatale was an image of female sexuality that the shy star felt she could never live up to. 'No one can be Gilda twenty-four hours a day', she said, lamenting that every man she knew fell in love with Gilda, but woke up with her. The physically confident, sexual

Below The white tunic evening gown was decorated with gold bead stripes, and was worn with gold evening sandals, and gold and rhinestone jewellery.

Right Rita Hayworth and Glen Ford relax between takes for the scene where Gilda is first introduced, in a diaphanous 'boudoir gown', that falls from her shoulders.

image of Gilda was in marked contrast to the real life woman, who director Charles Vidor called 'a trusting child', who has a 'half-afraid, half-repressed, little-girl soul'.[5] Choreographer Jack Cole, who took her through the steps in *Gilda*, said she was more like 'a dancing gypsy girl, who could have been very happy working in a chorus, happily married to some average-type husband who wanted a nice female lady, which she is.'

The budget for Hayworth's costumes was $60,000 and women, who had suffered from the rationing of fabric during the war, coveted the luxurious Jean-Louis costumes.

Life magazine declared the end of 'the spendthrift mood of the US', and wrote, 'In the clothes Miss Hayworth, whose beauty is a national asset on the order of Grand Canyon or TVA, looked so lovely that no one was rude

enough to ask if the effect could not have been achieved for less than the final total.[16] Jean-Louis created sensual gowns and negligees in luxurious silks, satins, metallic and transparent fabrics, with exposed shoulders, bare midriff and skirts slit to the hip. There was a $35,000 chinchilla coat and a $10,000 ermine wrap which she dragged along the floor, along with 'ten dresses, three negligees, a masquerade costume and a pair of pyjamas.'[17]

The production of *Gilda* was fairly haphazard, without a completed script when it began. It may be one of the classic scenes of 1940s cinema, but *Put the Blame on Mame* was injected into the film as an afterthought once production had wrapped.

Director Charles Vidor recalled: 'Rita had to study at night, so did I, so did Jean-Louis the dress designer, but somehow he kept one leap ahead of us all. So that particular *Mame* morning, none of us knew how Rita was going to look. She sauntered on the stage holding her head up high, in that magnificent way that she does, stepping along like a sleek young tiger cub and the whistles that sounded would have shamed a canary's convention. She enjoyed every second of it. Then she did that elaborate difficult *Mame* number in two takes.'[18]

Above left The Amado Mio bare midriff evening gown reportedly cost $1,800, and was embroidered with a design taken from a Fra Angelico painting, so Rita could look both 'angelic and alluring'.[14]

Above For the carnival she wears a dangerous black Zorro-style costume, with an embroidered waistcoat, a black skirt split to the hips, embroidered cowboy boots, and accessorised with a bull whip and a mask over the eyes.

Jean-Louis was inspired by the John Singer Sergeant painting *Madame X* when designing the gown. When it was shown at the Paris Salon of 1884 it caused quite a scandal with the strap brazenly falling from off her shoulder. Rita had just given birth to her first daughter, Rebecca, and the dress was designed to disguise her belly with the use of the large bow at the hip. By exposing her shoulders and arms he created a complete illusion of slenderness despite the extra baby weight. 'Rita had a good body', said Jean-Louis. 'It wasn't difficult to dress her. She was very thin-limbed, the legs were thin, the arms long and thin and she had beautiful hands. But the body was thick. She also had a belly then, but we could hide that. That was what my job was.'[9]

Jean-Louis recalled that he had used a harness inside for support, and then moulded plastic around the top of the dress to keep it from slipping down. 'Poor Rita. She was rehearsing so hard, her feet were bloody, but the dress did not fall down.'[10] Choreographer Jack Cole said he based the burlesque routine on 'a stripper named Charmaine . . . an extraordinarily beautiful broad who looked incredible when naked.'[11] 'I must say of all the things I ever did for movies, that's one of the few I can really look at on the screen right now and say: if you want to see a beautiful, erotic woman, this is it.'

According to Jean-Louis, the *Gilda* dress was used by Columbia chief Harry Cohn to test young starlets. The actress who wore it the best would win the part, but only a select few would measure up. Kim Novak, who was seen as Hayworth's younger rival, was one of the few.

But what happened to the original dress remains a mystery. 'After Harry Cohn died, the studio moved to Warner Brothers. By then the original dress was in shreds and it just disappeared,' said Jean-Louis.[12] He recreated the gown for *Vogue* editor Diana Vreeland's Metropolitan Museum of Art exhibition in the 1970s as she was a big fan of the movie. When she first viewed the film, she immediately sent a telegram to Jean-Louis. All it said was, 'Superb.'[13]

THE KILLERS 1946

Ava Gardner as Kitty Collins is the ultimate femme fatale, swathed in black satin, with her long dark hair falling around her shoulders.

It was no coincidence that the femme fatale of film noir emerged as the Second World War came to an end. They represented the fear that returning men felt as their wives and girlfriends found independence in the work place. There was also the worry that their girl had been duplicitous and unfaithful, one of the traits of a femme fatale like Kitty Collins, whose beauty men will lie, cheat and steal for.

Producer Mark Hellinger paid a record amount of $50,000 for the Ernest Hemmingway short story in which two strangers terrorise a small town lunch counter while looking for a man called the Swede. The hard-boiled tale ended with the Swede awaiting his fate in his dingy lodgings, but in the adaptation an entire back story was created, particularly with the invention of Ava Gardner's character, and an insurance man trying to solve the case. 'Ever since Fred MacMurray and Edward G. Robinson made insurance men colourful and dramatic in *Double Indemnity*, insurance salesmen took on a glamour they didn't have before,' said a Universal Studios press release.

The Killers was the first of three Hemingway adaptations that Ava starred in, and the one that the author respected the most. She became friends with the man she called Papa and recalled that he would pull out a projector and show *The Killers* to his guests at his house in Cuba. But he'd fall asleep after the first reel, as it was only the first twenty minutes that was based on his words.[1]

> Ava Gardner was the classic femme fatale whether in sleek black satin or sweaters, checked shirts and knee-length skirts.

Ava Gardner was the postwar femme fatale in black satin. The slinky gown with one shoulder strap and ruching around the bodice and skirt shimmered under the natural lighting, and was worn with long black gloves and a pair of strappy sandals. 'Ava has dark hair, grey-green eyes, is five foot six inches tall, and weighs a hundred and sixteen pounds, which on her looks thin,' studio publicists declared. Ava said, 'I eat like a horse but nothing happens.'

Kitty was Ava Gardner's first major role and the one that lifted her status to one of the most in-demand actresses in Hollywood. Ava wrote in her biography, 'A lot of people have told me through the years that it was *The Killers* that set me on the road to stardom, that defined my image as the slinky sexpot in the low cut dress, leaning against a piano and setting the world on fire.'[2]

Vera West was chief designer at Universal from 1927 to 1947. Before arriving in Hollywood, she had worked at a Fifth Avenue salon, dressing the rich and pampered New York elite, which put her in good stead for working with movie stars.[3] Ava Gardner was given fifteen changes of wardrobe designed by West, and most of her costumes were simple shirts, skirts and sweaters. While Kitty was described as an 'attractive, scheming wakeling',[4] she didn't wear the usual costume of a femme fatale. Ava told *Screen Guide*, 'Men seem to expect to see the femme-fatale sultry Jezebel dripping orchids and mink. When they see, instead, a skirt, sweater and saddle shoe girl, with no make-up, it's a great let down.'

Kitty was also played with a natural face. When Ava came on to the set with her face covered in regulation MGM make-up, director Robert Siodmak ordered her to wash it off. 'I did as I was told and quite happily in fact. My regulation face was gone for good.'[5] Instead she wore no make-up except for Vaseline on her skin to create a soft sheen. The film used natural lighting which created pockets of darkness and shadows over the characters' faces,

Kitty reclines on the bed in a dark hotel room, in a black knee-length skirt and grey sweater. The costume makes her look innocent, but she eyes up the Swede like a black widow spider eyeing her prey. It's all it takes for him to agree to take part in a heist.

and gave Kitty 'a soft glow, making her appear even more sensuous.'

Ava Gardner's biographer Lee Server wrote that after seeing the test footage of Ava without makeup, cinematographer Elwood Bredell was inspired to keep the visuals throughout the film. 'The smooth ivory tone of her skin produced such a pure white image that Bredell based his whole lighting treatment around it.'[6]

Ava said Siodmak coached her to create the sultry character with cat-like movements and expression. She also trusted the producer, Mark Hellinger,

enough to sing in her own voice, the seductive *The More I Know of Love, the Less I Know*.[7] 'I liked Mark Hellinger at once, because I could tell he saw me as an actress, not a sexpot.' However, Hellinger joked to the press that the reason he cast Ava Gardner was 'sex two and even'. She had to be a girl someone would sacrifice their freedom and their life for.

'I've always felt a prisoner of my image, felt that people preferred the myths and didn't want to hear about the real me at all. Because I was promoted as a sort of siren and played all those sexy broads, people made the mistake of thinking I was like that off the screen. They couldn't be more wrong. Although no one believes it, I came to Hollywood almost pathologically shy, a country girl with a country girl's simple values.'[8]

Ava saw the role of Kitty as a turning point in her career and showed her what it meant to act. Kitty says she is poison to herself and everyone who knows her, but Ava recalled she 'liked the odd but interesting twists of Kitty's character, the lack of emotional security she felt in her early years, and the way this contributed to what she turned into later.'[9] When the Swede first catches sight of Kitty at a hotel party full of underworld types, she is poured into black satin. When she leans against the piano to sing, he stands beside her transfixed by her beauty as she glows under the gas lamp. His girl Lilly knows that she's finished with, just by the way he looks at Kitty.

Former circus acrobat Burt Lancaster, a 'rugged ex-GI', was labelled a 'postwar type' by the studio. 'Like other service men, he has seen a lot of life and suffering in the war, and has grown up, although still young in years.' Lancaster was a dark, moody noir hero, tormented in darkened rooms wearing white vests, or fighting it out in the boxing ring. 'There's nothing pretty boy about him. A perfect part in his hair, or the ultimate in fashionable clothes,

Left Kitty wears a casual checked shirt with rolled-sleeves, worn tucked into a black midi skirt, her long 1940s waved hair hanging loose around her shoulders. Jeff Corey and Albert Decker wear the braces and striped shirts of shady characters of film noir, while Burt Lancaster as the Swede is cleaner looking as a character who is essentially good, but falls in with the wrong people.

Below Burt Lancaster, Ava Gardner and Virginia Christine relaxing on set during filming of the party scene. In contrast to Ava's satin gown, Virginia wears a conservative black suit with striped collars and cuffs and a soft black hat.

wouldn't go good on Lancaster.' He was a tough guy through and through. He often recounted the story of his discovery, when he was being looked up and down by a man in an elevator. So Lancaster grabbed him by the neck, asked him what he was looking at, until it was revealed that he was casting for a play. Siodmak called Burt Lancaster 'knucklehead' because of the 'individual' way he wore his hair.[10] He was given vests because the censor's would not allow him to be 'stripped to the waist'. He also wore four 'high-class business suits' and a camel's hair top coat, which had to purchased at ceiling price because of the 'postwar difficulties of filmmaking . . . still, the studio got 'em'.[11]

In the scene at the Green Cat café, Ava Gardner wears a low cut dress with structured shoulders and an elaborate 'pancake hat' which casts a net-like shadow around her neck. She wears a stolen spider emblem brooch, which she unpins from her dress and drops into a bowl of soup to evade arrest. The spider reference was often linked to the femme fatale, the spider woman who weaves a web to trap her prey.

THE KILLERS 1946

ALL ABOUT EVE
1950

One of cinema's most famous lines is uttered by Bette Davis as a boozy, ageing stage actress at a cocktail party for the New York theatre world. With cigarette in one hand, she knocks back a martini, drops the olive in the glass, and as she turns to leave, she cracks: 'Fasten your seatbelts – it's going to be a bumpy night!'

All About Eve was written and directed by Joseph L. Mankiewicz, known for his women's pictures. It starred a cast of prominent Hollywood actresses – Bette Davis, Anne Baxter, Celeste Holm and a young Marilyn Monroe.

Claudette Colbert was originally to play ageing actress Margo Channing. Colbert had been very keen on the role, even when Mankiewicz 'particularly stressed the fact that Margo is forty and says so . . .'.[1] But she injured her back while filming *Three Came Home* (1950) and was forced to pull out. Other actresses including Connie Bennett and Miriam Hopkins were reluctant to take on an 'ageing' part, but Bette Davis, contracted to Warners, loved the script and stepped in.

Charles LeMaire, head of wardrobe at 20th Century Fox, had begun his career on Broadway, and performed in Vaudeville himself in the 1910s. When Colbert pulled out, LeMaire's costumes for her were packed away to be used on other films. He had already designed the other female costumes, but Bette persuaded the director to hire Edith Head, who she adored, for her costumes.[2] LeMaire said: 'Sure, I would have liked to have dressed Davis too, but there was no time. I was already on another film. I had confidence that Edith could do it, so I asked for her on loan.'[3]

In tribute to Edith in 1973, Bette Davis, said: 'I loved her, loved her, loved her.'[4] Edith Head was equally enamoured. 'No one can drop a mink more elegantly than Bette Davis. There was no greater star in my eyes.'[5]

Bette was still filming *Payment on Demand* (1951), but would go for costume fittings in the evenings. Edith Head said Bette 'strode around, hands deep in her pockets, studying the fabrics, the sketches. For each costume,

Anne Baxter, Bette Davis, Marilyn Monroe and George Sanders in the famous cocktail party scenes.

Left In the scene where Eve attempts to blackmail Karen in the powder room, she wears a black evening gown with sheer neckline and scalloped edges, very similar to the dress Margo is wearing in the restaurant. Karen as a wealthy 1950s New Yorker wears strings of pearls and a luxurious jersey gown scattered with sequins.

Below left Anne Baxter was at first made to look dowdy and sympathetic in a raincoat and rain hat, compared with Bette Davis, as the older actress in a mink coat, worn with a simple black shirt dress.

I'd place my favourite sketch on top, then alternates. In nothing flat, she'd whipped around the room, selected each of the top drawings, and was saying, "when do we fit?"[16]

Bette lost her voice just before filming, but Mankiewicz liked the 'whisky-throated voice that Margo should have,' and asked her to keep it.[7] Her hair,

shoulder length with loose waves and a side parting, was more 1940s than the short hairstyles coming into fashion in the fifties – another indication that she was slightly out of date. Mankiewicz told Bette that Margo 'was the kind of dame who would treat her mink coat like a poncho'. She throws them on the bed and scoops them up off the floor.[8]

Furs were used extensively throughout the production, as they were a status symbol for those in the theatre world. At the cocktail party, Margo's bed is piled with $500,000 worth of mink coats, and security guards were posted to protect this pile of fur.[9]

In the car scene, driving through the cold snow, Bette Davis and Celeste Holm were bundled up in fur coats, but in reality they were roasting hot from the studio lights. A make-up man would wipe the sweat from their brows and powder their noses between takes. Projected behind were backgrounds which had been shot at the Canadian border by the second unit. But the scene had been spoiled by a problem with process film, and they had to go through it all again the next day.[10]

Bette's co-star and soon-to-be husband Gary Merrill first met her during make-up tests, and the two would fall in love during filming. 'The make-up people should have been pampering her but instead they were twirling her around, examining facial lines. They were trying to see if our age difference would be too noticeable. The professional attitude Bette adopted throughout the ordeal was impressive,' he said.[11]

Tallulah Bankhead was supposedly the inspiration for Margo, with Bette apparently affecting her mannerisms and voice. Edith even based Margo's wardrobe on Tallulah Bankhead. 'I steeped myself in Tallulah, and everything looked as if it was made for her, yet the clothes complimented Bette. She is such a good actress that she makes clothes belong to her.'[12]

Tallulah Bankhead, on hearing that her temperament was imitated by Bette Davis, said on her radio show: 'When I get a hold of her I'll tear every hair out of her moustache.' Later she would protest she was joking. 'Bette and I are very good friends. There's nothing I wouldn't say to her face – both of them.'[13] Talullah recounted that Mankiewicz had been observing all her ad libs and mannerisms on the set of one of her movies, *A Royal Scandal* (1945) directed by Ernst Lubitsch.[14] The director remembered her 'outlandish insistence' differently. 'She vividly recalled my "studying her" while she was being directed by Ernst Lubitsch. I was "studying" indeed. I watched every move – and absorbed every word – of Ernst Lubitsch.'[15]

While Edith Head was solely responsible for Bette, she worked with LeMaire to co-ordinate the costumes. During the famous cocktail party scene, Eve's dress, designed by LeMaire, was to mirror Margo's, showing Eve's attempts to be just like her idol. It was also hinted that it was a cast-off from

Margo; in a previous scene Eve was wearing an old suit of Margo's which she had taken in. Margo complains: 'Stage struck kid? She's a young lady of quality. And I'll have you know I'm fed up with both the young lady and her qualities. Studying me as if I were a play or a blue print, how I walk, talk, think, act, sleep . . .'

Margo's evening dress was a personal favourite of both Bette Davis and Edith Head. Bette kept a signed sketch of the 'fabulous' brown cocktail dress hanging on the wall of her home.[16] Edith said:'I think if somebody asked me which costume I'm most proud of, I would say the dress Bette Davis wore when she came down to the party. She looked fabulous.'[17] It was a classic version of the very popular New Look style for the early 1950s – a tight bodice, nipped in waist, bare shoulders and flowing skirt. Exactly the style an actress like Margo would wear. Bette places her hands in the pocket of her dress as she struts around the party, smoking on cigarettes and slugging back martinis. 'Bette's dress did just the right thing for her character,' said Celeste Holm. 'Margo had a terrible sense of being old. That dress made her all the more eager to show off her shoulders and be voluptuous.'[18]

According to Edith, the dress on screen was an accident. She had originally designed it with a square neckline and said she had 'high hopes' for the dress as its brown heavy silk fabric would film well in black and white, and the brown sable trim added a luxurious edge.[19] Hidden support was built into the dress, while the fur trim was designed to distract from her low chest.

Working to a tight deadline, the dress was made up the night before the party scene was to be filmed. When Bette tried it on early the next day, to Edith's horror the bodice and sleeves were too big for her. She was about to tell the director that it was no good, when Bette told her to turn around and take a look. 'She pulled the neckline off her shoulders, shook one shoulder sexily, and said, don't you like it better like this anyway?' recalled Edith. 'With a few simple stitches I secured her neckline in place so she could move more comfortably, and she left for the set.'[20]

Marilyn Monroe, as Miss Caswell, arrives in a low cut, strapless gown worn with a bright white fur coat. Celeste Holm apparently complained 'she's dressed ridiculously in that titular number. We're filming a cocktail party. No one else is in an evening

Bette Davis' cocktail dress is in the New Look style of a structured bodice, with a long, full skirt.

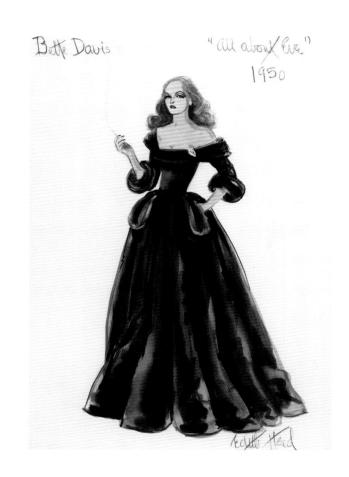

Bette Davis

"All about Eve"
1950

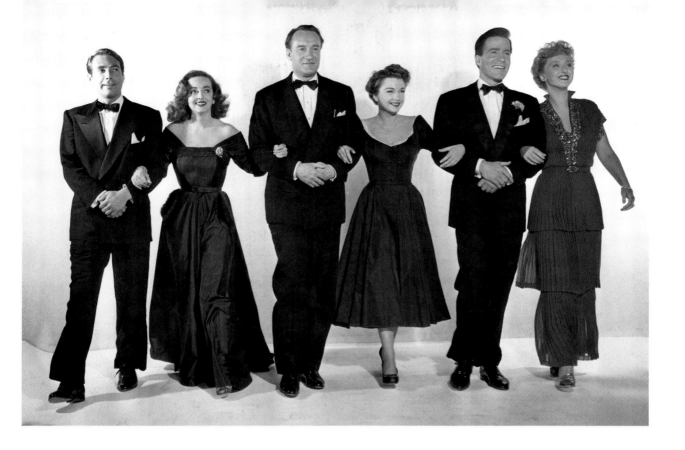

Above Cast publicity shot, from left to right, Gary Merrill, Bette Davis, George Sanders, Anne Baxter, Hugh Marlowe, and Celeste Holm. Bette Davis' brown fur trimmed off-the-shoulder cocktail dress was the perfect style for her character, in the New Look style of nipped in waist, bare shoulders and full skirt. Anne Baxter's cocktail dress mirrored Bette's, although it was more youthful with its shorter length and white trim around the collar. Celeste Holm wears a tiered crepe dress with jeweled bodice.

Left A costume sketch by Edith Head for Bette Davis in *All About Eve*.

gown.'[21] But that was Charles LeMaire's idea – Miss Caswell, from 'the Copacabana School of Dramatic Arts', was to look slightly too much.

Monroe was terrified of Bette Davis, who she called 'a mean old broad'.[22] Davis in turn had said, according to George Sanders, 'That little blonde slut can't act her way out of a paper bag! She thinks if she wiggles her ass and coos, she can carry her scene. Well, she can't.'[23] In the lobby scene in San Francisco, Marilyn chose a costume from her own wardrobe, 'a tightly woven sweater-dress' which she had worn previously in *Home Town Story* (1951) and *Fireball* (1950).[24]

A wardrobe test reveals that a grey suit for Bette Davis, worn with a high collared white shirt with a large white bow tied at the neck, replaced a more basic blouse with a small black bow. Bette wanted a collar to fiddle with during the dramatic scene. The suit was also to be loose enough for Gary Merrill to push her on to the bed in the theatre. [25]

The short shooting schedule proved to be exhausting: 'Forty days for a script of 180 pages, involving three female stars – two of whom are chores to photograph,' the director told producer Darryl Zanuck.[26] But on release it was praised by the critics, and was nominated for fourteen Academy Awards, winning six, including Best Picture.

A PLACE IN THE SUN 1951

Long before she was the diamond-wearing grande dame of cinema, Elizabeth Taylor was the fresh-faced debutante with the violet eyes and black hair, whose complexion was likened by one PR man to 'a bowl of cream with a rose floating in it'.[1]

When A Place in the Sun was released in 1951, the only dress to wear to the high school prom that year was the white, full-skirted violet strewn gown that Taylor wore as Angela Vickers; a fresh and youthful take on Dior's New Look.

She starred opposite Montgomery Clift, the original angst ridden rebel in a leather jacket whose tormented hero spoke to youths of the day, a few years ahead of Marlon Brando and James Dean. Five years after the end of the Second World War, teenagers were a new phenomenon; rebellious, moody and a consumerist force, and A Place in the Sun was one of the first films to speak to this demographic.

Paramount had released an unsuccessful adaptation of Theodore Drieser's novel An American Tragedy in 1931, but this time director George Stevens made sure that a new version for 1951 would be a hit. The new title played down the dark, taboo themes of abortion and murder and gave a sense of hope. As Stevens told the Los Angeles Times in 1951, 'The real tragedy was when the rich girl accepted him. That was his downfall. The rest is mere mechanics.'[2] Set in any, unidentifiable American town, A Place in the Sun captured the mood of that period, and, as Stevens said, 'the behaviour of people in our society as it exists today, the story as it is happening.'[3] Stevens changed the setting from the twenties to contemporary, because the clothes of the 1920s would have looked 'quaint' or 'amusing' and would have created a 'strangeness'.[4]

Elizabeth Taylor was a stylish 1950s teenager in denims and a plaid shirt, with fashion-forward cropped hair.

For spending time by the lake, Taylor wore a checked shirt and jeans, her hair in the short, fashionable 1950s style, while Clift wore white chinos and a tweed jacket.

120

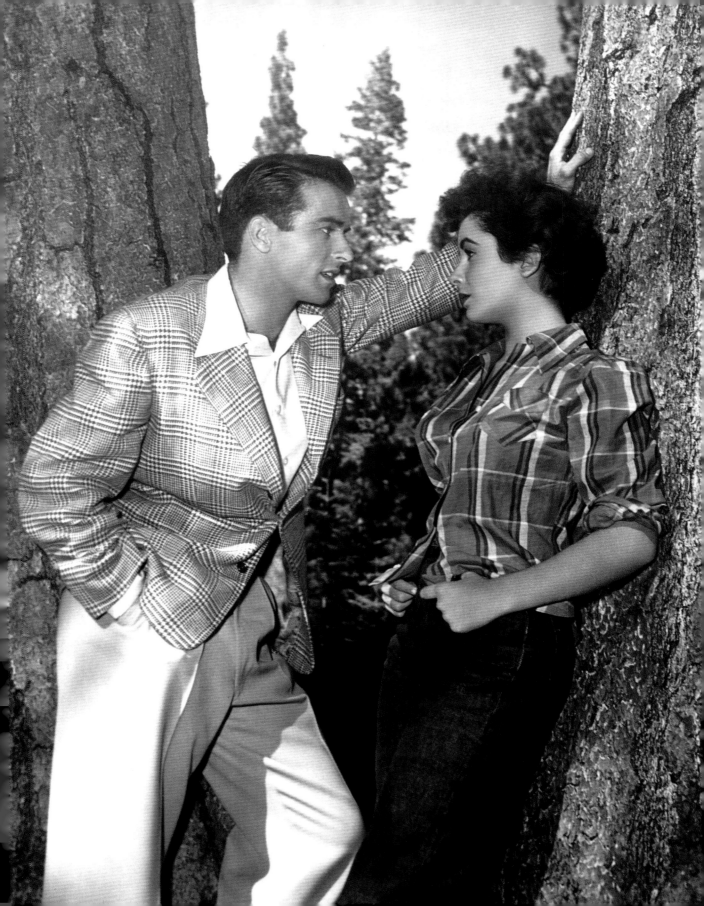

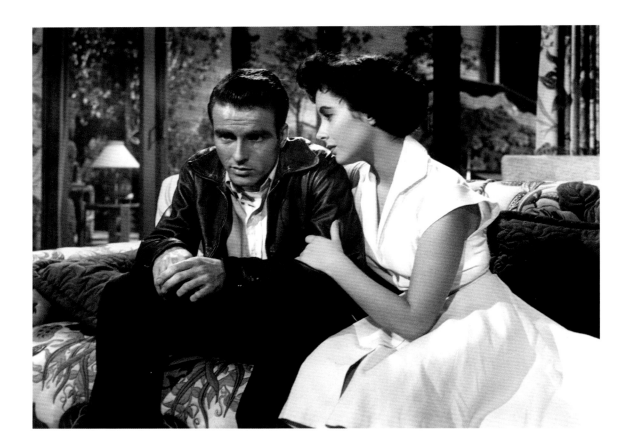

Paramount's head designer Edith Head won the Academy Award for black and white costume, for a very modern wardrobe that *Variety* praised for having 'the smartness of taste'.[5] She depicted the look of carefree 1950s teenagers holidaying on Lake Tahoe in bathing suits, Hawaiian shirts and chinos, riding in speed boats and in open top cars, as if from the pages of *Harper's Bazaar*. The film went into production in 1949, two years before the release date, yet Edith created costumes that looked fresh and undated. She needed to create clothes that looked contemporary, in order to reflect fashion-conscious high society teenagers. 'People have said that my clothes for *A Place in the Sun* were prophetic and that I was a great fashion trendsetter in 1951,' she said. 'That's very funny. My clothes were middle of the road in terms of the current fashion trends.'[6] Despite the sensation surrounding her wardrobe, Edith maintained that she hadn't been forecasting fashion when she designed the clothes. 'In fact, it was a case of taking the styles that were current in early 1949 and translating them into something timeless,' she said.[7]

29-year-old Montgomery Clift played the ambitious outsider George Eastman, his leather airforce jacket an indicator of harder times in the past. In the opening scene, he is hitching a ride on the outskirts of town, wearing

Left Montgomery Clift wore a leather aviator's jacket from the Second World War, shirt and t-shirt underneath. He was the new type of brooding, scarred hero of the postwar period. Taylor wears a crisp white sleeveless shirt dress, a woman's staple inspired by Dior's New Look.

Right Elizabeth Taylor and Montgomery Clift photographed together on the Paramount lot. The two became good friends after working together on *A Place in the Sun.*

the clothes of a 1950s rebel – white t-shirt, blue jeans and bomber jacket. He looked different from the screen heroes of the past.

Clift is less known today than Brando and Dean, but with his angst ridden style of acting, George Eastman is the classic brooding loner. Monty was Taylor's first leading man, after a childhood spent acting against horses and dogs, and his complete absorption in the role inspired her to love acting. She would observe the way he was completely consumed by the character, shaking in the courtroom, sweating and crying real tears.

Sidney Skolsky, columnist at *Photoplay*, wrote in July 1957 about the new Hollywood stars taking over from traditional actors like Clark Gable, John Wayne and Jimmy Stewart. They were working class and troubled, their emotic playing out physically, dressed down in a uniform of leather jackets and t-shirts. Skolsky believed this change to a 'hero with neuroses' was owing to the war being won, and there being no need for the physical heroes of before. He called it 'the new look in Hollywood men'.[8]

But George is an outsider within his own family; not even invited to dinner or to stay at their home. When he wears the traditional masculine uniform of suit and tie, it is ill-fitting and he looks uncomfortable and out of place. At the

Eastman ball, he feels so isolated that he goes to play pool by himself, a cigarette dangling from the corner of his mouth.

Stevens said the part of Angela 'called for not so much a real girl as the girl on the candy box cover, the beautiful girl in a yellow Cadillac convertible that every American boy, some time or other, thinks he can marry.'[9] Elizabeth Taylor had only worked at MGM in family pictures like *Lassie Come Home* (1943), *National Velvet* (1944) and *Father of the Bride* (1950), but her role as the womanly and seductive Angela Vickers helped transition her career into adulthood. Elizabeth was just seventeen during production, a virginal bride about to marry hotel heir Nicky Hilton, and whose first ever kiss was on screen with Clift. Taylor was one of the first screen teenagers, and one of the first teen idols who fans could copy the look of.

When Edith Head first met the young starlet, they immediately hit it off, and would remain friends for life. Edith recalled that Elizabeth would bring a menagerie of pets to fittings. 'She would bring dogs, cats, parakeets, squirrels – whatever her latest fancy was. What a picture! Here's this beautiful, exotic and very sexy girl listening to a school teacher tell her about the Seven Wonders of the World or whatever, with all the animals around and the fitter being very cautious because one of the dogs was cavorting about. It was like a three-ring circus; it was lovely.'[10]

In publicity shots, Elizabeth was photographed in a simple, strapless white gown, but it would be the gown worn to the Eastman ball that would make a huge impact. In fact, 32,000 teenagers were said to have bought a copy of the much imitated white strapless violet strewn gown to wear to their senior prom. Edith Head recalled: 'One of my young friends reported a party she attended at the time of the pictures release; in attendance were seventeen Elizabeth Taylors decked in white violets.'[11]

It had all been a well executed plan by the publicity department, and Herb Steinberg, Paramount's

Above The sketch for the famous white evening gown was pure 1950s Dior, with its full skirt, bare shoulders and nipped in waist.

Right The bodice and full tulle skirt were dotted with white velvet violets and underneath the yards of white tulle was a pale green satin lining. Edith Head couldn't predict what the fashions for jewellery, collars and sleeves would be, so kept the silhouette as simple as possible.

former head of publicity, said: 'We marketed them with the special ads and sold them throughout the country in department stores, and they were manufactured with the Edith Head label. There was not a girl who graduated from High School that year who didn't wear that dress.'[12] In designing the famed dress, Edith said Elizabeth was to be a 'bewitching debutante', and the gown had to be 'white and important'. She was to be alluring and glamorous, a contrast to the dowdy Alice played by Shelly Winters who George wants to escape from. 'She's a pretty girl, who wears nice clothes' says George, when Alice nags him over his feelings for Angela.

Edith used Dior's New Look, with slender waists and full skirts, a look that was all the rage. 'By the time I was planning the Angela Vickers wardrobe, the public had already shown its acceptance of the New Look, so I was convinced Dior's style would be around long enough for me safely to dress Elizabeth in full skirts.'[13]

Elizabeth Taylor —

The white debutante may have made her look innocent, but Angela was the instigator of their illicit relationship. The only exception to the 'white' rule is the black velvet strapless gown, with white daisies scattered on the bodice. The black dress suggests that Angela isn't quite so innocent as they engage in a steamy clinch, and she whispers, 'Tell Mama, tell Mama all.'

Shelley Winters was known as a blonde, glamorous bombshell, but she campaigned for the part of the dowdy and doomed factory worker, Alice. She researched how factory girls dressed and approached George Stevens in drab clothes with dyed brown hair, to prove she could play this part. However, during filming she would constantly disagree with hair and make-up as she wanted to retain some sense of her glamorous self. In contrast to Angela's gowns, Alice wears cardigans, blouses and plain skirts.

On the film's release, George Stevens was flooded with telegrams from movie people impressed by his fresh style of filmmaking. Irene Dunne wrote to him, 'Will you accept the Irene Dunne award for 1951? I sure as heck hope you will. I simply adored the picture and can well imagine how proud you must be to have turned out such a masterpiece.'[14]

A STREETCAR NAMED DESIRE 1951

His was one of the first male bodies eroticised on screen – a torn, sweat-drenched t-shirt clinging to a muscular torso, as he drunkenly yells for Stella. In *A Streetcar Named Desire*, Marlon Brando became the first male sex symbol and set a new trend for t-shirts as outerwear. Whereas before they had been undergarments or workmen's clothes, they became the look of the rebel, worn with a pair of jeans or a leather jacket.

Brando had won rave reviews playing brutish Stanley Kowalski in Elia Kazan's pre-Broadway and Broadway production of the play. But as a relative unknown, he was not the first choice to play Stanley. Producers had wanted John Garfield, perhaps best known for his role in *The Postman Always Rings Twice* (1946). But Brando's Method style of acting was considered 'the most revolutionary technique since the talkies'.[1] He and contemporaries Montgomery Clift and James Dean marked a new type of screen hero – tortured, brooding and with youthful sex appeal.

Tony Award winning costume designer Lucinda Ballard was renowned for her work on theatre, having earned Elia Kazan's respect for her thoughtful costumes for his Broadway production of *Streetcar*. Lucinda, who only designed for one other movie, *Portrait of Jennie* (1948), was Academy Award nominated for her work on *A Streetcar Named Desire*. Ballard acknowledged her success in 'making historical costumes look human rather than museumish.'[2] Her costumes for *Streetcar* were real, lived in and sculpted to the characters, and she created soft, moth-like, almost ethereal costumes for Vivien Leigh. As Blanche Du Bois, Vivien is a faded beauty, with affected mannerisms and a desire to

Marlon Brando wore a vest or t-shirt, jeans and pair of work boots to create the tough, stripped down look for Stanley.

Lucinda Ballard was inspired by ditch-diggers in New York when costuming Stanley. 'Their clothes were so dirty that they had stuck to their bodies. It was sweat of course, but they looked like statues. I thought, 'That's the look I want . . . the look of animalness.'[18] Brando worked up sweat the hard way, by refusing a glycerine and oil combination to create perspiration. He lifted weights in his dressing room with the heating on, because using fake sweat, he said, 'just doesn't seem right'.[19]

Left Kim Hunter and Vivien Leigh with director Elia Kazan. Vivien wears the birthday party dress – ruffled and faded and slightly torn at the sleeves.

Right A wardrobe test for Marlon Brando shows him in a t-shirt, slacks and a pair of work boots, the tough stripped down look for Stanley.

live in a fantasy to escape her past. Ballard once said Blanche had 'a terrible daintiness' to how she dressed, a phrase that impressed Tennessee Williams.[3]

For eight months Leigh had lived and breathed Blanche du Bois when she played her in the critically acclaimed West End play directed by her husband Laurence Olivier. To really create a character that was faded and ragged, Leigh bleached her hair and plastered her face with heavy make-up to take away the prettiness and turn her into a 'scarlet woman.' Vivien said: 'Blanche is a woman with everything stripped away. She is a tragic figure and I understand her. But playing her tipped me into madness.'[4]

The Blanche on screen would be more moth-like and less brash than Olivier's version. Olivier stayed true to Williams' slightly sleazy description of the costumes, 'a worn out Mardi Gras outfit' and a 'dark red satin kimono' but Lucinda Ballard saw her as ethereal, faded, and gave Blanche whites and organdies to wear.[5]

At early stages of pre-production it had been thought that they could use Leigh's West End stage costumes for the film adaptation. But after Kazan received the complete set of images for the costumes, he quickly changed his mind. The designer had created tailored suits and fussy dresses with ostrich feathers. Kazan wrote to Jack Warner that he was 'terribly worried' about Leigh's costumes. 'To put it in one word: they were "English". I mean stuffy, dull, ultra conservative – and "English". They have to be completely redesigned, in order to get the best out of Leigh.'[6] Kazan was anxious to retain his Broadway costume designer and wrote a persuading letter to Jack Warner.

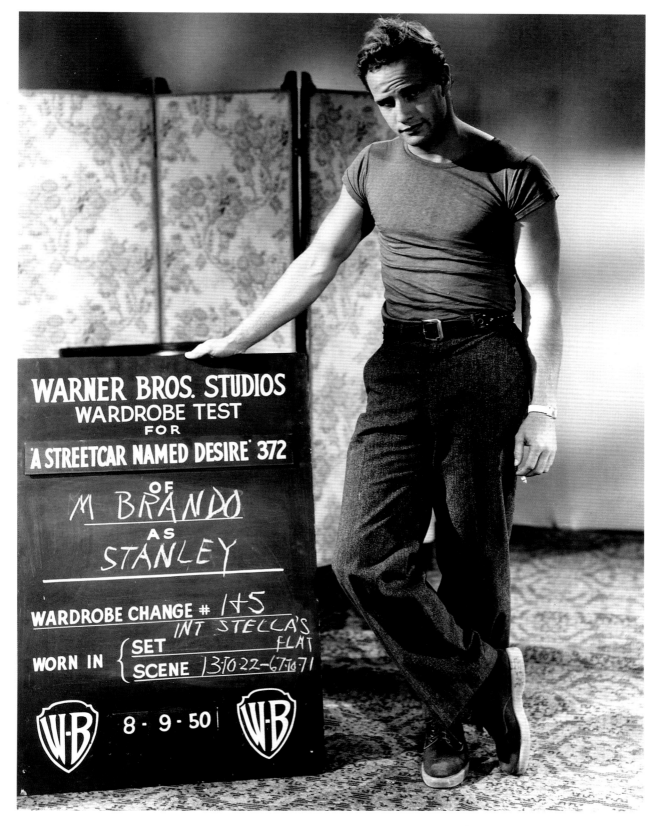

The chalkboard in the image reads:

WARNER BROS. STUDIOS
WARDROBE TEST
FOR
'A STREETCAR NAMED DESIRE' 372
OF
M BRANDO
AS
STANLEY

WARDROBE CHANGE # 1+5
INT STELLA'S
WORN IN { SET FLAT
 SCENE 13-10-22-67-16-71

W·B 8 - 9 - 50 W·B

'All I can say about her is that she is the best,' he told the studio boss. 'A picture is made up of beautifully chosen details, and believe me Ballard is worth everything.'[7]

Because the Oliviers lived in England, the logistics of costume fittings needed to be worked around. Leigh had also recently suffered from tuberculosis and was still in ill health. Kazan told Warner, 'Nothing slows up a shooting schedule like an easily exhausted woman. And if we brought her here something like the end of July, or even the middle there would be a last minute rush.'[8]

Kazan was keen to send Ballard to England to carry out the fittings, so that 'Leigh would be happy with the clothes, instead of worrying about them all the time I was trying to get great scenes out of her.' Even though there would be added expense in this, he told Warner it would be a small one compared with delays in the shooting schedule. 'Ballard could go there with complete instructions from me – after all she has already designed this show twice for me, and knows what I want by now, better than I do.'[9]

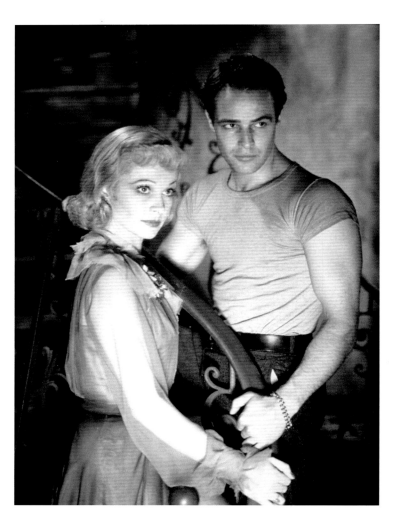

Kazan also thought that it would be useful if Leigh heard and picked up the accent from New Orleans-born Ballard. 'She is from Louisiana and has a really genuine southern accent . . . very very slight – really barely discernable – not one of those broad corny accents,' Kazan told Warner. 'I think it would be wonderful for Leigh to listen to her for a week or so, and model her accent on Ballard's. I understand from reports that Leigh's accent was rather heavy and any heavy regional accent on the screen is deadly.'

Ballard made the trip to the Oliviers' gothic marital home of Notley Abbey in Oxfordshire for two days of costume discussions. She was greeted at the front door by Leigh as if they were long lost friends. They had met previously at the Old Vic just after the war. She told Leigh: 'I see Blanche with blondish hair, clothes heavily dated, soft-flowing and in pale tones – absolutely no white suit or red satin wrapper like the English production. A prostitute she is

Blanche was the exact opposite of dirt and sweat-stained Stanley. She wore delicate chiffon gowns, bleached blonde hair and was desperate to be clean and unstained.

not!' Ballard said of Leigh: 'As I got to know Vivien I saw this chameleon side to her – she could assume a look very easily.'[10]

Ballard reported to the Warner Brothers studio with the material and designs for Leigh's costumes. It was expected she would take a week to do fittings and have them constructed for the actress.[11] But producers were worried when Ballard got off to a slow start in making the costumes. Studio honcho T. C. Wright had words with her, while assistant Lucile Donovan was under instruction to keep an eye on Ballard and her progress. Normally a designer only used one cutter and fitter, but for Ballard, the entire department was 'at her disposal'.[12]

Filming proved to be exhausting for Leigh, and she chose to eat in her dressing room so that she could rest between takes. She even requested more lights around her dressing room mirrors, so she could be made up there every morning, instead of going to the make-up department.[13] Vivien was very troubled at the thought of Blanche being led away in a straight-jacket for the final scenes. She convinced Kazan that it would be better for Blanche to be in her own clothes. Ballard designed a soft chiffon dress for this scene, which 'restored a sense of tranquillity to Blanche as she is led away, it wrapped itself around her – didn't imprison her.' Ballard thought that Vivien's need for Blanche to be at peace in the final scene reflected the actresses own fears of insanity.

Ballard saw that Blanche was haunted by the suicide of her husband, so 'was always cleansing herself mentally and physically, always fearful of dirt settling on her.'[14] The first costume in Blanche's wardrobe plot was a travelling suit, with an artificial violet in the lapel. There was a satin robe, a silk wrapper, the birthday party dress, and a white satin evening gown as she touches into madness.

Brando's costume changes consisted of a bowling outfit, trousers, t-shirts stained with car grease, a suit, and red pyjamas for the crucial rape scene.[15] Brando's tight t-shirts defined a new trend for wearing them as casual wear, rather than under shirts. One company reported a 375 per cent increase in undershirt and t-shirt sales on the back of *Streetcar*. 'The t-shirt looks so good on the muscular Brando that sales of this type of garment began zooming immediately,' said a Warner Brothers press release.[16] Such was the popularity of the look, a sportswear company was keen to sign up Brando, but he turned them down. A press release at the time said: 'He never wears a t-shirt except on the screen anymore and if he did, they would have to be old and well worn.'

When producers realised the impact of Brando's magnetism, they chose to make his sex appeal one of the strong points of the publicity campaign, suggesting they 'run a few ads playing up Brando . . . many voters think his performance is one of the greatest of all time'.[17]

GENTLEMEN PREFER BLONDES 1953

Marilyn Monroe's billowing white pleated dress in *The Seven Year Itch* (1955) may be the most iconic of movie costumes, but *Gentlemen Prefer Blondes* is a close second in cementing her as a sex symbol and pop culture icon.

It was also the film that personified her classic pneumatic blonde style. Her hair may have been bleached blonde, her face in heavy make-up and her body squeezed into the tightest of gowns, but Marilyn could pull it off without looking cheap. Her raw sensuality was counteracted with a sweet, innocent persona and vulnerability. Norman Mailer said her appeal was that she 'suggested sex might be difficult and dangerous with others, but ice-cream with her.'

Anita Loos wrote the biting novel *Gentlemen Prefer Blondes* in 1925, on a train from New York to Hollywood. Lorelei was a gold digger in the roaring 1920s, but Fox head Darryl Zanuck and director Howard Hawks set their adaptation in modern day and the flat-chested flapper turned into a fifties sex bomb. The film tells the story of two glamorous showgirls played by Monroe and Jane Russell, let loose on an oceanliner to Paris, and looking for love in very different ways. They are real 1950s women who like a martini and are not afraid to flirt or assert themselves. Fox publicity man Harry Brand proclaimed, 'The teaming of these two women who have set the standards of feminine sex appeal . . . they complement one another like rum and cola.'[1]

Jane Russell is Dorothy, the wiser, less materialistic of the two, but is thrilled at the prospect of sharing a ship with the Olympic team. In one particularly camp musical number, she dances amongst a troupe of men working out in small flesh-coloured trunks. Russell had been billionaire Howard Hughes protégée, who he

In the opening sequence, Marilyn Monroe and Jane Russell perform *Two Little Girls from Little Rock* in matching scarlet sequined gowns split to the thigh and slashed to the waist. The spiralling pattern of the sequins caught the light from all angles and a flesh-coloured body stocking was worn underneath to calm the censors.

cast in *The Outlaw* (1943) to great fanfare, famously proclaiming he had built a special bra for Russell, using his knowledge of aeronautics. But she found it uncomfortable and used her own, disguising it with her blouse. 'I never wore his bra, and believe me he could design planes, but a Mr Playtex he wasn't,' she said.[2] Russell was used to puns being created over the size of her chest, and in *Gentlemen* it was no different. 'Those two couldn't drown,' says a love struck member of the Olympic team.

On being told that Jane Russell was the lead over her, Monroe quipped: 'Well whatever I am, I'm still the blonde.' Like the real life Marilyn, Lorelei affects the dumb persona to appeal to men. 'I can be smart when it's important,' she says, 'But most men don't like it.'

Gowns were designed by Fox costumer William Travilla, and took full advantage of glittering Technicolor. Travilla created burlesque showgirl outfits and shimmering, clinging gowns for Monroe and Russell. His designs have become synonymous with Monroe's sex appeal. 'Marilyn Monroe was an absolutely beautiful creature. She glowed. You couldn't take your eyes off her when she entered a room. She was a full-sized woman but she had a very tiny waist. She could wear the most outrageous clothes without ever looking vulgar,' he said.[3] Russell remembered that at first the costumes 'were ridiculous' on her. But she was given a new wardrobe once Travilla had worked out what suited her. 'Any designer has to experiment with a new body,' she said.[4]

Travilla's interest in burlesque was sparked as a teenager, when he would pass strip clubs on the way to school, and would later create costume sketches for the dancers. His Hollywood career began in 1942 and he worked his way up from B movies to winning an Oscar in 1949 for best costume design for Errol Flynn's *Adventures of Don Juan*. At Fox Studios, he first dressed Marilyn as an unhinged babysitter in *Don't Bother to Knock* (1952), and went on to create costumes for seven more of her films including *How to Marry a Millionaire* (1953) and *There's no Business Like*

Get the burlesque look with fishnet stockings, sparkling corsetry, long gloves and feathers with strong make-up – kohl on the top lashes and red lips.

Far right Travilla created classic burlesque stage costumes for Russell and Monroe complete with top hat and cane.

Right Travilla's sketch for one of the stage costumes.

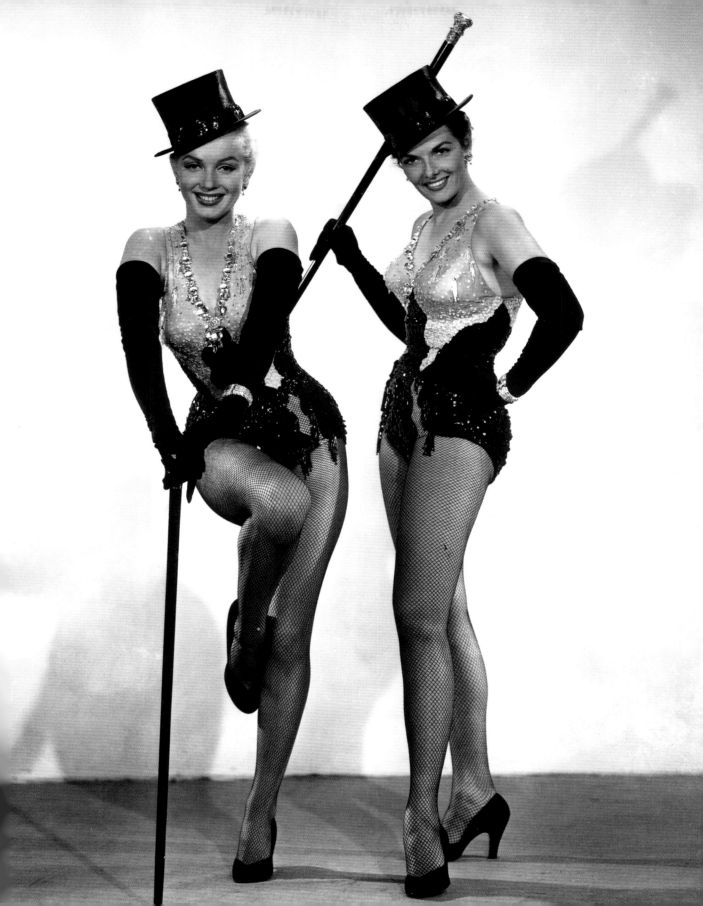

The candy pink strapless gown for
Diamond's Are a Girl's Best Friend
was worn with long opera gloves
and a heavy sprinkling of diamonds
up the arms and around the neck.
The scene was famously imitated by
Madonna in her *Material Girl* mu-
sic video. 'People always wonder
what happens when someone does a
dress of yours cheaply. I get worried
when people don't copy me. I think
it's flattery and I'm pleased about it,'
Travilla said in response.[13]

Show Business (1954), for which he was nominated for Academy Awards. Later in life he would be the man behind the shoulder pads and Stetsons of eighties TV series Dallas.

Jack Cole choreographed the musical numbers, using burlesque moves with comic timing, and perfecting the ditzy Monroe manner-isms. It was her first musical, and she was determined to make it a suc-cess, so rehearsed relentlessly alongside Jane Russell. 'Marilyn and I had never danced before; we were a pair of klutzes,' Russell told Jack Cole biographer Glenn Loney in *Dance* magazine. 'Jack was horrible to his own dancers, but with us, the two broads, he had the patience of Job.' The rehearsals, Russell remembered, 'were hard, sweaty work, I never dressed up, but always wore lip and lashes. Marilyn looked like she'd just crawled out of bed – no make-up, tangled hair and blue jeans.'[5]

Hollywood was controlled by the censor's office, headed by Joseph Breen, who strictly ensured that movies didn't cross their moral line. To meet their demands, Travilla was not allowed to reveal belly buttons, too much thigh and cleavage. But his cos-tumes came up against the censors time and again. They wrote 'great care will have to be exercised in the pho-tographing of these costumes to avoid camera angles in which the breasts will not be fully covered.'[6] Many of the costumes were rejected as they were 'deliberately designed to attract vulgar attention to her breasts,' while they warned that in a dressing room scene, 'the least that would be acceptable in terms of intimate garments would be a full slip.' Even the dialogue came under scrutiny from the censors, concerned that some of the lines 'should not be delivered in a way calculated to get a dirty laugh.'[7]

One of Monroe's iconic gowns is a gold sun-ray pleated gown, worn in publicity stills for the film and appearing very briefly in one scene, albeit through a window. Because of its plunging neckline and the tightness of it, the dress was considered to be too risqué and it is only glimpsed for a few seconds. The gown was created from a single circle of gold lame, with two hidden flexible iron bars from the waist, to create the v-neck shape. Monroe loved the dress so much, that she was insistent that she wear it to the 1953 Photoplay Awards. Travilla at first refused. 'The gold dress was fine for the movie, but for real life it was way too sexy,' he said. And without a zipper she would have to be sewn into it. Monroe went directly to Zanuck for permis-sion, and he agreed she could wear it to the awards. Veteran actress Joan Crawford almost dropped her fork at the sight of Monroe and her

blatant sexuality, squeezed into the gown as she went to the stage to collect her award for Fastest Rising Star.[8]

The *Diamonds are a Girl's Best Friend* number is the most celebrated sequence in the film, and of Monroe's career. But the gown was almost an accident in its design, and was dreamt up very quickly by Travilla, after the censors cracked down on the original costume, a showgirl fishnet body stocking covered in layers of strategically placed rhinestones, and with a floor-length velvet and diamond tail. It cost almost $4,000, but was never used. 'A harness of rhinestones travelled around her hips and fell into a pony tail at her back, with black Bird of Paradise feathers. Marilyn had to stand for hours while the jeweller and I shaped everything to her body, then we soldered the jewels on,' said Travilla.[9] Nude photos of Monroe, taken in 1949 when she was a struggling starlet, surfaced during production and threatened to create a scandal. 'There were problems with the censors all during filming. When it came out about the nude photos, that was about it,' said Travilla.[10] In response, Darryl Zanuck sent Travilla a memo: 'Cover her up.'

To prevent further scandal through too many revealing costumes, Zanuck demanded a more modest gown and the pink dress was born. Made from pale pink peau d'ange backed with green felt, it was folded into shape on her body, a boned bodice kept it from slipping down and the oversized bow was stuffed with ostrich feathers and horse hair. 'Any other girl would have looked like she was wearing cardboard, but on the screen I swear you would have thought Marilyn had on a pale, thin piece of silk. Her body was so fabulous, it still came through!'[11]

The gown bears a striking similarity to Rita Hayworth's black *Gilda* gown, also strapless and worn with opera gloves. In bright Technicolor, the pale pink fabric showed up bolder and brighter.

Travilla would dress Marilyn for eight films and they shared a close relationship off set. They had a fleeting affair on the set of *Gentlemen*, 'while my wife was in Florida and Joe DiMaggio was away'.[12] As a gift, she wrote on her nude calendar, 'Billy dear, please dress me forever. I love you, Marilyn.'

GENTLEMEN PREFER BLONDES 1953

FROM HERE TO ETERNITY 1953

As the original film about the attack on Pearl Harbour, *From Here to Eternity* is perhaps famous for two things – the Hawaiian shirts worn by off duty GIs which became so popular in the 1950s, and the love scene between Deborah Kerr and Burt Lancaster, on a beach as waves crash over them.

Set in and around a Hawaiian military base in the lead up to Pearl Harbor, Montgomery Clift plays a soldier who is harassed by his regiment after refusing to get in the boxing ring because he once blinded a man in a fight. Director Fred Zinnemann fought to cast Montgomery Clift as Private Robert E. Lee Prewett instead of Aldo Ray, who had been Columbia head Harry Cohn's first choice. In the first draft of the script, Prewett was described as '23-year-old deceptively slim, immaculate, decisive, the picture of a soldier. And on his sleeve are marks where chevrons have been removed.' This hinted that he had been a corporal relegated to private for disobeying orders, while Zinnemann said that it was the 'deceptive slimness' that gave an edge to the character.[1]

When Montgomery Clift was cast, he knew nothing about the army, but completely absorbed himself in the part. He became an expert in bugle playing, and heard tapes of the Kentucky dialect from where Prewett was from. Even after shooting had finished and he was back in Los Angeles, Clift couldn't shake the character. He would still wear the Hawaiian print shirts, and sit in the Hollywood Roosevelt Hotel playing the bugle.

Joan Crawford was the lead choice for adulterous wife Karen Holmes, but Zinnemann wanted to cast against type with an actress who was seen to be prim and proper. Crawford was so certain she had the role that she even had talks with costume designer Jean-Louis about what she would be wearing on screen. Scottish actress Deborah Kerr had an icy reputation, particularly after

Deborah Kerr's halter neck bathing suit was worn with a wide belt and a little skirt to make the famous clinch in the sea seem more modest.

Burt Lancaster and Deborah Kerr pose for publicity shots on the Hawaiian beach where they filmed the famous love scene.

140

her role as a nun in *Black Narcissus* (1947) and was cast instead. Karen is said to have slept with every soldier on the post, and Zinnemann said, 'The casting of Deborah would create an added sense of suspense and excitement. If a sexy actress were to play that part the outcome would be a foregone conclusion.'[2] As the bitter military wife, Jean-Louis dressed her in prim white gloves and handbags, but her sweaters and skirts were tight, her shirts form-fitting and in one scene she opens the door in little shorts and a striped shirt.

Frank Sinatra was desperate to play Maggio, and while Hollywood lore has it that he left a horse's head in Harry Cohn's bed, in actuality his wife Ava Gardner used some influence, and he paid for his own screen test to convince that he could do the part justice. He absorbed himself in the role, even referring to himself as Maggio; to mark the first day of shooting, Sinatra wrote a telegram to Fred Zinnemann, saying simply 'Be a Smash, Maggio'. Maggio

Previous pages
Deborah Kerr wears a striped shirt worn with high-waisted shorts and strappy sandals.

The white halter neck evening dress was designed by Jean-Louis. Its circle cut skirt has an interesting link-effect pattern, but is more of a 1950s evening dress than the early 1940s style when the film was set.

Left Donna Reed wears a crucifix around her neck, despite being in an unrespectable profession she longs to be 'proper'. Off duty from the New Congress Club, she wears a cream coloured shirt-waist dress with black court shoes.

Right In the New Congress Club, Donna Reed wears a black halter neck dress with sequined straps. Frank Sinatra and Montgomery Clift wear their Aloha shirts hanging out from their chinos. While Zinnemann chose to shoot it in black and white for a grittier, realistic feel, Technicolor would have done well to show off the fabrics and colours of the shirts.

was to be scrawny looking, and while Sinatra was not exactly muscle bound, producer Jerry Wald was concerned that 'Sinatra is actually beginning to look healthy. Tell him that once he loses that cadaverous look, that sort of fugitive from Vitter McKinley, he'll get in trouble. Tell him not to eat.'[3]

The famous love scene was particularly controversial, as it was an adulterous relationship, they were only in bathing suits, and the waves crashing over them made it even more symbolic. Joseph Breen of the Hay's Office said 'We feel that the adulterous relationship between Karen and Warden in this present version of the story is handled without any recognition of the immorality of this relationship.'[4] He advised that Karen and Warden should 'put on a beach robe or some other type of clothing before they go into the embrace.'[5] Zinnemann did not pay attention to this, but Kerr's swimsuit was given a skirt so as not to be too provocative. The black bathing suit had a structured bodice and a wide belt to cinch the waist. 'I don't think anyone knew I could act until I put on a bathing suit,' the actress once said. Jerry Wald told Fred Zinnemann

he thought the love scenes were 'superb! I haven't seen anything as warm and effective on the screen, and a love scene, in a long, long time.'

In the novel, the New Congress Club is a brothel and Alma a prostitute but Breen stressed the importance that 'all the activities of this club be clearly and affirmatively established as a legitimate business enterprise . . . It would be well to have these girls state exactly what it is they do in the club, that is to say, that they are paid to drink and dance with the men there.'[6] Donna Reed was not Zinnemann's choice to play Alma but she was on a Columbia contract, and he was pleasantly surprised by her Academy Award winning performance.

While Hawaiian shirts were a popular summer item in the 1950s, it was *From Here to Eternity* that brought them to the forefront. On the streets of Honolulu, off duty GIs wear Hawaiian shirts and chinos, amidst the crowds of sailors in their white uniforms and Chinese in traditional shirts. Aloha shirts were first created in the 1930s by a Chinese Hawaiian who cut them from kimono fabric to create bright patterned shirts. During the Second World War every GI or marine stationed in the Pacific would pick up a shirt in Hawaii to wear for a weekend pass or to take back to the States. It was a symbol of the good times of the army, and were seen as an outfit for the holidays and leisure times. In the sixties they were perhaps mostly associated with Elvis Presley in *Blue Hawaii* (1961).

The film was a huge success with audiences and critics, and was nominated for thirteen Oscars, 'including an incredible one for costumes, which consisted largely of uniforms and a bikini for Deborah,' said Zinnemann.

TO CATCH A THIEF 1954

Grace Kelly's offscreen persona was the ice cool blonde and the epitome of ladylike elegance. Hitchcock's 1954 romantic crime caper *To Catch a Thief* not only captures this style on screen, but with a Cote D'Azur setting, foresaw Kelly's later role as Princess of Monaco.

Grace Kelly's look is all about Mediterranean elegance. A wide-brimmed sun hat is worn with Capri pants, or a yellow sundress with a pale cardigan thrown over the top.

Kelly starred in two other Hitchcock films that year, *Dial M for Murder* and *Rear Window*, where she played the aloof, bewitching blonde who Jimmy Stewart complains is 'too perfect, too beautiful, too sophisticated'. She was Hitchcock's idealised leading lady who he shaped into a remote, fantasy figure on screen. 'He was in love with her the way a schoolboy develops a hopeless crush on an unattainable object of desire,' said his biographer Donald Spoto.[1] Hitchcock was obsessive over the image he created for Kelly as a 'credible hybrid of elegance and sex'. There was a reason for every colour and every style that she wore as he wanted her to look almost untouchable.

Like Marilyn Monroe, Grace was once asked what she wore to bed but instead of giving a 'Coco Chanel' reply, she said, 'I think it's nobody's business what I wear to bed. A person has to keep something to herself or your life is just a layout in a magazine.' Gary Cooper, who worked with Grace on *High Noon* (1952) when she played his Quaker wife, said she was 'certainly a refreshing change from all these sexballs we've been seeing so much of.'[2] But she also had a reputation as a man-eater, seducing a number of her co-stars ('and all the time wearing those white gloves').[3] Hitch could see this

In a peach and white dress, and matching scarf wrapped around her neck, Grace Kelly drives Cary Grant along the coastal road, not a hair out of place.

side to her, considering her a 'snow-covered volcano', and like a voyeur, his camerawork focused obsessively on her beauty. In *To Catch a Thief*, wearing a glacial, white, strapless gown, in a darkened room as fireworks explode outside, she whispers seductively to Cary Grant before they move in for a passionate kiss.

For Paramount costume designer Edith Head, *To Catch a Thief* was 'a costume designer's dream'. She was given Grace Kelly and Cary Grant as her two stars, Alfred Hitchcock as director and an exotic south of France setting. 'Grace played the part of possibly the richest woman in America, with the most fabulous clothes and the most fabulous jewels. Her mother, played by Jessie Royce Landis, was equally elegant.'[4]

Edith was invited out to France for the location shoot; something that rarely happened to costume designers. Grace Kelly's costumes had already been made in Hollywood, but Hitchcock wanted Edith close, just in case he needed her. 'Hitchcock was constantly aware that we were filming the story in one of the fashion capitals of the world. He told me, "Edith, we are now in France. People dress here. It's the place where style is created – so do it."'[5]

Cast and crew flew out in June 1954, first stopping over in Paris. This gave Edith and Grace the opportunity to shop at Parisian boutiques for accessories and jewellery. They paid a visit to Hermés, as Grace had heard they sold the

Below left Grace wears a simple white strapless gown with a huge diamond necklace to watch the fireworks. The dress contrasts with her tan and the neckline highlights her necklace. She looked like a Delphic statue, haughtily gliding in loose chiffon. But then she would do something surprising, like planting a kiss on Cary Grant when he was least expecting it.

Below For the climactic ball scene Grace was given a bold, dramatic Marie-Antoinette style gold gown, decorated with birds, and a large wig dusted with gold. Make-up artist Harry Ray feeds her cake between takes.

Right Edith Head's sketch for a costume to be worn by Grace Kelly, never used in the final cut of the film.

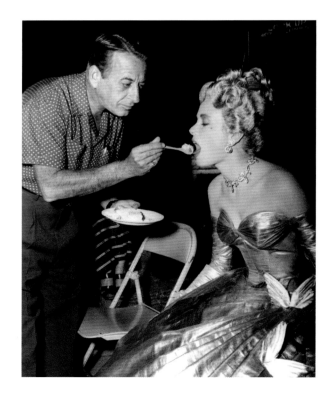

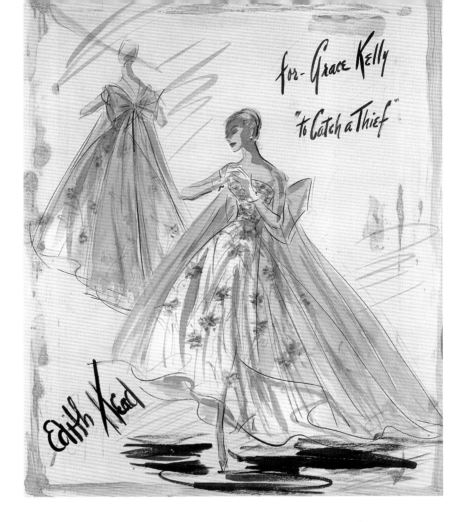

for Grace Kelly "to Catch a Thief"

Edith Head

best gloves. 'Like two girls in an ice cream shop, we fell in love with everything we saw,' remembered Edith. 'We chose gloves with little roses embroidered on them, gloves with openwork trim, all kinds of gloves. Grace got more and more excited – she got the same kind of joy collecting gloves as other women did diamonds.'[6]

Harry Ray was the make-up man on the film. Grace asked him if she could get a tan on the Riviera and he told her to go ahead. 'The part called for an American girl vacationing on the Riviera with her mother, so it seemed to me quite natural that she should pick up a little tan for the part,' said Harry. 'Besides she looked pale and tired and some sunbathing would do her good, I felt. She turned the softest apricot colour, which was fine for the Technicolor the film was being made in. Her skin was just gorgeous, beautiful. All I had to do every day was to add a little mascara. It took me seven minutes flat.'[7]

As Frances Stevens, a very wealthy American girl, Grace was dressed in clothes dripping in elegance and wealth; capri pants and sunglasses, strapless

gowns and tailored sun dresses. To work with the bright, Mediterranean location, Grace was dressed in pale shades – azure blue, lemon yellow, coral. While the head scarves, Capri pants and sunglasses were perfect for driving in an open top car along the winding roads of the south of France, Edith Head also created some dramatic and bold statement costumes. As Grace emerges from the elevator into the hotel lobby she needed to be in a show-stopping outfit. She wore a black and white Capri pantsuit with a white skirt and a huge white sun hat. A black halter neck bathing suit was worn underneath. Edith wrote, 'When Grace went to the beach, she wore a huge sun hat and the most beautiful black and white sun costume that I've ever done. It was striking – almost too striking. But the script said that she was the kind of American girl who liked attention, so I gave her attention-getting clothes.'[8]

She was originally to wear the same costume in the scene before, but Paramount producer Frank Caffey told Edith, 'Hitch felt that the sport outfit that she wears in the lobby scene was such a startling thing that it would be well to disclose it to the audience for the first time when she steps out of the elevator. Therefore she will have to appear in some sort of dressing gown in the scene immediately preceding this.'[9]

A blue gown with tiny spaghetti straps, pleated with a sheer drape over one shoulder, gives Grace the appearance of a Greek goddess. Her neck and shoulders are bare, and her hair in a Grecian knot. Grace also wore a similar white version that was even simpler, for the big love scene. This gown was designed to give prominence to the diamond necklace she was wearing, so that when the camera did a close up, the gown acted as a background. But there had to be enough fabric to show that she was wearing clothes, and it had to 'emanate an haute couture quality that matched the luxury of the jewels'. There was also a mid-fifties trend for the Grecian look, with a slim, flowing silhouette that contrasted with the structured, nipped in shape of Dior's New Look.

As the tension mounts, the colours become more dramatic, climaxing at the masquerade ball where Grace is dressed in a spectacular Marie-Antoinette gold lamé ballgown decorated with gold birds. Edith said: 'Hitchcock told

me he wanted her to look like a princess in that scene.' The masked ball was, according to Edith, 'the most expensive setup I've ever done'. It was based on the Marquis de Cievas' costume ball held in Biarritz in 1953. Held in an eighteenth-century palace, the terrace was illuminated with 3,500 candles, a garden filled with olive and almond trees was covered with a midnight blue canopy and Swan Lake ballet was performed on the lake.[10]

As a notorious jewel thief, Cary Grant looked the part in a striped top, grey trousers and a red and white neck-tie. While Edith Head had claimed she purchased his checked swimming trunks from Hermès, Cary was explicit that he provided his own wardrobe, as male actors would normally do. 'I planned and provided everything myself. In fact, I bought everything in Cannes, just before we began shooting . . . Hitch trusted me implicitly to select my own wardrobe.'

SABRINA 1954

In her debut Hollywood film, *Roman Holiday* (1953), Audrey Hepburn played a princess who falls in love with a reporter, while *Sabrina* is the story of a chauffeur's daughter who falls in love with a prince, 'albeit a merchant prince'.[1]

As the mousy chauffeur's daughter who goes to Paris to escape from her unrequited love, and returns as an elegant, matured young lady, Audrey needed an incredibly stylish wardrobe.'Every designer wishes for the perfect picture in which he or she can really show off design magic,' said Paramount's chief costume designer Edith Head. 'My one chance was in *Sabrina* . . . it was the perfect set up. Three wonderful stars and my leading lady looking like a Paris mannequin.'[2]

As an unknown in *Roman Holiday*, Audrey allowed Edith full control in what she wore and allowed her to hide her supposed flaws. But after winning the Best Actress Academy Award and finding herself as the toast of Hollywood, Audrey was now in a position to express what she wanted to wear. And what she wanted was a designer wardrobe.

Edith's mantra as a costume designer was that her designs wouldn't follow trends, as trends would look dated. Instead she used her skills to accentuate an actress's best features, and hide her flaws. For *Roman Holiday*, Edith dressed Audrey in a shirt with short rolled sleeves to cover her thin arms, and a red and white necktie to disguise her long neck.

But Edith was horrified when Hepburn suggested that she wear a wardrobe bought from Paris. From shy waif to sophisticated Parisian, Sabrina needed a make-over from a real French couturier. Audrey knew what suited her, and with more power from her new found fame, she insisted that she select her wardrobe, and Billy Wilder agreed. 'The director broke my heart

Sabrina was to look like a princess when she arrives at the Larrabee ball, shining out amongst the other girls in their New Look gowns. Consisting of silk orçandie, her gown was decorated with a navy floral pattern and the ruffled, flowing overskirt is split at the front to reveal a pencil straight skirt beneath. William Holden as David Larrabee wore the classic fifties black tie outfit, with white dinner jacket, black trousers and a black bow-tie.

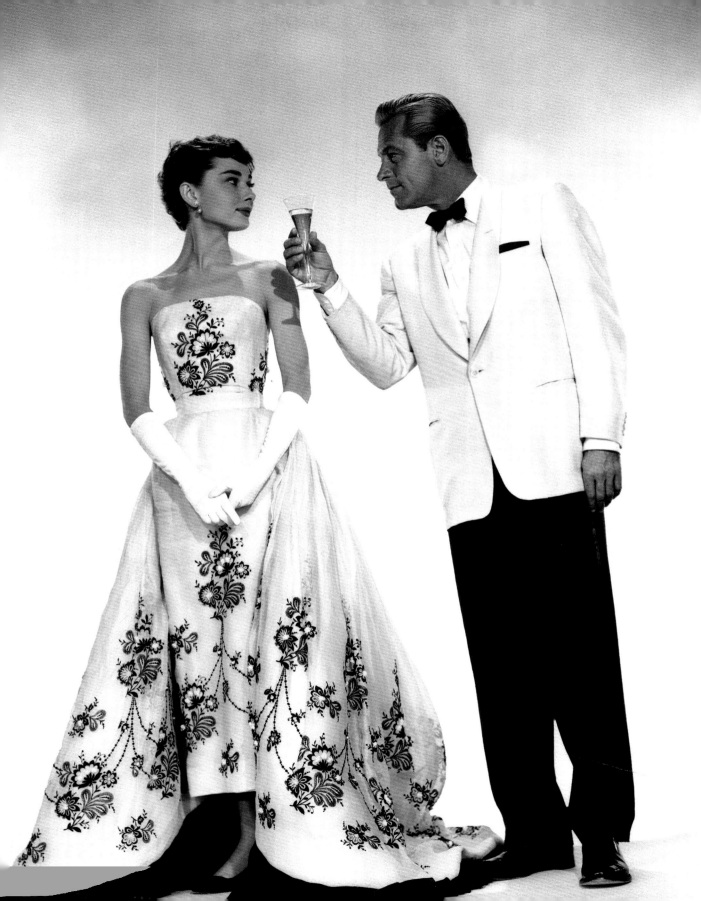

by suggesting that while the chauffeur's daughter was in Paris she actually buy a Paris suit designed by a French designer,' said Edith.[3] Besides, Paramount did not have a permanent tailor and the work they did in the wardrobe department was considered 'strictly American-type work'.[4]

Edith visited Audrey in San Francisco, where she was starring on stage in *Ondine*. Edith recounted how she had sketched out pages of 'little Audreys' for the actress to doodle ideas for costumes[5] but she was also there to discuss the purchasing of couture in Paris. Audrey was given instructions to buy a dark suit that could be worn in the first week of June, 'the type she would wear crossing the Atlantic by plane and arriving in upstate New York by train.' But she was also advised by Edith to make sure she did not 'select dead black or dead white. We would suggest dark blue or oxford or charcoal grey.' Extreme black and whites did not show up well on film, so costumes were usually made in derivations of tones. Several blouses were to be used with

Audrey Hepburn wears her hair fashionably cropped, with a checked shirt, little white shorts worn with espadrilles, and a pair of hoop earrings.

Sketched for Audrey Hepburn in 'Sabrina Fair'

the suit along with a selection of 'extreme French hats'. She would also need a 'very smart French day dress', which would be the now iconic bateau neckline cocktail dress.[6]

Gladys de Segonzac, wife of Paramount's Paris executive, worked in fashion and she suggested that Crystobal Balenciaga would be able to provide a fabulous wardrobe. Audrey was going on holiday with her mother to Biarritz, travelling straight from London to Bordeaux. Because she wasn't passing through Paris she would have to make a special trip and this would cost the studio in expenses. It was suggested that Gladys de Segonzac make some selections for Audrey to approve in August, when she could go via Paris on the way back to New York.[7] 'I am sure that Mrs De Segonzac would be most helpful in shopping with Hepburn,' said Russell Holman. 'Being in the Paris couture business, [she] knows Paris clothes better than Hepburn.'[8]

Edith Head discussed with Audrey that after she had tried on a sample of the clothes, she should change the colour and the material, 'as well as perhaps altering collars and cuffs', to ensure that the clothes weren't exactly like the original design. 'In other words, we do not want to select clothes from the latest Paris collections to use as is. Obviously we cannot afford to give any screen credit and the clothes as selected and modified by Hepburn should be under the guise of her own wardrobe, without reference to Paramount.'[9]

When Audrey arrived in Paris, Balenciaga was snowed under with preparing his latest collection for the autumn showings, so he suggested a young designer called Givenchy. The 26-year-old, who stood tall at six foot six, had worked for Balenciaga and was gaining a name for himself with his simple and elegant designs. When Audrey arrived at his shop at 8 Rue Alfred de

Left Edith Head sketched out several ideas for Audrey's shorts and shirt combination for the yacht scene.

Above When Sabrina was to go sailing with Linus, she needed something summery and easy to wear, so Edith dressed her in a checked shirt with the collar turned up, and little white shorts worn with espadrilles.

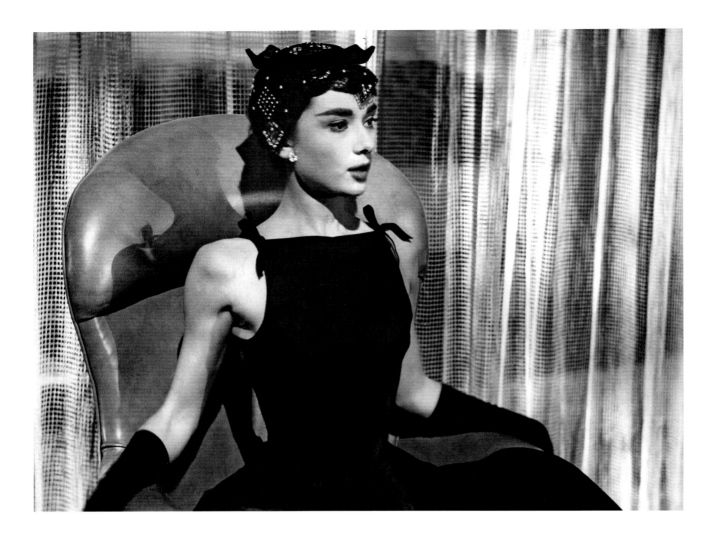

Vigny in July 1953, announced as Miss Hepburn, Givenchy naturally assumed it was Katharine Hepburn. Instead he met a thin, doe-eyed young woman in a striped t-shirt and Capri pants. Busy with his new line, he allowed her to select some items from his previous collection. 'My first impression was of some extremely delicate animal. She had such beautiful eyes, and she was so extraordinarily slender, so thin,' remembered Givenchy.

He explained to her he didn't have time to show her his collection personally, but she offered to choose pieces herself and demonstrated an understanding of her own style and what would compliment her figure. She selected three outfits – the wool double-breasted suit worn when arriving back from Paris, the ballgown which wows the rich society guests and a black cocktail dress with the celebrated bateau neckline, which she chose because it hid her prominent collar bones. 'Audrey says her wardrobe is exactly what she wants,' wrote Holman.[10] The total cost of the Givenchy wardrobe was around $850.[11]

Left Givenchy's black, bateau neckline cocktail dress, worn with a black, jewelled headscarf, boldly displayed Hepburn's thin arms and accentuated her tiny waist.

Below William Holden and Audrey Hepburn on location in New York. She favoured slacks, short heels or flats, and comfortable sweaters or shirts in her personal wardrobe, which was unusual but refreshing in an era of girdles and pointed bras.

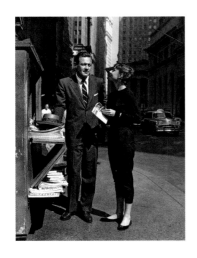

While the 'impact' costumes were Givenchy, Edith Head designed the remainder of Hepburn's wardrobe. There was the patterned shift dress worn over a long sleeve black top, as a mournful, mousy young girl watching the glamour of the Larrabee party while safely hidden in the trees. There was a pair of white shorts and a checked shirt knotted at the waist for the yachting scene with Humphrey Bogart, and for the costume described as a 'street outfit and light coat', she was dressed in slim black Capri pants worn with a high necked black top which plunges into a v-neck at the back, and accessorised with ballet flats and hoop earrings. Over this she wore a black wool coat.

Edith claimed the black, bateau neckline cocktail dress was her own design. The dress, with slim bodice and ballerina skirt, showed off Audrey's thin arms and emphasised her tiny 22-inch waist. The style was so popular that the neckline, with small straps fastened with bows, became known as the Sabrina neckline. Edith wrote in *The Dress Doctor*, 'I had to console myself with the dress, whose boat neckline was tied on each shoulder – widely known and copied as "the Sabrina neckline".' It was later revealed that the dress had been made at Paramount under Edith's supervision, but from a Givenchy sketch that had been sent over from Paris.[12] Givenchy wrote, 'What I invented for her ended up a style so popular that the t-shirts and boat neck dresses of the period became known as the "décolleté Sabrina".'

Sabrina's cinematographer Charles Lang Jr. was instructed to watch Audrey in *Roman Holiday*, 'so that he can familiarise himself with her face'.[13] Even though he was instructed to be careful of back lighting, to ensure her shoulders did not look bony in the strapless gown, audiences still commented on her thinness. In a preview showing, one viewer made the comment that 'Miss Hepburn's gowns do not do her justice. Her shoulders are not good and should be concealed. She is too thin to wear such gowns and the black dress is particularly offensive.'

Humphrey Bogart required dinner clothes, a Sunday suit and hat, a conservative business suit and homburg, an old well-worn sailing outfit, and a blazer and Yale cap for when he takes Sabrina sailing.[14]

When Edith won the Oscar for Best Costume Design in a Black and White film, she made no mention of Givenchy, and because the clothes had not been designed specifically for the film, it was acceptable for her to take all the credit. Givenchy recalled: 'They showed the film, and my name was mentioned nowhere. Imagine if I had received credit for *Sabrina* then, at the beginning of my career. It would have helped!'[15]

After *Sabrina*, Audrey requested Givenchy to design for all her films, as she felt confident and sure of herself in his clothes, as if they were protective wear. She said: 'His are the only clothes in which I am myself. He is far more than a couturier; he is a creator of personality.'[16]

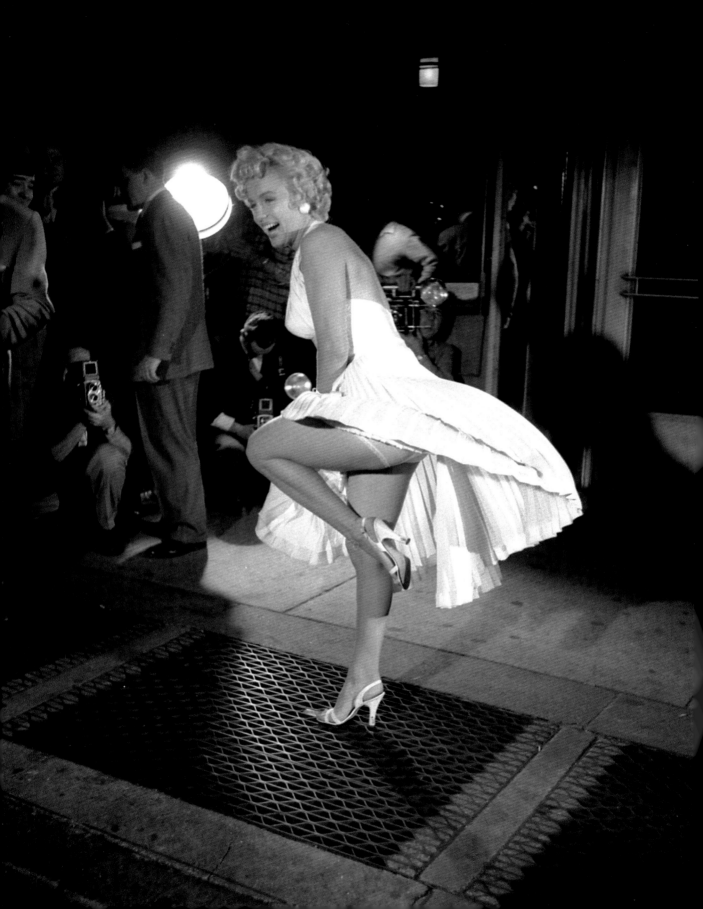

THE SEVEN YEAR ITCH 1955

Marilyn Monroe's white pleated dress, blowing up from the breeze of the subway vent, is arguably the most recognisable movie costume in history. It was a scene that only lasted for a minute, but was the biggest of her career. 'Oh, do you feel the breeze from the subway. Isn't it delicious!' she purrs as she stands over a subway vent, enjoying the air as a train rushes past and her skirt billows around her.

But for such an iconic image, Billy Wilder's *The Seven Year Itch* is a film that hasn't retained the same status. A Broadway smash in 1952, it shocked and thrilled its 1950s audience with themes of sex and adultery, but because this couldn't be shown on screen, George Axelrod's story was adapted so that Richard Sherman's affair with the Girl is just a fantasy.

Get the look with a white pleated halter neck dress, white strappy sandals and a halo of platinum blonde hair.

The Girl, a model who is renting the apartment above, was to look irresistible and Darryl Zanuck knew Marilyn Monroe would be perfect. He told Billy Wilder, 'In spite of the enormous success of this play on the stage it would not be, in my opinion, 50 per cent of the picture it will be with Marilyn Monroe. She is an absolute must for this story.'[1] She was tempting but innocent looking, and played the Girl as if she is completely unaware of the effect she has on men. In typical Monroe fashion, she conveys suggestive innocence. The Girl is interested in Sherman (played by Tom Ewell) partly because of his air-conditioning, and also because of his lack of suaveness. Conceited, good-looking men are constantly trying to impress her, and she likes Sherman because of his modesty. 'You're just elegant,' she compliments him.

The famous white dress had to demonstrate her beauty amidst the grey concrete of New York City, and look breezy on a sticky summer's day. The sun-burst pleated skirt was designed to catch the breeze, so it would blow up to reveal her legs. There was a wire support on the bodice to prevent any exposure that would shock the censors.

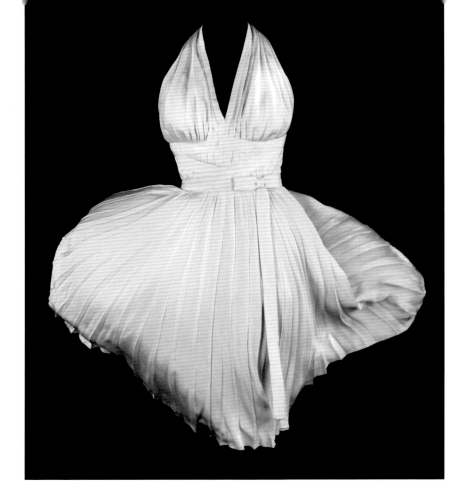

Left The fabric was ivory coloured rayon-acetate crepe, heavy enough to flow as she walked, and light enough to blow up. Natural fabric would not hold pleats, so Travilla used fabric with a percentage of man-made fibres to hold it into shape. It sold for $4.6 million at a 2011 auction in Beverley Hills.

Right William Travilla's costume sketch for the white subway dress

There were 'in-jokes' in the film that suggest the blurring between Marilyn and the Girl. 'Maybe it's Marilyn Monroe!' Sherman sarcastically replies when questioned as to the identity of the girl upstairs. Marilyn's nude shots were also alluded to when it is revealed that the Girl posed for nude shots in a book that Sherman happens to have on his book case. She even offers to sign it for him.

The white, pleated halter neck gown was worn in a scene where Sherman and the Girl have just been to the cinema to see *Creature from the Black Lagoon*. Designed by Monroe's favourite costumer, Billy Travilla, the dress was made from crepe fabric and was, as he would recall, 'cool and clean in a dirty, dirty city'. It was his favourite creation and was available to buy off the rack from his own fashion line in the 1980s.

Because she was to stand over a subway grate, Travilla said he 'wanted her to look fresh and clean . . . talcum-powdered and adorable. What would I give her that would blow in the breeze and be fun and pretty? I knew there would be a wind blowing, so that would require a skirt.'[2]

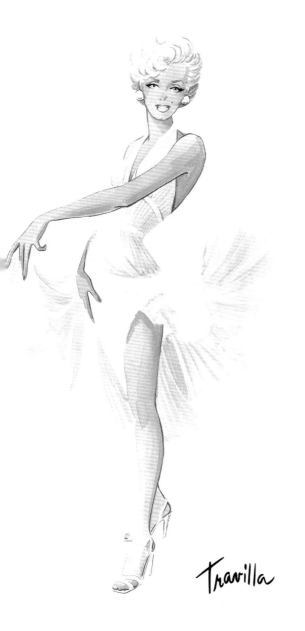

Travilla

Marilyn flew into New York for location shooting on 9 September 1954. Roy Craft, her PR, said 'the Russians could have invaded Manhattan, and nobody would have taken any notice,' such was the Marilyn fever in town.[3] The subway scene was shot outside the Trans-Lux Theater at 52nd Street and Lexington Avenue, and a press release was issued to tempt the media with Marilyn in a costume that would 'stop traffic'.[4] As one newspaper put it, it was 'the most interesting cheesecake display since Lady Godiva took her famous ride.'[5] 'A crowd of 1,500 fans whistled and cheered as the full expanse of Monroe's legs and ruffled white panties came into view. Once they booed, but that was because a sixty-foot trailer truck lumbered by and temporarily blocked the display.'[6]

Marilyn had only recently married baseball hero Joe DiMaggio in San Francisco. When she performed the subway scene late at night, with huge wind machines blowing up her skirt, DiMaggio stood at the side, getting angrier and angrier. Billy Wilder would later comment: 'I'd have been upset, you know, if there were 20,000 people watching my wife's skirt blow over her head.'[7]

At first her pants were too revealing, so Marilyn doubled up with an extra pair, but the crowds could still see enough to shock DiMaggio. The scene took many takes to get right, and all the while DiMaggio got more and more upset. He began to realise that her stardom clashed with his traditional views of how a wife should behave. That night they had a blazing row in their suite at the St Regis Hotel, which could be heard by production staff. Their divorce was announced a few weeks later. 'He didn't like the actors kissing me, and he didn't like my costumes,' said Marilyn. 'He didn't like anything about my movies, and he hated all my clothes. When I told him I had to dress the way I did, that it was part of my job, he said I should quit that job.'[8]

The skirt scene had to be re-shot at Fox studios in Hollywood as the crowd on Lexington Avenue had made too much noise. The image of her skirt going up was used in the publicity stills, and for the Time Square premier, a 52 foot high cut-out of Marilyn in the white dress was erected. 'That's the way they think of me, with my skirt over my head,' she joked.

The Seven Year Itch was given a 'morally objectionable' rating by the National Legion of Decency. It was ruled that the 'costuming, dialogue and situation' were 'suggestive'.[9] The Legion was worried about a scene were the plumber drops his wrench into the Girl's bubble bath and must retrieve it, and a line in the skirt blowing scene where the Girl says she feels sorry for men having to wear 'those hot pants'.

But Monroe, Wilder and a sparkling script proved to be a winning combination, and *The Seven Year Itch* was the biggest hit of the summer when it opened on Marilyn's 29th birthday, 1 June 1955.

Left Marilyn is ditzy but kittenishly alluring in cool, white dresses for a sweltering hot New York summer. She is first seen as a silhouette, and then stumbles through the door in a white polka dot halter neck dress.

Below The white terrycloth robe Marilyn wears after the bathtub scene also became iconic. It was the juxtaposition of sexy and innocent, and she could wear a robe as if it were a couture gown. In an early photoshoot in 1949, photographer Andre De Dienes captured Marilyn on a beach, her messed up hair around her shoulders, wearing simply a white dressing gown.

THE SEVEN YEAR ITCH 1955

REBEL WITHOUT A CAUSE 1955

Rebel without a Cause was the definitive film of 1950s disaffected youth, and one of the first to bring rebellious teenage gangs into the mainstream. From James Dean's trilogy of films, it is the one that cemented his image as cool rebel in jeans, t-shirts and vivid red windbreaker.

Jeans were originally heavy duty clothing for cowboys, and it wasn't until the fifties that they became a wardrobe staple for teenagers. When James Dean put on his Levi's an entire new look for teenagers was launched, and dressing down became the new rebellion.

Dealing with the subject of rebellious teenagers was controversial. The British Board of Censors was concerned about the 'harmful influence' it would have on young people. 'I do not have to tell you the serious view which this board takes about any film dealing with juvenile delinquency, especially in these times when there is such wide-spread public anxiety about the problem,' they warned.[1] Reviewer Bosley Crowther called it a 'violent, brutal and disturbing picture of modern teenagers.'[2]

Director Nicholas Ray carried out eight months of research to interview hundreds of police officers, judges, youth leaders, juvenile hall authorities and

Corey Allen as Buzz, leader of the gang, wears a leather jacket, white t-shirt and jeans turned up. James Dean wore Lee 101 Riders, without turn-ups.

teenage gangs. The principals were to be middle-class, not from slum districts, but it 'does not mean they are not hip or that they don't use bop talk'.[3] Acting alongside Dean were Natalie Wood, Dennis Hopper, Corey Allen and Nick Adams, who had previously worked with Dean on a 1950 Pepsi ad, where they danced around a juke box. After shooting the tough and complicated knife fight scene in black and white, Ray was told he would have to completely start afresh – this time filming it in Technicolor. Jack Warner had seen the dailies, and loved it so much that he wanted it to become one of Warner Brothers big pictures for 1955. 'Nick Ray should lose very little time in picking up in color the scenes he has already shot,' said Jack Warner. 'This is a very important picture.'[4]

During production, with the release of *East of Eden* (1955), James Dean's fanmail jumped from 400 letters a week to 1,200.[5] He was being catapulted into stardom and this would be the perfect film to showcase him as the teenage idol, in glorious Technicolor.[6]

Nicholas Ray was already shooting in Cinemascope, which opened up the LA cityscapes, creating a sense of alienation for the teenagers. Technicolor added an even greater dimension, bringing vivid colours onto the screen. As soon as he found out the important Technicolor change was to be made, Nick

James Dean wore the look of 1950s teen rebellion with a white t-shirt, classic blue jeans, a vivid red windbreaker and black work boots.

Left James Dean in the vivid red windbreaker that acts as a 'warning'.

Above right Jim was described in the final script as 'a good-looking kid of seventeen with a crew-cut and wearing a good suit.' The suit he wears in the first scenes separated him from the teenage gang, but it's when he dresses down in jeans that he starts to belong. Pluto wears black, reflecting his mood and feelings of despair and isolation.

Ray called in a colour consultant and they flicked through old copies of *Life* magazine for ideas. He chose to use primary colors in vivid blocks, creating symbolism through colour and costume. Natalie Wood as Judy would go from a bright red coat and red lipstick to represent her trampy, sexually confused persona in the opening scenes, to softer pinks as the film progresses. Sal Mineo as Plato would wear a black jacket and blue sweater, one black and one red sock, indicating his confusion, while Corey Allen, as hot-head Buzz, wore orange and yellows.[7] And of course, James Dean as Jim Stark would wear the bright red windbreaker. 'When you first see Jimmy in his red jacket against his black Merc, it's not just a pose. It's a warning, it's a sign,' said Nick Ray.[8]

There was poignancy for those watching *Rebel without a Cause* on release in October 1955, as James Dean had died tragically weeks before when he crashed his Porsche while speeding. While he would forever be connected with the teenage rebel role, James Dean was a 24-year-old student of the Method school of acting, who had some interesting hobbies including playing the bongos and collecting recordings of Israeli and Haitian music. 'Everybody on the set is becoming bongo happy after Dean did an impromptu session and caught on with other actors,' said press release.[9] But he raced to the set every

day on a British motorcycle and bought the fatal Porsche during production. He even asked for time off on Saturdays to take part in derbies.

Costume designer Moss Mabry spent several days at Los Angeles high schools observing the clothes and style of teenagers. He also recalled that Nick Ray showed him a picture from *Life* of a group of college students. 'I remember thinking, that's what he wants? That's what he got.'[10]

Mabry said the costumes were 'plain, simple everyday clothes'.[11] He gave the young stars access to the Warner Brothers wardrobe department and they rummaged through old costumes to find something that could be adapted to modern teenagers. Tom Bernard wore a leather jacket that had been worn by Alan Ladd in *Shane* (1953), while the fur collar on Natalie Wood's red dress had come from a costume of Bette Davis'. 'Bette Davis was such a big star, I thought it might bring me luck – or bring Natalie luck – if I put it on her.'[12]

The members of the motorbike gang were given leather jackets and jeans, and the wardrobe department aged and laundered more than 400 pairs of Levi's for the extras. 'It was learned that high school boys who wear Levi's always try to dirty the pants first and then have them washed three or four times to get that well-worn look,' said the Warner Brothers press department, which also declared that the cast and crew labelled the blue Levi's 'Deans Jeans', and that 'James Dean cuts his own hair. He calls it a "Jim Trim".'[13]

Teenage actor Frank Mazzola played one of the gang members, and had experience of it himself, having ridden with a motorbike gang, carrying switchblades and wearing leather jackets. He acted as advisor to Nick Ray and James Dean about the wardrobe, manner and speech of delinquents. He gave advice about the drag race and helped map out the fight sequence.[14]

While Nick Ray once recalled the red windbreaker came from the Red Cross, Frank Mazzola remembered going shopping with James Dean to Mattson's, a cheap Los Angeles clothing store to buy a blue Athenian jacket, which was then dyed red.[15] The Athenians were a Hollywood High fighting gang of which Mazzola had been a member. But in reality it was more likely Moss Mabry who created the jacket from scratch. In the 1950s costumes were

Right Child star Natalie Wood was in a transitional period of her career but after being cast as Judy, her hair was cut and styled and she wore the fitted dresses of a fifties teenager. 'No more pigtails, no more bobby socks, no more "nice little girl next door" parts. I've played daughter to about every top star in Hollywood. I can be a femme fatale, too,' she said.[21]

Below Offscreen James Dean wears the fifties rebel look of jeans, t-shirts and boots. Natalie Wood as Judy wears a buttoned down short sleeve sweater and a long, flowing skirt.[22]

handmade by wardrobe departments, rather than buying them off the rack. Ray had originally wanted Jim to wear a khaki army style jacket, but Mabry saw a guy in a red jacket, thought how amazing it was and so created a jacket and two duplicates from a fabric sample of red nylon he found in the wardrobe department. 'Even though the jacket looked simple, it wasn't. The pockets were in just the right place; the collar was just the right size.'[16] After wearing brown jackets and neutral colours, Jim puts the red jacket on over a white t-shirt and blue jeans to go to the chicken run. Immediately an iconic image was created, with the red standing out against the night landscapes. In 1955, the red windbreaker became an essential item for cool high school students.

As a successful child star Natalie Wood had grown up fast in Hollywood, and she was tired of playing the kid sister or daughter. When she heard about the role of Judy, she was desperate for it, as it would be a transition into more adult roles. Nick Ray saw Judy as 'ebullient, giving, a centre of attention, a girl who is living for the moment . . . at home she is lipstickless, appealing, docile demure.'[17] Debbie Reynolds was first considered, particularly from 'an exploitation standpoint' as her name could guarantee success, and blonde bombshell Jayne Mansfield was also tested. But Nick Ray thought that Warner Brothers could establish Natalie Wood as a star of their own. 'I'd be happy to close with her as I could start work on her voice – wardrobe – hair etc,' he said.[18]

'Physically I'm slight and small. I've been able to work right along because I never went through that awkward plump growing up stage with braces and the whole bit. When I was too young to play grown-up parts, I still could play a 12-year-old. Now I'm old enough to change to older roles,' said five foot two and ninety-four pound Natalie Wood in a 1955 interview.

Under instruction from Nick Ray, Moss Mabry and the wardrobe department transformed Natalie from 'choirboy' to high school senior. He padded out her hips and gave her a special uplifted bra to give her some degree of cleavage at least.[19] While Natalie was fond of piling on the make-up to make her look older than her years, in *Rebel* it was to be toned down, as Judy was essentially a girl-next-door despite her confusion. Hairdresser Jean Reilly styled her hair in a way that was appropriate for a 17-year-old girl. 'Young girls should never adopt a hairdo too sophisticated for their years,' she said.

James Dean had given Natalie her first screen kiss in a TV play called *I'm a Fool*, and she was crazy about him. According to Moss Mabry, they talked about him all the time in the dressing room, and she hoped that they would one day start dating.[20] It crossed over on to the screen. In the scenes in the abandoned house you can see the look of idolisation as she gazes up at him. 'It's just pulsating,' said Natalie. 'Jimmy generates theatrical electricity. Anyone playing with him can't help but feel his tempo and drive.'

HIGH SOCIETY 1956

The swinging musical remake of *The Philadelphia Story* opens with a Calypso number by Louis Armstrong and was peppered with musical numbers by Cole Porter, a duet with Frank Sinatra and Bing Crosby, and starred Grace Kelly in elegant fifties costumes.

High Society was unfavourably compared to the original movie, with the *New York Times* saying 'it misses the snap and the crackle that its unmusical predecessor had'.[1] Instead of Katharine Hepburn's 'beautifully nettled creature', Grace Kelly's Tracy Lord is 'more like a petulant girl who is almost apologetic for her occasional audacities'.[2] But as the *Hollywood Reporter* wrote, it was 'like attending the most marvellous house party in the world where the background is magnificent, the people are the nicest, and the entertainment so enchanting you wish it would go on and on.'

On the eve of her second marriage, Tracy Lord's first husband, sportsman and songwriter Dexter (Bing Crosby), arrives in Newport for the jazz festival. Also turning up at the door of the Lords' mansion is reporter Mike Connors (Frank Sinatra) and photographer Liz Imbrie (Celeste Holm), who are covering the wedding for *Spy* magazine.

Bing Crosby and Frank Sinatra performed for the first time together on screen, doing the famous *Well Did you Evah!*

The ballerina length wedding dress, 'a demure yet luxurious gown',[14] was made from embroidered white organdie layered over pink taffeta, and worn with a large picture hat.[15] As a sports reporter and jazz musician, Bing Crosby wore preppy sportswear, including a blazer, open-necked shirt and slacks.

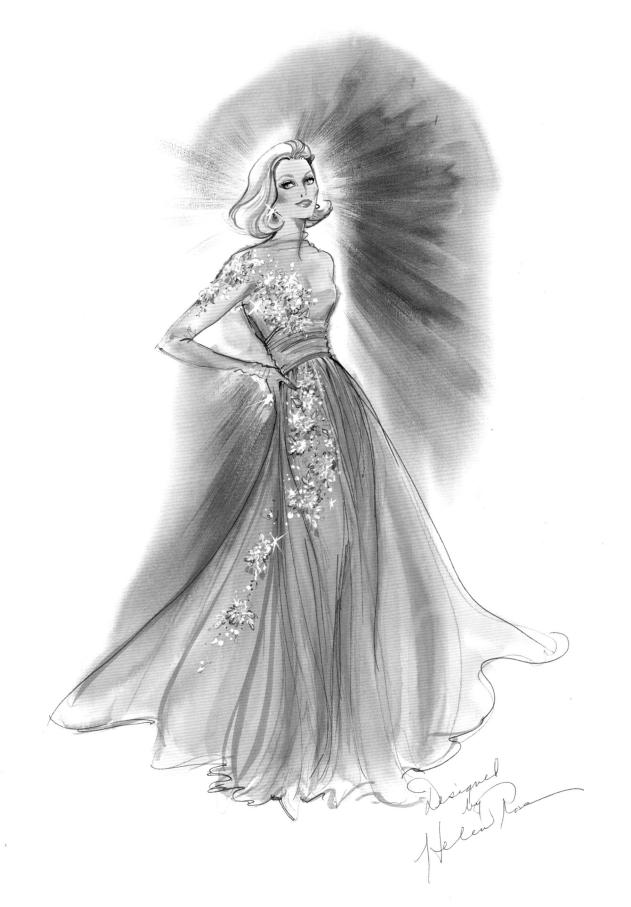

Designed by
Helen Rose

Left Helen Rose's costume sketch for the long sleeved, flowing evening dress. It was created with grey chiffon over a pink strapless under-layer, to give a barely-there covering over her arms and neckline. The grey fabric was scattered was diamante stones and floral embroidery.

Below Grace Kelly, pictured on set with Frank Sinatra, wears the pink and grey evening gown for the party scene.

routine, in matching tuxes. As *Collier's* magazine reported: 'Cut ups and old masters of the adlib, the crooners turned their rehearsals topsy turvy, invented dizzy dialogue while prancing through a deft soft-shoe routine.'[3]

Costumes in *High Society* were preppy but elegant in blues, beiges and dusky pinks. Bing Crosby wears sports jackets, cardigans, slacks and spectator shoes, Frank Sinatra wears the suits of a reporter and jazz musicians are dressed in boating hats. Celeste Holm, as photographer Liz, was given a smart charcoal suit with white trim, a beige cocktail dress and stole, and green chiffon cocktail dress and hat.

As in her personal life, Grace Kelly made casual clothes glamorous – shirt dresses, jeans, loafers and shirts, worn in a way that reeked of class. Her blonde hair is waved in a casual, but perfect way, and her clipped Philadelphia Main Line accent suited the part of blue-blood Tracy Lord.

MGM's chief costume designer Helen Rose said she created 'a complete daytime to evening collection of modern fashion'.[4] Tracy first appears in a neat beige shirt with rolled sleeves, beige slacks and a dark brown belt, which complements the beige and blue car that fiancé George arrives in. There's a smart yellow sleeveless shirt dress, a mustard Chinese style gown and a long hooded cream coat, lined with red silk.

Helen Rose previously dressed Grace Kelly in *Green Fire* (1954) and *Mogambo* (1953), and the actress was a particular favourite of hers. 'She had acting ability, she had beauty, she had the body to wear fashion. She knew what was right for her and she had good taste. Grace was not miss goody-two-shoes and she was not exactly a push over to please. While she was not unreasonably temperamental, she expected the very best and she got it . . . When I discussed any changes with her – whether it was period or modern, she would sit for hours with me and we would discuss

fabric, jewellery and all the details which go to make perfect grooming.'[5]

During filming of *Green Fire*, Grace's mother accompanied her to the fittings and one day she took Helen Rose aside, confiding that Grace could do with putting on a few more pounds. 'No designer ever considers a star too thin,' was Helen's reply. Celeste Holm remembered Grace dieting like crazy during filming. 'She would have grapefruit, honey and tea for lunch and nothing else. She was so slender that I thought it was a little odd, but she was so strong-minded, almost stubborn about it.'[6] In all likelihood Grace was dieting for her impending wedding to Prince Rainier of Monaco. She accepted his marriage proposal on 28 December 1955, and they planned the wedding while she filmed *High Society*.

Grace asked the director if she could wear her own engagement ring during filming, and arrived with a beautiful diamond ring on her finger.[7] She was also busy during production with a vast amount of press interviews, fittings for her wedding gown and trousseau and personal calls from friends wishing her well.

'Preparing the wardrobe for a film is a most exciting time. Even if it means standing some times for long hours of fittings,' wrote Grace, paying tribute to Helen Rose. 'Helen knew her job so well, and her enthusiasm was contagious. The fitters and seamstresses at MGM were top-flight, and they worked for perfection.'[8]

The pale blue and white striped chiffon gown gives her the appearance of little Bo Peep, and was designed to be overly fussy, as she puts on airs to scare off the reporters. As Tracy is described as being like a goddess by the men in her life, she was dressed to look the part. By the pool, she wears a white Grecian robe with drawstring, worn over a classic fifties white swimsuit.

While there was a wedding scene in *High Society*, another, more famous wedding gown was also being created during filming. MGM offered Grace the gift of a Helen Rose designed wedding dress. 'No studio designer had

Left Grace wears a classic fifties style swimsuit with a halter neck, clasps down the front and the side, and a little skirt.

Below Grace was given her *High Society* costumes as a gift from MGM, perhaps in the hope that she would resume her contract after her honeymoon. She liked them so much that they became part of her trousseau for her wedding to Rainier III, Prince of Monaco.

ever been asked to do anything like this before and I knew the eyes of the entire world would be on me and the MGM wardrobe department,' she said.[9] With a long sleeved, high necked bodice from antique rose point lace, embroidered seed pearls, and long silk and train, Grace said it was a 'dream' and 'far surpassed my imagination and hopes'.[10] The bridesmaids' dresses were based on the wedding dress from *High Society*.

Helen Rose liked to layer sheer fabric over a darker fabric underneath, creating the look and feel of a diaphanous chemise. This was used in several dresses for *High Society*, as well as for Grace Kelly in *The Swan* (1956), where white chiffon skims over a lace-sleeved ballgown.

The gown both Helen Rose and Grace Kelly liked the most was the evening dress 'of pale grey silk chiffon over dusty pink which gave it a translucent effect'. It was appliquéd with rhinestones and 'a cascade of pink carnations embroidered in silk floss'.[11] Grace liked the dress so much that she took it on honeymoon.

On the flashback to their honeymoon in the film, on board their yacht, *True Love*, Dexter wears 'well-worn yachting garb' with a cap, while Tracy wears jeans and a beige checked shirt. Although in the original wardrobe plan, she was to wear blue jeans and a pale blue shirt.[12]

This was the final scene filmed, as well as being Grace Kelly's last ever movie scene before retiring to her Monaco denizen. The end of shoot party also acted as a farewell party for Grace.[13]

CAT ON A HOT TIN ROOF 1958

The image of Elizabeth Taylor dressed in a white satin slip and clinging to the bed posts, is the one most commonly associated with the star. In *Cat on a Hot Tin Roof*, as the sultry Maggie the Cat, she practically invented the under-slip worn as outerwear, languorously staying cool in the southern heat.

The Tennessee Williams Pulitzer prize winning play that the film was based on is an erotically charged drama about a wealthy but dysfunctional family, who gather for an afternoon birthday party for the patriarch, Big Daddy, who is dying from cancer. His son, Brick, is alcoholic, impotent and in a leg cast, and grieving over the suicide of his close friend and homosexual lover, Skipper. Brick's sultry wife, Maggie, is used to being wanted by men, but desperately claws for her husband's affection. The play was directed by Elia Kazan and premiered on Broadway in 1955.

MGM swiftly bought the rights for a screen version, but the story was changed to comply with production codes which objected to any suggestion of homosexuality. This led to director George Cukor turning it down and Tennessee Williams calling for audiences to boycott it. Nevertheless it was nominated for six Academy Awards including Best Picture,

In the boudoir scenes, Elizabeth Taylor wore a pale pink lace trimmed slip with cream stilettos, simple diamond earrings and short hair, perfectly coiffed.

Best Director for Richard Brooks, Best Actor for Paul Newman as Brick and Best Actress for Elizabeth Taylor as Maggie.

As was typical for 1950s drama productions, the film was to be shot in black and white but when Taylor, with her violet eyes, and Newman with his bright blue eyes, were signed up, it was decided to shoot in colour.

As costume designer for MGM, Helen Rose was tasked with designing for some of Hollywood's most glamorous women, including Ava Gardner, Grace Kelly and Lana Turner. Her signature style was luxury, using chiffon, silks and fur in flowing, body flattering shapes. But *Cat on the Hot Tin Roof* 'was not exactly a designer's dream,' she said. 'There were only three changes of wardrobe in the entire picture; a slip, a skirt and blouse, and a short, simple afternoon frock which was worn throughout most of the film.'[1]

Maggie first wears a pencil skirt and blouse slashed with a red belt. She removes them in the bedroom while getting changed for the party to reveal an ivory, lace trimmed satin slip. Helen Rose spent $2,000 on creating this perfect slinky undergarment. 'Her figure was the best it had ever been and in the shell-pink satin and lace slip she was quite a woman,' said Rose.[2]

During pre-production preparation, Elizabeth went on a trip to Russia with her husband, but she promised to come in for a fitting the day she returned; one day before shooting started. For the first scenes on the shooting schedule, she was to wear the simple afternoon frock, which played an important part in the film.

Because director Richard Brooks and Helen Rose shared a similar eye for simple clothes, they would usually agree. He had signed off the slip, blouse and skirt, but they were still to come to a decision on the dress for the late afternoon birthday party. They both wanted it to be white and 'unobtrusive', so as not to detract from the impact of the scene. Richard was keen on a white silk tailored shirtwaist dress ('all men adore shirtwaists for women'[3]) but Helen was sure that Elizabeth would object to wearing something understated for a party scene. 'Knowing Elizabeth's figure and preferences, I suggested a white chiffon dress with draped Grecian bodice and short full skirts. I made sketches of both,' wrote Helen. In her workroom, Helen had a dressmaker's dummy for Elizabeth's figure so she could have the clothes almost completed before she came in for a fitting. But because they were rushed for time, only the shirtwaist dress was ready. Elizabeth came in the day after she returned from holiday, and tried on the other costumes, which she loved. But when she tried on the

The white chiffon 'Cat dress' has a draped Grecian bodice and short full skirt. A cinched in two-inch satin belt highlights the waist.

The Grecian styled bodice of the 'Cat dress' was created with complex draping, while the chiffon skirt swished gracefully as Elizabeth moved. Rose said: 'The bodice fit Elizabeth like she was poured into it and there was not one tiny wrinkle.'[12]

CAT ON A HOT TIN ROOF 1958

shirtwaist and saw herself in the mirror, 'her face fell'. The director was summoned in, and she told him, 'Love, I can't wear that – it looks awful on me.'[4] 'Darling, wear whatever makes you happy. I'll leave it to you and Helen. Just keep it simple,'[5] he replied. So Helen brought out the sketch for the white chiffon dress, and Elizabeth loved it. The wardrobe department worked through the night to get it ready for shooting the next day.

A week into shooting, Taylor's film producer husband, Mike Todd, was killed in a plane crash. Taylor had wanted to go with him on his trip to New York, but with a bad case of flu, she was under doctor's orders to stay in bed. Helen Rose rushed to Elizabeth's house when she heard the news. 'I have never seen anyone so grief stricken. Her whole life seemed to have come apart, and there were no words of comfort. For the next three days she lay in bed, hardly closing her eyes or eating, and tears seemed to flow without stopping.'[6]

With the tragedy, they were considering recasting or scrapping the film, but Elizabeth stoically went back on set to finish. Mike had been so enthused with the part, seeing it as a sure way to demonstrate her acting talents. On returning, Elizabeth sent Richard a card with the printed words Mrs Michael Todd scored out. She wrote: 'The flowers you sent me upon my return to the studio were lovely – thank you so much for your thoughtfulness. It is good being back working again with you.'[7]

When Helen launched her own ready-to-wear business, Helen Rose Inc., which specialised in evening gowns, she replicated the afternoon dress, which was to become known as the Cat dress. Despite being another 'short chiffon cocktail dress', it had something special. While the dress used for the film 'was a masterpiece of delicate draping which could not possibly be put into a commercial product', she simplified its construction for the mass market.[8]

The $250-dresses flew off the shelves of department stores, with orders coming

Below For day wear, Helen Rose dressed Taylor in a beige wool pencil skirt, cream short sleeved shirt, red belt and heeled shoes with bows on the front. She hitches up the skirt to straighten up her stockings, trying to catch the eye of her husband.

Right Paul Newman and Elizabeth Taylor go over the lines during a break from filming.

in by phone. They sold thousands of copies in different sizes and colours for ordinary women who were all seeking a little bit of the Taylor effect. 'Every woman who could afford $250 apparently wanted to look like "Maggie the Cat". We sold thousands of that one dress . . . it not only assured me financial success for several years, but eventually it was knocked off by another manufacturer who used an inexpensive non-silk chiffon and was able to wholesale it for $26.75.'[9]

Taylor loved the dress so much that she asked Helen to make replicas for her personal wardrobe. The dress would also be linked to the scandal of 1958, when Taylor ran off with Eddie Fisher, who was married to Debbie Reynolds. Fisher was a close friend of Mike Todd's, and he had comforted her at her most devastated time. Elizabeth was photographed in the press wearing many coloured versions of the gown.

Film reviewers praised Taylor's image on screen. *Motion Picture Daily* said she 'had never looked lovelier',[10] while *Variety* wrote, 'If any views exist that Miss Taylor's stunning qualities are just face and body, they should disappear with her portrayal of Maggie.'[11]

It would also launch Taylor into realms of serious actress, just as Mike Todd had predicted. She would be nominated for an Academy Award for this and her following film *Suddenly Last Summer* (1959), before winning her first Oscar for *Butterfield 8* (1960), as call girl Gloria, in costumes also by Helen Rose.

IMITATION OF LIFE 1959

Douglas Sirk's 1950s melodramas were often dismissed by critics of the time as banal and irrelevant, but he used irony, symbolism and colour to reflect important issues of the day. *Imitation of Life*, a remake of a 1934 movie starring Claudette Colbert, deals with mother and daughter relationships and the controversial topic of race and civil rights.

The original Fanny Hurst novel told of a white woman who starts a successful chain of restaurants with a recipe for waffles given to her by her black maid. In Sirk's remake Lana Turner is Lora Meredith, a mother who becomes a successful star on Broadway with help from her black assistant and friend Annie, played by Juanita Moore. As one of the few strong black characters on film in the 1950s, she was praised as being 'mature, beautiful and intelligent, she is not the "mammy" type that in the past has been associated with the role.'[1]

Imitation of Life was Universal's top-grossing film at the time, and in a controversial move was released simultaneously in segregated cinemas in the deep South. But despite the serious social issues, it also proved to be a fashion show for Lana Turner, who was given a $23,564 wardrobe by costume designer Jean-Louis and $1 million worth

Blonde waif Sandra Dee was seen as a wholesome young starlet, dressed in sweaters, blouses and Capri pants. Lana Turner was dripping in diamonds, and wrapped in satins and furs, as a wealthy 1950s Broadway star.

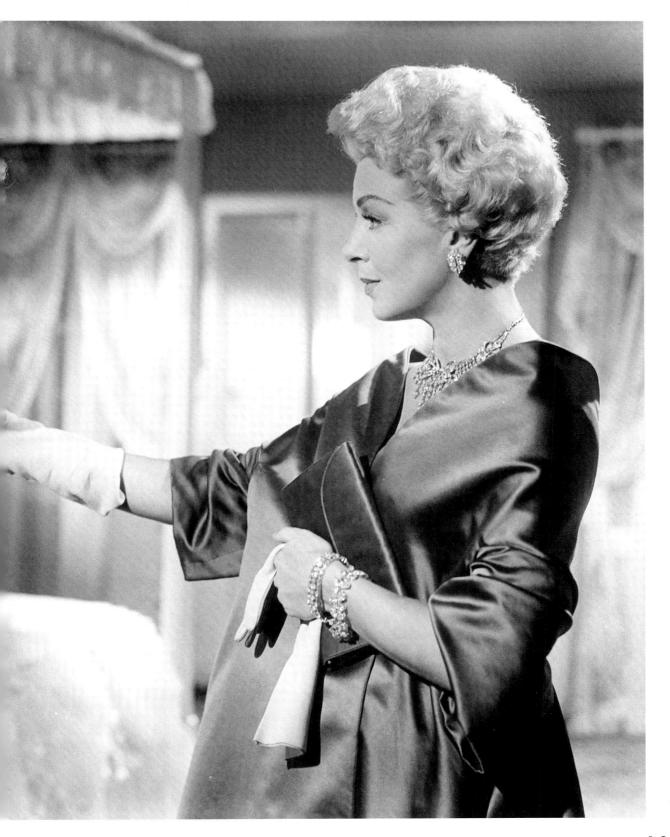

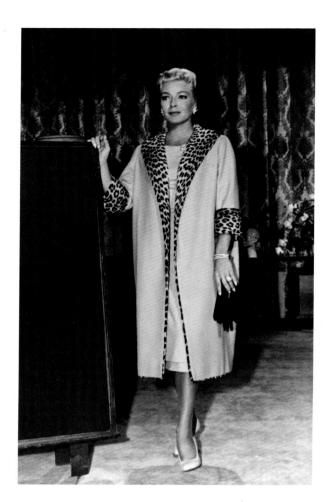
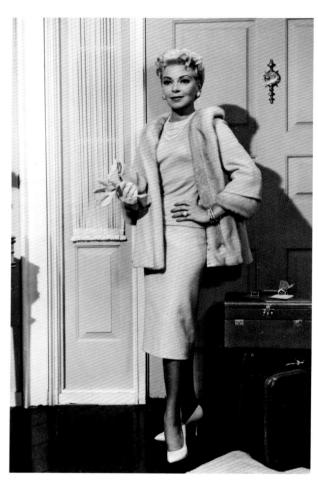

of jewels, watched over by armed guards. The studio press office boasted that she wore 'the most expensive wardrobe ever to gown a star in Universal history.'[2] 'They have given it about everything an audience wants including sex, high fashion, romance, youth appeal, an opulent leg show and glamour,' said *Reporter* magazine in 1959.[3]

As a huge movie star, Lana was treated like royalty by Douglas Sirk. Along with the expensive wardrobe, she was also given a 42-foot trailer with mirrored dressing room, stereo and electric kitchen – all the mod-cons for the late 1950s. A few days into production the trailer was remodelled. 'It was large enough for Lana, but too small for her movie wardrobe. We added on a wing to serve as king-sized closet,' said producer Ross Hunter.[4]

Her glamorous wardrobe was a rarity for late 1950s realism. Turner was fired from Otto Preminger's *Anatomy of Murder* (1959) when she wouldn't let up on having Jean-Louis design her costumes.[5] But Sirk granted her the wardrobe in his film as it is this extravagance that reveals the shallowness of Lora's life.

Left Wardrobe tests for Lana Turner, showing off her $23,564 wardrobe designed by Jean-Louis, including leopard trimmed coat, and pale pink sweater and skirt worn as she performs on stage.

Below While this Bill Thomas sketch was for Lana Turner, the cocktail dress was worn onscreen by Sandra Dee, in a scene where she tried to be more grown up than her years.

Lora has been called 'one of the coldest and strangest protagonists of Hollywood film'. She wears pale pinks, blues and whites, but 'Lora is anything but the soft, pastel-shaded person that pink implies.'[6]

Douglas Sirk recalled, 'Lana Turner told me, "Douglas, for the first time you have made me feel like an actress. It is not just being beautiful" – which, of course, is all she has ever been required to do. A sophisticated actress in this part would not have been any good. This character is supposed to be a lousy actress. She got to where she was by luck, or bullshit, or what-do-I-know, by dumb audiences. But she really grasped that part.'[7]

Lana Turner, known as the Sweater Girl, was famously discovered in a Hollywood drugstore in the 1930s sipping on a coca-cola. She got her name from the tight knits she wore in her film debut *They Won't Forget* (1937) and became an Armed Forces favourite during the Second World War. From the sweater girl look Lana morphed into a more sophisticated, but overly dressed style. According to her daughter Cheryl Crane, Lana went 'into a sultrier look as the years progressed, followed strikingly by a perfectly coiffed, regal style,' which 'made her look and act older than she was.'[8]

Lana was infamous for her love of mink and diamonds, and a tempestuous love life which in one notorious moment, ended in murder. In 1958 her daughter Cheryl stabbed Lana's gangster lover to death, and it was this real life event that gave *Imitation of Life* an extra edge – Sandra Dee playing a daughter in love with her mother's boyfriend. Because of the interest surrounding Lana Turner's first film role after the murder, the press had been invited to the set on the first day of filming. Lana walked on to the set confidently, her head held high, and the centre of attention.

She was wearing the simple blue and white gingham dress from the early scenes and Ross Hunter said, 'Lana looks just as good in gingham as she does in mink.'[9] At $670 for two copies of the dress, it was the cheapest in her wardrobe.[10] And for these early scenes she was given blonde hair extensions to indicate the younger, more youthful Lora. Hunter said Jean-Louis 'is as good

at creating an apron as a ballgown'.[11] Lana's wardrobe went from the blue tailored suit worn repeatedly for auditions, to the costume of a rich Broadway star. She was given satin wraps, coats with mink trim, and strapless lace cocktail dresses.

While Lana was dressed in expensive gowns and jewels, the other cast were costumed by Bill Thomas, Sirk's costume designer for ten other films. Prior to that he had worked as an apprentice to Walter Plunkett, costume designer on *Gone with the Wind*, and in 1961 would win an Oscar for *Spartacus*.

Thomas dressed Juanita Moore in dowdy housedresses and gave Susan Kohner as Sarah Jane and Sandra Dee as Susie the costumes for smart 1950s teenagers. Sarah Jane wears pencil skirts, belts and shirts, while Susie is more preppy in Capri pants and sweaters draped over her shoulders. As she falls for Steve, her mother's boyfriend, she becomes a doll-like version of her mother, in pale tailored clothes and carrying a little clutch bag.

At the start of filming, Lana gave Sandra Dee the famous sweater from *They Won't Forget*, as a good luck present. Sandra was set up as the next teen star with her role as a surfer girl in *Gidget* (1959). Columnist Louella Parsons even called her a 'peach-melba type honey with golden blonde hair'.

But Sandra Dee was battling her own demons, and throughout the filming of *Imitation of Life* was suffering from anorexia. Cast and crew tried to encourage her to eat, and make-up artist Bud Westmore would try to bribe her with a new lipstick if she would get a milkshake down her.[12]

Sirk used colour as metaphor, and this was particularly evident when representing Sarah Jane as she tries to pass for white, rejecting her mother Annie in the process. As she runs out of the school when her heritage is revealed, the bright red fire hydrant, the red Christmas sign and the red lunch box are almost screaming out at us. As Sam Stagg notes in his comprehensive book on the film, Sarah Jane's yellow clothes represented her 'high yellow' status, which was an expression that referred to light skinned

African Americans.[13] Sarah Jane wears a yellow dress, cardigan and shoes when she is beaten up by her white boyfriend, and Susie also speaks about buying Sarah Jane a yellow sweater. The colours of Harry's Club are garish reds and purples, which contrast with the cold blues and creams of Lora's world. The script described Sarah Jane in 'an abbreviated black, sequined, corset-like costume, with a short, feather-ruffled skirt', a 'wisp of a costume'.[14] Sarah Jane's attempt at cracking Hollywood is in a burlesque show, and Sirk said 'I wanted something with a certain feeling of cheapness about it.'[15] The *Rocking Chair Blues* number is an imitation of Lora's world, with the champagne and diamonds, but one that only a white woman can only live in.[16]

While Sirk's films, including *All That Heaven Allows* (1955) and *Imitation of Life*, were dismissed as garish melodrama when they were released, his directing style has gained recognition over the years. Directors Quentin Tarantino, Pedro Almodovar and Todd Haynes, particularly in his film *Far From Heaven* (2002), have all cited Sirk's influence.

Left Sarah Jane performs at a Los Angeles burlesque club in yellow corset, fishnet tights and long turquoise gloves.[17]

Above Sarah Jane and Annie argue on the streets outside Harry's Club. Sarah Jane wears an olive hued shirt and grey wool skirt, Annie in her drab coat Juanita Moore had to put on weight to give her the appropriate plump figure for Annie.

BREAKFAST AT TIFFANY'S 1961

It's that time of the morning when dawn has broken, but the city is still asleep. A yellow taxi pulls up on a deserted Fifth Avenue, outside the grandiose Tiffany's and Holly Golightly steps out, still in the black gown and pearls from the night before, but with large sunglasses to shield from the shock of daylight. She sips a coffee and takes a bite from a Danish as she gazes at the jewellery in the window, trying to get over her 'mean reds'. Holly considers herself 'top banana in the shock department' and takes $50 from rich men every time she goes to the powder room. Free-spirited, restless and escaping from a troubled past, Holly lives in a messy brownstone apartment where she keeps her telephone in a suitcase, drinks champagne for breakfast and looks after a cat with no name. *Breakfast at Tiffany's* is considered the ultimate Audrey Hepburn film. The elegant Givenchy gowns, large tortoiseshell sunglasses, beige belted raincoat, tiger-striped hair worn up in a beehive and long, elegant cigarette holders are still considered the ultimate in chic. The ASPCA even reported an increase in requests for orange cats on release of the film.

Hepburn was funny yet touching as kooky call girl Holly Golightly, a character she said was 'the jazziest of my career', and a complete change to the princesses and chauffeur's daughters she had played in the past. It was a very modern film in 1961, with its Henry Mancini soundtrack and sleek costumes, representing the shift from 1950s values into a more promiscuous

Holly Golightly's look is elegant, but simple, with oversized sunglasses, a pearl choker around the neck, hair swept up and a linear black gown.

The sleek black gown with cross detail at the back was worn with long, black satin gloves, sunglasses to blot out the morning light, a Tiffany necklace valued at $544,500 and a diamante hair ornament nestling in her beehive. Three copies were created – one is held at the Museum of Costume in Madrid, one at Maison Givenchy and one was given to Audrey. It was returned to Givenchy and in 2006 he donated it at auction for City of Joy Aid in India.[13] It sold for $800,000, making it one of the most expensive items of film memorabilia.

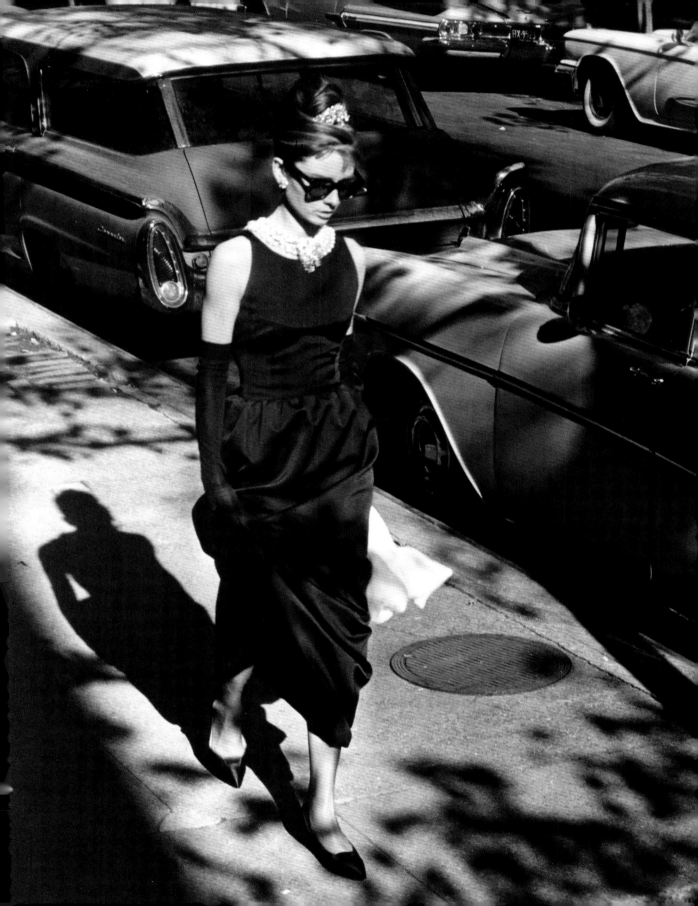

Left A black wide-brimmed hat with an enormous cream silk bow was worn with a little black shift dress and low heeled black shoes, on Holly's visit to Sing Sing. 'How do I look?' she asks, after hurriedly changing from an oversized shirt and eye mask. 'Very good. I must say I'm amazed,' George Peppard's Paul replies.

Below The hot pink silk cocktail dress studded with green rhinestones and with a pink bow around the waist, was sold for $192,000 at Christie's in New York.

decade. Hepburn was reticent of taking on the beloved character of American literature, not wanting to offend anyone who thought she wasn't right. 'I should be a stylish Holly Golightly. Even if that's all I can contribute,' she said.[1]

Truman Capote had envisioned Holly as a Marilyn Monroe type and believed that Audrey Hepburn was completely wrong for the part. He said: 'The book was really rather bitter, and Holly Golightly was real – a tough character, not an Audrey Hepburn type at all. Marilyn Monroe was my first choice to play her. I thought she would be perfect for the part. Holly had to have something touching about her – unfinished. Marilyn had that. But Paramount double crossed me and gave the part to Audrey Hepburn.'[2]

Audrey's sharp cheekbones and doe eyes were opposite to the Monroe look, and she was too regal to be the poor Midwestern runaway. But Capote's description of Holly in 'a slim, cool black dress, black sandals, a pearl choker', 'her chic thinness . . . an almost breakfast cereal air of health, a soap and lemon cleanness, a rough pink darkening in the cheeks,' and a 'pair of dark glasses blotted out her eyes' were just like Audrey's Holly.[3]

While Capote had written Holly as a prostitute, or an 'American Geisha', Audrey insisted Holly was a 'kook' and not a whore.[4] Press releases pushed the idea of this, with vignettes from the cast and crew offering definitions, such as co-star George Peppard's 'a kook is a girl who puts Scotch in the coffee', and producer Martin Jurow's 'a kook is a kitten who'll never grow up to be a cat'.[5] As *Life* magazine said, Holly is a 'slightly sleazy pixie' who 'is so enchantingly played by Audrey Hepburn that anything unsavoury in her character has been expunged.'[6]

To transform herself into Holly Golightly, Audrey's hair was streaked with blonde highlights, a look that made her feel 'jazzy' and 'a little kooky'.[7] She said, 'It helped to get me away from that primmer lady look, like nuns and princesses. It was nice to become a new girl as easily as that. I liked it so much, I decided to keep it for offscreen.'[8]

Edith Head was Paramount's chief designer and one of her big disappointments was that she was never given full control of dressing Hepburn. Once again Hubert de Givenchy designed Audrey's wardrobe. Edith had to settle for designing clothes for the extras and just a few of the 'dressed down' items worn by Audrey, including the man's shirt she wears to bed, and the blue jeans, grey sweater and cloth around her head as she sings *Moon River*. 'The real girl comes alive in the blue jeans. Every

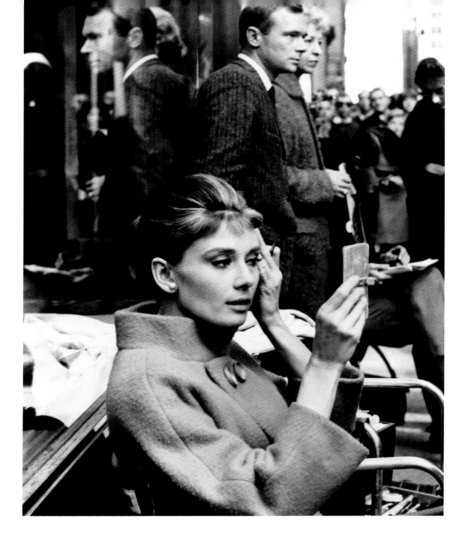

Left The double-breasted apricot wool coat worn in the shoplifting scene was much copied on release of the film. The funnel neck coat was classic Givenchy, and Audrey wore similar versions in *Charade* (1963) and in her personal wardrobe.

Right Patricia Neal, as 2-E, was also given a designer wardrobe by Pauline Trigiere. The designer understood perfectly what a wealthy Manhattan woman would wear, giving Patricia dramatic turbans, capes, tailored suits with elbow length sleeves and fur stoles.

woman is an actress in a Paris gown,' said Hepburn.[9] Even in the trench coat, sunglasses and headscarf worn at the bus station, and a polo neck and slacks, Audrey as Holly was sixties chic.

Hepburn flew into Los Angeles from her home in Switzerland, with 2-month-old son Sean and 36 large pieces of luggage filled with 'cocktail dresses, evening gowns, and other chi-chi apparel designed for her in Paris by Givenchy . . . This is the first time in pictures that Audrey has had so many changes and such a sophisticated wardrobe.'[10] 'Givenchy has designed lovely clothes for me in this picture,' Audrey told *Cosmopolitan* magazine in February 1961. 'He's my great love, and he's marvellous for me. I've been a good customer of his for many years. He made the first dresses I ever had from a good fashion house.'

In the novella, Holly has only one little black dress for the evening and another for the day, but Audrey was given a variation of black dresses, from the short day dress with a huge hat she wears to Sing Sing, to the long, sleek gown

worn in the opening. Possibly the most recognised gown is from the opening scene; a Givenchy straight lined, black, satin gown with cross straps at the back. Riccardo Tisci, creative director of Givenchy, said of the dress: 'It was 1961 and this dress is in a way very sixties. The front is severe, elegant, very clean, but at the back there is the very interesting neckline, somewhere between ethnic and Parisian; a softness that other designers in that time didn't have.'[11]

Costume designer Renie Conley remembered observing Edith Head taking one of Givenchy's gowns apart to create a copy. 'It was full of horsehair stuffing and lead weights to make it fall a certain way.'[12]

Audrey explained to Barbara Walters in a 1990 interview the reason she thought she appealed to women more than men. 'My looks are attainable because they can look like Audrey Hepburn if they want, by cutting off their hair, buying the large glasses, by wearing the little sleeveless dresses . . . I worked at it and the result has been a look which can be attained.'

MY FAIR LADY 1964

Cecil Beaton's Art Nouveau designs for *My Fair Lady* have become one of the most memorable of musical costume; a fantasy version of Edwardian London, with a sixties twist. The musical, based on George Bernard Shaw's *Pygmalion*, had a very successful run on Broadway and the West End, starring Julie Andrews and Rex Harrison. Cecil Beaton was the costume designer for the stage production, and he relished the challenge of recreating Edwardian London for the screen; it would be seen as the pinnacle of his costume design career. 'It's a very exciting job and one I would have hated anyone else to have done,' he said. 'Because it's a period that I love, I think it's very romantic, full of nostalgia and for me it brings back my earliest memories.'[1]

Beaton based the sets on moments from his past. The home of Professor Higgins was based on his doctor's home on Wimpole Street and Mrs Higgins' pastel parlour was inspired by Charles Rennie Mackintosh and the drawings of Kate Greenaway. In designing the costumes, Beaton flicked through early *Vogue* editions with their Art Nouveau covers – the magazines that had first inspired him to be a designer. A press release predicted that 'the Art Nouveau interior decoration and the Edwardian styles seen in *My Fair Lady* will have a great influence on homes and gowns when the picture is released.'[2]

Beaton worked with art director Gene Allen to depict Edwardian London as authentically as possible, and he spoke with director George Cukor about the little touches, such as 'the steam coming from the tea and coffee machines in the eating houses . . . the beautiful waving lilacs and other massed flowers on the barrows,' and women in Covent Garden 'with upturned bushels, in Eliza hats and white aprons shelling peas'.[3]

Audrey Hepburn had been asked by a journalist on the set of *Breakfast at Tiffany's* what her biggest ambition

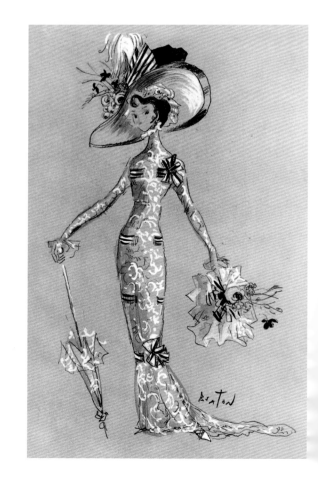

In the Ascot scene, Edwardian ladies pose, zebra-like, in black and white gowns, huge hats almost clashing together. Eliza enters in a tight white gown with black and white bows, and the enormous hat, with its splash of red and purple bursting out of the monochrome.

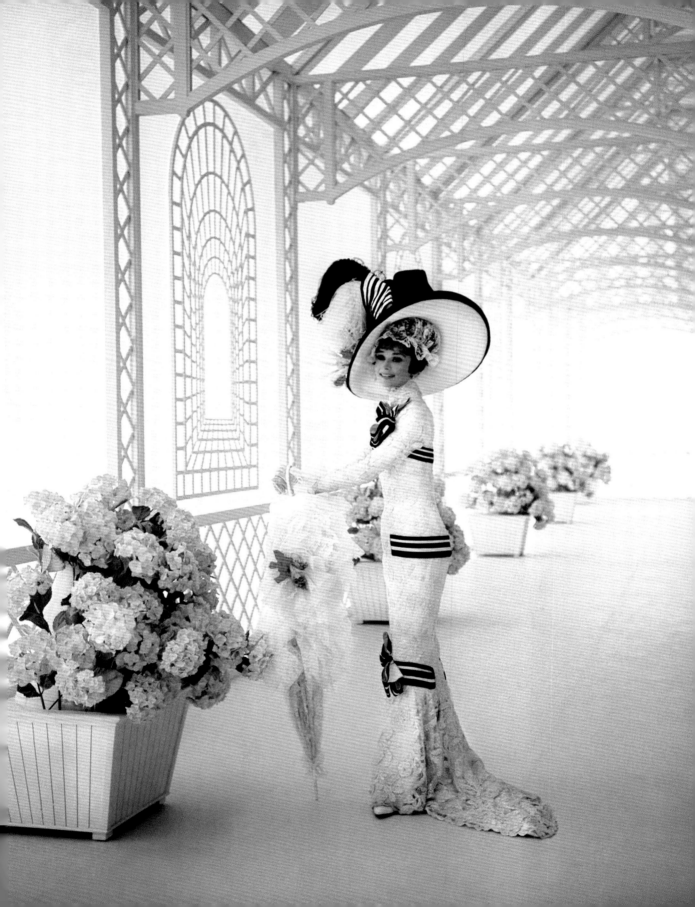

Left Cecil Beaton with the ladies in the hat department. An entire stage at Warner Brothers was taken up by the wardrobe and hat department, where milliners created hundreds of custom made hats. Audrey said, 'I'll never forget the sight of the enormous laboratory with hundreds of women sewing and doing and the beauty of the costumes which were on stands, of embroidery being done, of masses of beautiful aigrettes and feathers and velvets and ribbons, and violets, which had been made I don't know where.'[28]

Right Beaton photographed Audrey modeling some of the Ascot dresses. One design was based on Paul Poiret's 1913 sketch of his lampshade tunic – a black and white kimono style tunic, over a black hobble skirt.

was. 'That's easy. I'd do anything to play Eliza Doolittle,' she replied. 'I loved the show so much. There's no other role I'm dying to do. I just want to be Eliza. But I'm not alone, anybody would.'[4] She received the final script just as she was to leave for Madrid for a few days with husband Mel Ferrer, but she read it one afternoon while resting in bed. 'There are no words! It is all so good and so solid, warm, funny and enchanting . . . all the wonders of the musical and the play are there, it's just smashing!'[5]

Cukor wanted Audrey to look fresh, but slightly out of place. Not the Givenchy-clad sophisticate in previous films. 'Audrey has a marvellous wish to be as authentic as possible, and not to cheat in the way most stars would,' wrote Beaton. 'She is willing to be as ugly as anyone wishes in the early sequences, but she feels that when the time comes, she should be allowed to be beautiful.'[6] Beaton insisted Audrey wear her hair in the style of the day, with 'Gertie Miller bangs', even though she thought it made her face look square.[7] While many of the female extras wore heavy sixties eye make-up, Audrey went without her essential mascara and eyeliner, so Eliza would look young and fresh. 'Audrey's appearance without it will be quite a revolution and, let's hope, the end of all those black-eyed zombies of the fashion magazines,' wrote Beaton.

As the guttural, unkempt Eliza Doolittle, Audrey's hair was vaselined and thickened with fuller's earth, for that unwashed, tangled look. She had hoped she could get away with a few smudges of dirt, but her face and hands were smeared with grime, and dirt was pushed under her fingernails.[8] Her

one condolence was to spray herself liberally with Givenchy perfume, *L'Interdit*. 'I've got to do something to keep up my morale,' Audrey told Cukor.[9]

In *Pygmalion*, Shaw first describes Eliza as wearing 'a little sailor hat of black straw that has long been exposed to the dust and soot of London . . . a shoddy black coat that reaches nearly to her knees and is shaped to her waist.' Beaton followed the description closely, dressing her in bloomers, lace-up boots and woollen tights. Beaton recalled, 'When Audrey saw Eliza's thin green coat, drab skirts and black boater, she was so moved by compassion that she gulped – like a fish out of water.'[10] In the early fittings, Beaton said Audrey was in a cheerful mood, 'making rubber faces, speaking in Eliza's cockney accent joking with all adoring helpers.'[11]

After viewing the wardrobe tests for the black velveteen jacket that Eliza wears to visit Higgins for the first time, it was agreed that it looked far too elegant. Geoff Allan, 'a burly youth' from London, was an expert in ageing clothes, and he broke down the jacket. He dyed it darker, leaving the edges and the creases paler so as to look faded, then baked it in a furnace until it was brittle. He stained it as if she had spilt tea on it, and knifed the seams open.[12]

Cukor told the wardrobe department to start looking for old clothes to be worn in Covent Garden. He said he wanted to see 'real old, worn materials, and masses of them: vests and shirts and jerseys and coats on coats, and lots of petticoats under skirts . . . the poor people wore so much, layer on layer, and shawls on top of everything.'[13]

Rex Harrison suggested that they use his wardrobe from the West End production, which was still kept at the Drury Lane Theatre. He said, 'I still wear a variation of my original hat for private use but not the check because it became a little shall we say "overused!".'[14] Beaton was concerned that a

Eliza's dress for the final scene was to strike 'the right mood of romantic individualism'. After seeing Beaton's first sketch of the gown, Cukor wanted something 'more waspish and stylish'.[29] Finally he created a pale mauve muslin gown with a Charles Rennie Mackintosh rose on the bodice. 'It is like a froth built on Audrey,' said Beaton.[30]

double-breasted waistcoat would emphasise his girth, but Rex, to Beaton's surprise, was pleased with the costumes designed for him, including the cape-coat and Norfolk jacket.[15] 'The men's wardrobe could hardly believe their ears as suit after suit was pronounced equally successful,' wrote Beaton.[16]

Beaton designed individual black and white gowns for over a hundred female extras for the Ascot scene and some dresses were so tight that it was almost impossible to sit down. For authenticity, Beaton had the extras hold a particularly Edwardian stance called the Forzane slouch, with the hips pushed forward. Cukor had told Beaton that at Ascot, Eliza should seem 'overpowered by her finery', as if she couldn't quite carry it off. He wanted a costume that would 'work dramatically to accentuate the comic content of the scene.'[17] Audrey's now iconic white lace and silk ribbon gown with its hobble skirt was given distinctive black stripes. Even its lining, never seen on screen, was made from silk and lace.[18] There was a 'long and rather difficult fitting for her Ascot hat', said Beaton.[19] 'She looked incongruous under this enormous confection of lace, striped ribbon, ostrich feathers, lilac, wheat and rosebuds, wearing a print dress, ballet shoes and with her Yorkshire terrier on her lap.'[20] The hat had been designed to look beautiful yet hazardous, so that when she got over-excited when watching the race, 'the whole construction, with its bows and poppies, will wobble'.[21]

Eliza's ballgown was to be the show-stopper – the dress that represented her transformation from dirty flower girl to beautiful society lady. Eliza makes her dramatic entrance at the top of the staircase in a glistening peach empire gown, which Beaton compared to 'ice on trees in Switzerland'.[22] It was created from sequin, crystal and chenille embroidery taken from a genuine 1910 evening gown.[23] The dress was accessorised with long satin gloves and a diamond studded tiara once worn by Princess Alix of Hesse.[24]

Beaton had to get used to the constraints of Technicolor. The scarlet poppies on the Ascot hat became orange, and in long shots the black and white striped lacings and bows appeared green and yellow, so the fabric had to be dyed over and over.[25] Beaton said blue was particularly 'the devil incarnate', and Higgins' speckled tweed suits 'gave the effect of the screen twitching', while the braid designed to match the plum of Eliza's tuition dress came out very pale on camera.[26]

Beaton won two Academy Awards for the production – for Colour Costume Design and Colour Art Direction. Audrey received no nomination; some believing it was a deliberate snub for pipping Julie Andrews to the part. Audrey was hard on herself. 'From all the cables, articles and sweet letters I received, everybody seems to search for an explanation. It seems to me it is all very simple – my performance was not up to snuff . . . Because *My Fair Lady* meant so terribly much to me I had sort of secretly hoped for a nomination but never counted on an Oscar.'[27]

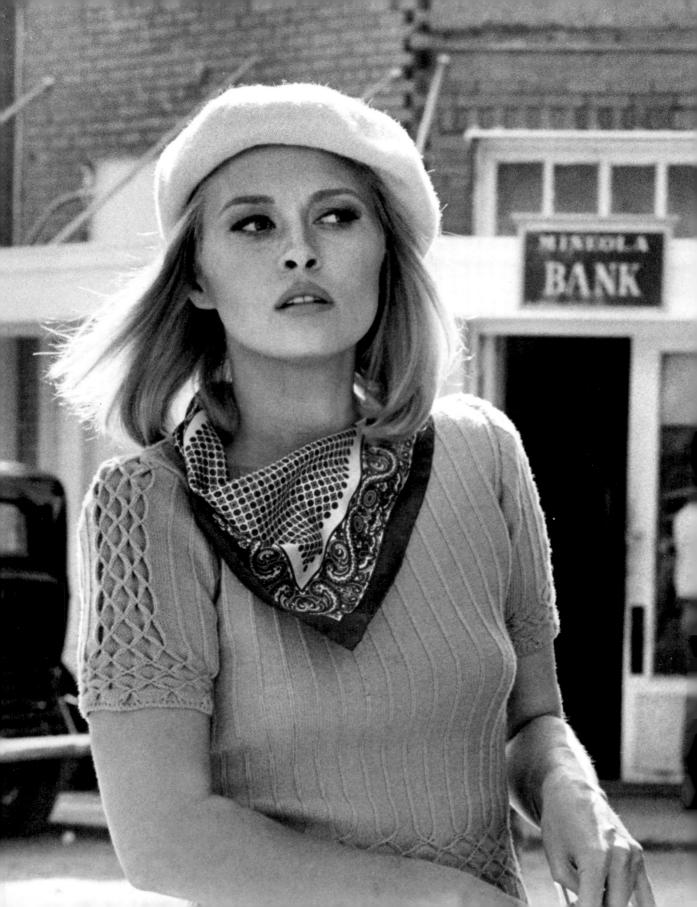

BONNIE AND CLYDE 1967

Bonnie and Clyde were the Depression era folklore heroes whose incarnation on screen in 1967 set a huge trend for pinstripes, midi skirts and berets.

With its dust bowl settings, Flatt and Scruggs banjo music, vintage Ford coupés and the small towns shutting up shop as they fell victim to the Depression, *Bonnie and Clyde* struck a chord with sixties audiences. But it was Theadora Van Runkle's costume design that really shaped a nostalgic, glamorous view of the thirties. Van Runkle created such excitement with her designs that she would become an overnight sensation, sparking a dramatic drop in hem lengths and bringing a new lease of life to the beret industry.

> The Bonnie look is all about calf-skimming tweed pencil skirts, v-neck sweaters, patterned silk neck scarves and berets pulled down over soft bobbed hair.

Directed by Arthur Penn, *Bonnie and Clyde* was at the forefront of the New American cinema movement; emerging from the collapse of the studio system and fuelled by European New Wave cinema and the softening of censorship. Penn mixed realism, sex and violence with stylised glamour that broke with convention and moral codes.

Faye Dunaway and Warren Beatty, as the impossibly glamorous crime spree couple, captured the imagination of the young, idealistic audience who felt that they were also fighting against stuffy traditions and the repressive government who were sending young men to fight in Vietnam. Women in the sixties wanted more than their fifties counterparts – a career and control of their sex lives. The Bonnie Parker style was one of confidence that rejected the submissive 1950s girdles, perfectly coiffed hair and petticoats.

Writers David Newman and Robert Benton said that 'If Bonnie and Clyde were here today, they would be hip . . . It is about style and people who have style. It is about people whose style set them apart from their time and place

Faye Dunaway as Bonnie Parker in a tight mustard cable-knit sweater, a patterned silk neckerchief and beret – the classic Bonnie look.

so that they seemed odd and aberrant to the general run of society.'[1] Dorothy Jeakins was originally lined up as costume designer, but with other commitments, she recommended her sketch artist, Theadora Van Runkle, despite her lack of experience. Theadora said; 'The minute I read the first page I saw everything. I knew it was going to be fabulous.'[2]

Part of the success of the Bonnie and Clyde look, Theadora said, was that 'they wore clothes that people could wear to work and wear in their real lives.'[3] As a film based on folklore, the mythical Bonnie on screen was a softer and sexier version of reality. While Warren Beatty's Clyde had the matinee idol good looks, newspapers had called the real life Clyde a 'shifty young Texas thug who spoke with a whiny drawl.'[4]

Bonnie's costumes chart her development from bored Midwest waitress to bank robber. She begins the tale in the loose, crumpled pale peach button-down dress and a pair of flat ballet pumps, swinging her bag down the dust bowl streets as she sips on a coca-cola. But as the gang get into the swing of bank robbing her dress becomes more professional. The couple get dressed up for their first bank robbery and Bonnie wears a black beret, printed necktie and blue sweater, freshly purchased for their new 'business'. Clyde, who is nervous and sweating before committing their crime, wears a pinstripe suit but with a baker-boy cap, which creates the impression of a boy who wishes to be taken seriously as a robber.

Bonnie was a half-starved Depression era waif and Faye Dunaway was determined to shed twenty-five pounds before the start of filming. 'I spent weeks walking around my apartment and working out wearing a 12-pound weight belt, with smaller weights around my wrists to help me burn the pounds off faster. I only took the weights off to sleep and bathe. By the time I headed to Texas, where we were shooting the film, I was gaunt.'[5]

It wasn't just Bonnie who was given the stylish wardrobe. Beatty ensured he retained the looks of a movie star. In one scene he wears a white vest, but rather than looking like a period item, it shows off his arms to full effect and gives him the appearance of Marlon Brando. The glamour of the young couple, who become legends and celebrities in the Midwest, contrasts with the poor Depression farmers depicted in battered dungarees, dirt-stained shirts and straw hats.

But Theadora didn't think the public were ready for a complete thirties look. She rejected marceled hair, chiffon, and high-waisted trousers in favour of silk and tweed, but even this wasn't enough to entirely please her two stars. She recalled a huge argument with Beatty over his hair. 'I wanted him to wear his hair parted in the middle and cut high in the back. Warren thought I was insane

Warren Beatty as Clyde. His pinstriped suits, fedora and spats befitted a gangster on the make. But the pinstriped suit was not just for men. The New York Times reported that the Bonnie and Clyde style of 'white pinstripe on a dark grey or black suit, pinched waist and flaring trousers, is apparently holding on for young women and some young men'.[13]

FOR PRESIDENT

FRANKLIN D. ROOSEVELT

PROGRESS

and sexless, and Faye thought I didn't care how she looked. Faye thought I was trying to make her ugly.'[6]

Van Runkle used a bias cut so that the dresses would swing, and incorporated her own concepts with vintage pieces and fagoting detail, where threads are pulled out for a lacy look. During production, Theadora met legendary designer Edith Head briefly at International Silks and Woollens as she searched for buttons. 'I told her my project was set in the early thirties and she said, "Flowered chiffons, flowered chiffons!" I said no, I had been doing research and once Bonnie and Clyde had some money from robbing banks, they started wearing tailored clothes from the Marshall Fields catalogue.'[7]

The beret made something of a comeback after adorning Bonnie's blonde locks and production in the French town of Lourdes reportedly shot from 5,000 to 12,000 being produced each week. It had been a trend for confident young American women in the 1930s, as worn by Ginger Rogers and Joan Crawford, but had fallen out of fashion. Theadora said: 'The beret was the final culmination of the silhouette. In it, she combined all the visual elements of elegance and chic. Without the beret it would have been charming, but not the same.'[8]

Left Costume sketches by Theadora Van Runkle show a belted tweed jacket with matching midi skirt, worn with a black beret and flat pumps. Written beside it is 'They have $ for clothes at last.' As a career girl who discovers her own niche with bank robbery, Bonnie adopts a powerful and professional look. Like the trouser suits of Marlene Dietrich and Katharine Hepburn, Bonnie's style is masculine with a feminine twist.

Above In a scene that reflected the real life Bonnie and Clyde, the bank robbers take provocative photos to enhance their sense of glamour. Clyde's waistcoat, white shirt and trilby give him the look of a renegade figure from the Wild West. Bonnie is the professional career girl in black blazer and flowing skirt, taking a cigar from Clyde, hitching up her skirt and holding the gun at her hip. Buck Barrow may be in a battered leather jacket and his wife dressed in a prim 1930s dress and cloche, but soon they will cast this aside and dress up for a life of crime.

The film was at first not well received in America. The *New York Times* review in August 1967 called it 'a cheap piece of bald-faced slapstick comedy that treats the hideous depredations of that sleazy, moronic pair as though they were as full of fun and frolic as the jazz-age cut-ups in *Thoroughly Modern Millie*.'[9] Despite the bad reviews in the States, *Bonnie and Clyde* was a huge hit in Britain, where the Bonnie look quickly caught on. When *Time* magazine featured the film on its front cover in December 1967, heralding a new wave of American cinema, the public and critics paid attention.

Theadora said: 'Bonnie and Clyde slept in cars and crummy auto courts; their clothes had to be livable. That's why they've been so successful now.'[10] Bonnie fever swept through Paris and London in 1967, and New York soon followed suit. Berets, neckties and mid-length skirts were requisite for smart young things, and Faye Dunaway even adopted the look off screen. 'The clothes are divine,' she said, 'they're masculine styles but in a feminine way.'[11]

When Faye Dunaway attended the French premiere of what was her first major movie, a crowd of thousands had gathered outside the Cinematique in Paris just to meet the star, many with bobbed haircuts and berets. In London, as she walked along the King's Road one day she was snapped by a fashion photographer, who was quite unaware of who she was. 'I was wearing a dark midi skirt, a belted sweater and a beret. A few days later a photo showed up in a story about how the Bonnie look was all the rage. No one, including the photographer, made the connection that I was Bonnie,' she wrote in her autobiography.[12]

THE THOMAS CROWN AFFAIR 1968

King of cool Steve McQueen had made a name for himself as the tough rebel in films like *Bullitt* (1968) and *The Great Escape* (1963), but in Norman Jewison's 1968 crime caper, *The Thomas Crown Affair*, he took on an entirely new character. 'I thought of changing my screen image for more than a year. I felt it was time to get past those tough, uptight types,' he said.

When Steve McQueen read the script, originally titled *The Crown Caper*, he immediately wanted to do it. He saw Thomas Crown as being a rebel, like him, only from the right side of the tracks. But Norman Jewison had envisioned Sean Connery or Jack Lemmon in the role. 'Tommy Crown wore silk skirts and Boston ties, a kind of sardonic, upper-class shit, unlike anything Steve had ever done before,' said Jewison. And that's why he wanted it. He said Tommy was his 'kind of cat'.[1] As the ultra-rich rebel, he was billed as a 'new Steve McQueen', unrecognisable from his past roles. Instead of the tough guy trench coats, or jeans and sweaters, he was suited in expensive tailoring.[2]

As a 'kicky, mod-fashion insurance investigator',[3] Vicki Anderson gets by in a man's world, by being self assured, smart and sexy. She uses this to trap Crown, who she suspects is the mastermind behind a $2.6 million bank robbery. Faye Dunaway was the stylish Vicki, and she sizzled onscreen with

At the beach Faye Dunaway wears a yellow hand-knit sweater, white trousers, a headscarf and sunglasses. Steve McQueen was wealthy but cool in an open neck shirt and Persol sunglasses. As a motorhead, McQueen helped design the poppy-red dune buggy, with Pete Condos, an off-road vehicle builder.[23]

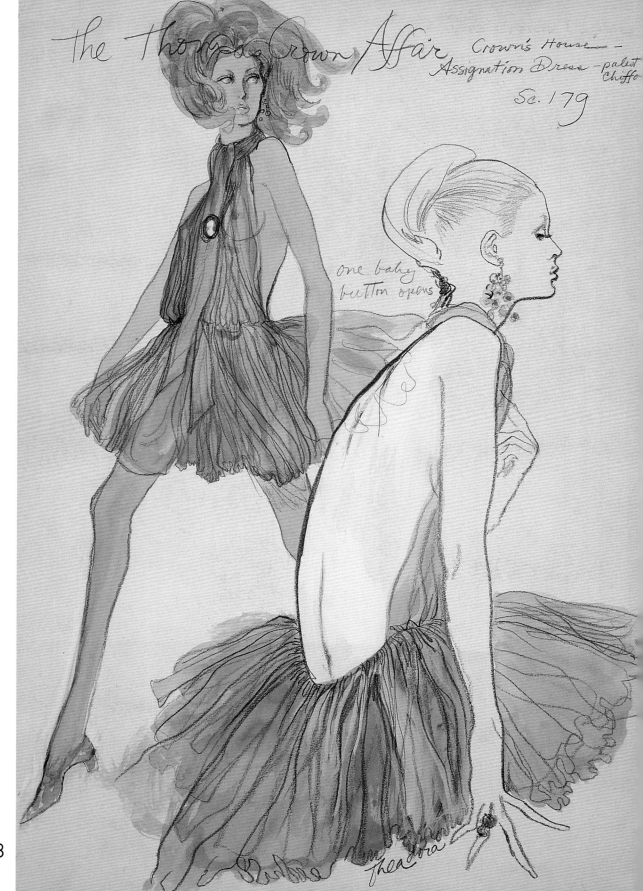

The Thomas Crown Affair Crown's House —
Assignation Dress — pale chiffon
Sc. 179

one baby
button opens

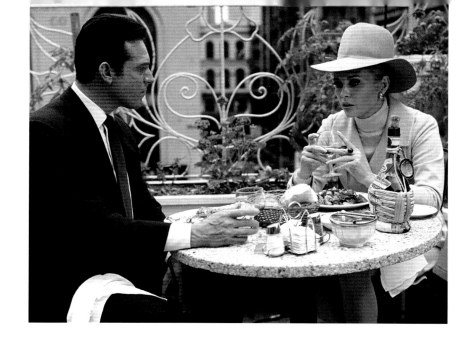

Left Theadora Van Runkle's costume sketch for the diaphanous beige pink dress worn for a steamy game of chess. It was backless, braless, and the draping was held together with a cameo brooch.

Right Paul Burke as Detective Eddie Malone with Faye Dunaway as Vicki Anderson. She wore a felt wide-brimmed hat, lilac polo neck and pale tailored blue suit and miniskirt. The *Hollywood Reporter* said Faye was 'perpetually fascinating, from the sleep-tossed natural radiance of her morning brunches, competing with zoom pull-aways to distant buildings, to the red-filtered glow of a scene played in a sauna bath.'[24]

McQueen, particularly during the now famous chess scene, which finished with a several minutes long camera-spinning kiss. Steve, Faye said, 'was darling' but 'daunting'.[4]

Norman Jewison wanted a hip but sophisticated 1960s look that would fit the upper class location of Beacon Hill in Boston. The heavily stylised film was soundtracked with *Windmills of Your Mind*, and used split screens that broke up into multi-coloured boxes, showing the action of different characters at the same time. The summer of 1967 was spent filming in many locations around Boston. Beacon Hill was used for Thomas Crown's mansion and Vicki's modern apartment and scenes were also filmed in Copp's Hill cemetery, the outdoor markets of Little Italy, and dunes near Provincetown.

Theadora Van Runkle, who got her first break on *Bonnie and Clyde* (1967), was hired as costume designer, teaming up once again with Faye Dunaway. The actress had been a champion of the designer, wearing her designs off screen and to the Academy Awards in 1968. Jewison called Theadora for an interview, and asked if she could draw as well as Bob Mackie. 'I said, "Better." And he said, "Well, I want to see that." When I showed him my drawings, he said, "Yeah, you are better." And we always got along. He was wonderful to me.'[5]

'I've been accused of being a clotheshorse – and this movie contributed to that,' said Faye.[6] There were twenty-nine costume changes for Faye, or thirty-one including a bed sheet and towel for the sauna scene. She wore huge hats, miniskirts, big belts, double-breasted coats and pleated suits worn with low-heels for a hip, modish 1960s look. The *Hollywood Reporter* said Dunaway

was 'cut from a *Harper's Bazaar* template . . . Fortunately she can wear practically anything with a command of fashion and may be able to spare Thea Van Runkle's more excessive costume absurdities from quickly dating the picture.'[7]

During the making of the film in summer 1967, before the release of *Bonnie and Clyde*, fashion was experiencing a transitional period 'when the counterculture and the youth quake movement was having its impact on the length of skirts, primarily, minis and the no-bra look.'[8] While *Bonnie and Clyde* would spark a trend for midi skirts which fell to the calf, for *The Thomas Crown Affair*, Theadora raised the hem to dress Faye in miniskirts. 'I said to Thea, "let's go very short, this woman doesn't do anything by half measure."'[9] Theadora originally envisioned knee-length skirts, 'but Faye wanted the skirts to be right up to her crotch. We got into a knock-down, drag-out over it and she won,' she said.[10]

Vicki's look is sixties excess. Her hair was sculpted into braided up-dos with the help of blonde hairpieces, and her long eyelashes and nails reflected the wide-eyed look of Twiggy and Liza Minnelli. To create even fuller lashes, two rows of fake eyelashes were layered on the top lashes and individual lashes glued on for the bottom. According to Faye, Steve didn't like the long nails at first, but after glancing at the notes on her script, 'he could see it wasn't a frivolous choice I had made. Those nails meant something.'

For the chess scene, the only direction in the script was 'chess with sex'. They play in front of a roaring fire, Faye toying with the chess pieces as she makes her move. 'Every man I've ever met since then, if we talk long enough, has mentioned the chess scene to me,' said Faye. 'It's the sensuality as well as the sexuality of it, the tease of it, that they liked.'[11] Theadora said, 'For one scene where Faye is obviously going to have a sexual encounter, I designed a dress of diaphanous flesh-coloured chiffon with just one button, at the neck. Faye wanted to wear jewellery that would symbolise control as counterpoint

Relaxing off camera, Steve McQueen wears a three-piece plaid suit, blue tie and shirt. Faye Dunaway's cream tailored suit and polka dot shirt was just the right amount of sixties hip.

Steve McQueen was sharp in Ivy League tailoring, while Faye Dunaway wore the modish sixties look of sculpted hair, long nails and suits or micro miniskirts.

to her passion. So I got a massive antique cameo pin, and we combined that tremendously sensual dress with that in-control, almost puritanical piece of jewellery.'[12] Faye said the brooch 'looks to be the only thing that keeps it all from falling in a heap at my feet.'[13]

When Vicki walks on Boston Common she wears a 'palest grey wool Norfolk, navy and white satin shirt and tie with an Adolfo bag'.[14] Theadora had asked Adolfo to design a Breton reptile bag especially for the film. 'Whatever I needed, I got,' she said, 'but I do remember that Norman didn't like it if I bought $350 purses for Faye, but, of course, I always did.'[15] For dinner, Vicki wears a chiffon brocade suit with a crimson and green ruffled blouse. On the costume sketch, Theadora noted 'The whole idea of this is that it should be highly fitted through the shoulders; set the arms eye in as far as humanly possible and then right under bust – the jacket gives way.'[16] Another costume was designed to give Faye the impression of being ruthless, 'so she wore a very understated sand-coloured linen suit. Her jewels were all carnelians and garnets: bloody jewellery because she was out for blood herself, and plotting.'[17]

Steve McQueen, who Theadora costumed in *Bullitt*, was relieved to see her as costume designer, as he trusted that the clothes would be good. 'Sometimes we had to put thirty pairs of trousers on him to get the right ones to make his behind look great.'[18] To get into the part, Steve McQueen learnt to play polo, was fitted out in tailored suits from Beverley Hills, and had his hair cut by celebrity stylist and good friend Jay Sebring, more famous now for being murdered by the Manson gang in 1969. The $10,000 wardrobe took some getting used to, and McQueen admitted that he 'fidgeted at first' in the $350 Glen-plaid suit by Ron Postal, worn in the opening scenes.[19] 'I loved the way he pulled his vest down, with a swift tug at the bottom, after I've just beaten him at chess,' said Faye.[20]

Suits were accessorised with a $2,225 Patek Philippe watch, Persol sunglasses and a gold Phi Beta Kappa key. 'I couldn't get used to the key, either. My fraternity emblem should be a couple of hub caps hanging from a tire chain.'[21] With McQueen, the epitome of cool, sporting their sunglasses, the Italian company Persol launched a Steve McQueen collection, with blue tint lens. He also elevated the Swiss Tag Heuer watch to iconic status when he wore it in *Le Mans* (1971).

On release, reviews were mixed. *Time* said it was 'a glimmering, empty film reminiscent of a haute couture model: stunning on the surface, concave and undernourished beneath.'[22]

ENDNOTES

CAMILLE

1 'Over the tea-cups', *Picture Play*, June 1921
2 Morris, Michael, *Madam Valentino* (Abbeville Press, New York, 1991), p.66
3 Ibid., p.71
4 Ibid., p.72
5 Walker, Alexander, *Rudolph Valentino*, (Stein and Day, New York, 1976), p.66
6 Bangley, Jimmy, 'An interview with Sydney Guilaroff', www.classicimages.com, January 1997
7 Morris (1991), p.80
8 Leider, Emily W., *Dark Lover: The Life and Death of Rudolph Valentino* (Faber and Faber, London, 2003), p.98
9 Walker (1976), p.35
10 Morris (1991), p.74
11 Leider (2003), p.137
12 Lavine, Robert, *In a Glamorous Fashion* (Scribner, New York, 1980), p.12
13 Ibid., p.7
14 Morris (1991), p.77
15 Leider (2003), p.135
16 Ibid., p.134
17 Walker (1976), p.37

OUR DANCING DAUGHTERS

1 Press book, Margaret Herrick Library
2 Ibid.
3 Fischer, Lucy, *Designing Women: Cinema, Art Deco and the Female Form* (Columbia University Press, New York, 2003), p.88
4 Chandler, Charlotte, *Not the Girl Next Door* (Simon & Schuster, New York, 2008), p.36
5 Cross, Joan, *Movie Weekly*, 27 March 1925
6 Crawford, Joan, *My Way of Life* (Simon & Schuster, New York, 1971), p.159
7 Core collection photographs, captions, Margaret Herrick Library

A WOMAN OF AFFAIRS

1 Ricci, Stefania (ed.), *Greta Garbo: The Mystery of Style* (Skira, Milan, 2010),p.13
2 Gutner, Howard, *Gowns by Adrian: The MGM Years 1928–1941* (Harry N. Abrams, New York, 2001), p.73

3 *Silver Screen*, March 1933, p.30
4 Adrian, 'The Garbo Girl Sways the Mode', *Screenland*, January 1929
5 Ibid.
6 Gutner (2001), p.75
7 *New York Times*, 21 January 1929
8 Gutner (2001), p.74

MOROCCO

1 Riva, Maria, *Marlene Dietrich* (Alfred A. Knopf, New York, 1993), p.85
2 von Sternberg, Josef, *Fun in a Chinese Laundry* (MacMillan, New York, 1965), p.245
3 Dietrich, Marlene, *My Life* (Pan Books, London, 1991), p.87
4 Head, Edith and Calistro, Paddy, *Edith Head's Hollywood* (Angel City Press, Los Angeles, 2008), p.36
5 Riva (1993), p.86
6 Press book, Margaret Herrick Library
7 von Sternberg (1965), p.246
8 Ibid., p.251
9 Fox, Patty, *Star Style* (Angel City Press, Los Angeles, 1995), p.52
10 von Sternberg (1965), p.242
11 *Motion Picture*, April 1933
12 von Sternberg (1965), p.252
13 Dietrich (1991), p.72

QUEEN CHRISTINA

1 Guntner, Howard, *Gowns by Adrian: The MGM Years 1928–1941* (Harry N. Abrams, New York, 2001), p.94
2 *Silver Screen*, March 1933, p.30
3 Ricci, Stefania (ed.), *Greta Garbo: The Mystery of Style* (Skira, Milan, 2010), p.155
4 *Picturegoer Weekly Supplement, Queen Christina*, 1933
5 Guntner (2001), p.87
6 *Picturegoer Weekly Supplement, Queen Christina*, 1933
7 Eyman, Scott, *Lion of Hollywood: The Life and Legend of Louis B. Mayer* (Robson, London, 2005), p.191

FLYING DOWN TO RIO

1 'Hollywood Voices', BBC interview, c.1974
2 Croce, Arlene, *The Fred Astaire and Ginger Rogers Book* (E.P. Dutton, New York, 1972), p.27
3 Fox, Patty, *Star Style* (Angel City Press, Los Angeles, 1995), p.38

4 Croce (1972), p.25
5 Richards, Dick, *Ginger: Salute to a Star* (Clifton Books, London, 1969), p.59
6 Fox (1995), p.32
7 Lavine, Robert, *In a Glamorous Fashion* (Scribner, New York, 1980), p.213
8 Ibid., p.213
9 'On Dress Parade', *Modern Screen*, March 1934, p.72
10 Croce (1972), p.26
11 Richards (1969), p.62
12 Ibid., p.63
13 'On Dress Parade', *Modern Screen*, March 1934, p.72
14 'Hollywood Voices', BBC interview, c.1974
15 Lavine (1980), p.80
16 'Hollywood Voices', BBC interview, c.1974
17 Fox, p.32
18 'On Dress Parade', *Modern Screen*, March 1934, p.72
19 Faris, Jocelyn, *Ginger Rogers: A Bio-Bibliography* (Greenwood Press, London, 1994), p.64

THE DANCING LADY

1 Crawford, Joan, *My Way of Life* (Simon & Schuster, New York, 1971), p.159
2 David O. Selznick to Mr Brock, inter-office memo, 13 January 1933
3 Colman, Wes, 'Fads: Hollywood Ideas that Spread Over the World', *Silver Screen*, October 1932
4 Newquist, Roy, *Conversations with Joan Crawford* (Citadel Press, Secaucus, New Jersey, 1980), p.57
5 Crawford (1971), p.163
6 *Silver Screen*, March 1933, p.30
7 Newquist (1980), p.62
8 Gutner, Howard, *Gowns by Adrian: The MGM Years 1928–1941* (Harry N. Abrams, New York, 2001), p.116
9 Newquist (1980), p.58

CLEOPATRA

1 Louvish, Simon, *Cecil B. DeMille and the Golden Calf* (Faber & Faber, London, 2007), p.180
2 Ibid., p.313
3 Ibid., p.326
4 Chierichetti, David, *Mitchell Leisen: Hollywood Director* (Photoventures Press, Los Angeles, 1995), p.43
5 'How to Get a Job in Hollywood', *Motion Picture*, June 1942
6 Surmelian, Leon, 'Studio Designer

Confesses', *Motion Picture*, December 1938

7 Tapert, Annette, *The Power of Glamour: The Women Who Defined the Magic of Stardom* (Crown, New York, 1998)

8 Staggs, Sam, *All About All About Eve* (St Martin's Press, New York, 2001), p.58

9 Louvish (2007), p.326

10 Lavine, Robert, *In a Glamorous Fashion* (Scribner, New York, 1980),p.38

11 Press book, Margaret Herrick Library

12 Ibid.

13 Whitney, Diane, 'Designer's Say Shorter Skirts!', *Shadowplay*, July 1934

JEZEBEL

1 *Chicago Daily News*, 5 April 1937

2 Letter from David O. Selznick to Jack Warner, 8 March 1938, USC Warner Brothers Archive

3 *New York Sun*, 11 March 1938

4 Louis Edelman to Hal Wallis, memo, 22 July 1937, USC Warner Brothers Archive

5 Press release, USC Warner Brothers Archive

6 First National Pictures press release, 20 April 1935, USC Warner Brothers Archive

7 Lavine, Robert, *In a Glamorous Fashion* (Scribner, New York, 1980), p.71

8 Ibid., p.75

9 DVD commentary

10 'William Wyler Directs Bette Davis in *Jezebel*', Columbia University Oral History Research Office

11 Ibid.

12 Press release, USC Warner Brothers Archive

13 Lavine (1980), p.75

14 'William Wyler Directs Bette Davis in *Jezebel*', Columbia University Oral History Research Office

15 Charles Einfeld to Hal Wallis, 15 April 1938, USC Warner Brothers Archive

16 *Chicago Daily News*, April 5 1938

GONE WITH THE WIND

1 Miss Mitchell's endorsement of cast, Atlanta Constitution, 16 January 1939, Margaret Herrick Library

2 Harmetz, Aljean, *On the Road to Tara: The Making of Gone with the Wind* (Harry N. Abrams, New York, 1996), p.176

3 Behlmer, Rudy, *Memo from David O. Selznick* (Viking Press, New York, 1972), p.197

4 Harmetz (1996), p.169

5 Ibid., p.191

6 Ibid., p.184

7 *Picture Play*, August 1939, p.43

8 Maeder, Edward, *Hollywood and History: Costume Design in Film* (Thames & Hudson, London / Los Angeles County Museum of Art, 1988)

9 Behlmer (1972), p.228

10 Molt, Cynthia Marylee, *Gone with the Wind on Film: A Complete Reference* (McFarland & Company, Jefferson, North Carolina, 1990), p.163

11 Ibid., p.179

12 Behlmer (1972), p.200

THE PHILADELPHIA STORY

1 Silver, Alain, *Movie Icons: Katharine Hepburn* (Taschen, Cologne, 2007), p.11

2 Chandler, Charlotte, *The Real Kate* (JR Books, London, 2010), p.129

3 Ibid., p.130

4 Ibid., p.132

5 Silver (2007), p.12

6 Esquevin, Christian, *Adrian: Silver Screen to Custom Label* (Monacelli Press, New York, 2007), p.43

7 Ibid.

8 Ibid., p.93

9 Gutner, Howard, *Gowns by Adrian: The MGM Years 1928–1941* (Harry N. Abrams, New York, 2001), p.54

10 Chandler (2010), p.135

11 Ibid., p.138

12 Wardrobe department records, 18 June 1940, Margaret Herrick Library

KITTY FOYLE

1 'On the Set with Kitty Foyle', *Modern Screen*, December 1940

2 *Life*, 2 March 1942

3 Rogers, Ginger, *Ginger: My Story* (Headline, London, 1991), p.332

4 Ibid., p.331

5 *Time*, 13 January 1941

6 Rogers (1991), p.339

7 'On the Set with Kitty Foyle', *Modern Screen*, December 1940

CASABLANCA

1 Miller, Frank, *Casablanca: As Time Goes By* (Virgin Books, London, 1993), p30

2 Wallis, Hal, *Starmaker* (Macmillan, New York, 1980), p.83

3 Hal Wallis to T. C. Wright, 21 April 1942, USC Warner Brothers Archive

4 Hal Wallis to Arthur Edeson, 2 June 1942, USC Warner Brothers Archive

5 Hal Wallis to Michael Curtiz, 21 May 1942, USC Warner Brothers Archive

6 Production notes, USC Warner Brothers Archive

7 Wallis (1980), p.86

8 'Kaleidoscope', BBC Radio Four, 27 October 1980

9 Hal Wallis to Perc Westmore, memo, 4 June 1942, USC Warner Brothers Archive

10 Hall Wallis to Michael Curtiz, memo, 3 June 1942, USC Warner Brothers Archive

11 Hal Wallis to Michael Curtiz, memo, 26 May 1942, USC Warner Brothers Archive

12 Hall Wallis to Michael Curtiz, memo, 3 June 1942, USC Warner Brothers Archive

13 Hal Wallis to Michael Curtiz, memo, 26 May 1942, USC Warner Brothers Archive

14 Harmetz, Aljean, *Round Up The Usual Suspects: The Making of Casablanca – Bogart, Bergman and World War II* (Weidenfeld & Nicolson, London, 1992), p.169

15 Press release, USC Warner Brothers Archive

16 Ibid.

17 Chandler, Charlotte, *Ingrid: A Personal Biography* (Simon & Schuster, London, 2007), p.90

18 Hall Wallis to Michael Curtiz, memo, 21 May 1942, USC Warner Brothers Archive

19 Ibid.

20 Miller (1993), p.90

21 Hal Wallis to Lee Katz, 28 May 1942, USC Warner Brothers Archive

22 Hal Wallis to Michael Curtiz, 3 June 1942, USC Warner Brothers Archive

23 Hal Wallis to Al Alleborn, 3 June 1942, USC Warner Brothers Archive

24 Miller (1993), p.160

COVER GIRL

1 Kobal, John, *Rita Hayworth: The Time, the Place, the Woman* (W.H. Allen,

London, 1977), p.169

2 Ibid.

3 Thomas, Bob, *King Cohn* (Putnam, New York, 1967), p.236

4 Kobal (1977), p.171

TO HAVE AND HAVE NOT

1 Publicity files, USC Warner Brothers Archive

2 Bacall, Lauren, *By Myself* (Ballantine Books, New York, 1980), p.118

3 *Motion Picture Daily*, 11 October 1944

4 'To Have and To Have Not', *Vanity Fair*, March 2011

5 'Howard Hawks: Slim and the Silver Fox', *BFI Sight and Sound*, February 2011

6 Bacall (1980), p.90

7 Markel, Helen, 'Easy Does It', *The Spokesman Review*, 12 May 1945

8 Bacall (1980), p.115

9 Morris, Mary, interview with Lauren Bacall, *PM*, December 1944

10 Joseph Breen to Jack Warner, memos and correspondence, 15 February 1944, USC Warner Brothers Archive

11 Morris (1944)

12 Cini, Zelda, 'Bill Travilla', *Studio*, September 1970

13 Morris (1944)

14 Herman Lissauer to Orry Kelly, memo, 19 January 1944, USC Warner Brothers Archive

15 *Detroit News*, February 1945

16 Steve Trilling to Jack Warner, memos and correspondence, 9 December 1943, USC Warner Brothers Archive

17 Advert, *Variety*, 17 January 1943, Marty Weiser Collection, Margaret Herrick Library

18 *Daily Express*, 26 January 1945

19 Marty Weiser to Alex Evelove, inter-office correspondence, 16 October 1944, Marty Weiser Collection, Margaret Herrick Library

20 Morris (1944)

21 Memos and correspondence, USC Warner Brothers Archive

MILDRED PIERCE

1 Press release, USC Warner Brothers Archive

2 Thomas, Bob, *Joan Crawford: A Biography* (The Chaucer Press, 1978), p.136

3 Newquist, Roy, *Conversations with Joan Crawford* (Citadel Press, Secaucus,

New Jersey, 1980), p.95

4 Gutner, Howard, *Gowns by Adrian: The MGM Years 1928–1941* (Harry N. Abrams, New York, 2001) p.143

5 Hedda Hopper column, USC Warner Brothers Archive

6 *New York Times*, 28 January 1945

7 Press release statement by Joan Crawford, USC Warner Brothers Archive

8 Jerry Wald to T.C. Wright, memo, 24 October 1944, USC Warner Brothers Archive

9 Press release statement by Joan Crawford, USC Warner Brothers Archive

10 Jerry Wald to Milo Anderson, inter-office memo, 5 February 1945, USC Warner Brothers Archive

11 Press release, USC Warner Brothers Archive

12 Press release statement by Joan Crawford, USC Warner Brothers Archive

13 Notes, 28 November 1944, USC Warner Brothers Archive

14 Press release, USC Warner Brothers Archive

15 Jerry Wald to Milo Anderson, clothes continuity for Joan Crawford, 27 November 1944, USC Warner Brothers Archive

16 Joseph Breen to Jack Warner, letter, 2 February 1944, USC Warner Brothers Archive

17 Ibid.

18 Jerry Wald to T.C. Wright, memo, 20 November 1944, USC Warner Brothers Archive

19 Ibid.

20 Production notes, USC Warner Brothers Archive

21 Norma Webb to Jerry Wald, box office digest, 27 September 1945, USC Warner Brothers Archive

22 Jerry Wald to Joan Crawford, telegram, 28 September 1945, USC Warner Brothers Archive

23 Jerry Wald to Milo Anderson, telegram, 28 September 1945, USC Warner Brothers Archive

GILDA

1 *Academy of Motion Pictures Arts and Sciences Magazine*, 20 July 1954

2 Ibid.

3 'Jean Louis and his First Ladies', *W*, 27 March – 3 April 1981

4 Kobal, John, *Rita Hayworth: The Time, the Place, the Woman* (W.H. Allen, London, 1977), p.205

5 McLean, Adrienne L., *Being Rita Hayworth* (Rutgers University Press, New Jersey, 2004), p.82

6 '$60,000 wardrobe', *Life*, 2 February 1946

7 Ibid.

8 Kobal (1977), p.209

9 Ibid., p.210

10 'Jean Louis: He Alluringly Underdressed the Superstars', *People*, 9 February 1987

11 Kobal (1977), p.208

12 'What happened to Gilda dress?', *Santa Barbara News*, 7 October 1990

13 'Jean Louis and his First Ladies', *W*, 27 March – 3 April 1981

14 '$60,000 wardrobe', *Life*, 2 February 1946

THE KILLERS

1 Gardner, Ava, *Ava: My Story* (Bantam, New York,1990), p.84

2 Ibid., p.87

3 Lavine, Robert, *In a Glamorous Fashion* (Scribner, New York, 1980), p.90

4 Production notes, Margaret Herrick Library

5 Gardner (1990), p.86

6 Server, Lee, *Ava Gardner: Love is Nothing* (St Martin's Press, New York, 2006), p.123

7 Gardner (1990), p.86

8 Ibid., p.114

9 Ibid., p.85

10 Press release, 8 May 1946, Margaret Herrick Library

11 Press release, 26 April 1946, Margaret Herrick Library

ALL ABOUT EVE

1 Joseph Mankiewicz to Darryl Zanuck, 31 January 1950, Joseph L. Mankiewicz papers, Margaret Herrick Library

2 Chierichetti, David, *Edith Head: The Life and Times of Hollywood's Celebrated Costume Designer* (Harper Collins, New York, 2003), p.112

3 Head, Edith and Calistro, Paddy, *Edith Head's Hollywood* (Angel City Press, Los Angeles, 2008) p.123

4 *Hollywood Reporter*, 43rd Anniversary Edition, November 1973

5 *Screen International*, October 1990

6 Staggs, Sam, *All About All About Eve* (St Martin's Press, New York, 2001), p.83

7 Spada, James, *More Than A Woman: An Intimate Biography of Bette Davis* (Bantam, New York, 1993), p.270

8 Staggs (2001), p.66

9 Ibid., p.138

10 Moore, Louis, Tait, Donald and Johnson, Julian, 'The Truth about All About Eve', *Action*, December 1950

11 Staggs (2001), p.68

12 Head and Calistro (2008), p.125

13 Sikov, Ed, *Dark Victory: The Life of Bette Davis* (Aurum, London, 2008), p.290

14 Liza Wilson to Hedda Hopper, 1950, Joseph L. Mankiewicz papers, Margaret Herrick Library

15 Joseph Mankiewicz answers questions from James Spada, 9 December 1991, Joseph L. Mankiewicz papers, Margaret Herrick Library

16 Head and Calistro (2008), preface

17 Edith Head, American Film Institute seminar, 1977

18 Staggs (2001), p.120

19 Head and Calistro (2008), p.124

20 Ibid., p.125

21 Staggs (2001), p.123

22 Ibid., p.94

23 Ibid., p.93

24 Spoto, Donald, *Marilyn Monroe: The Biography* (Harper Collins, New York, 1993), p.207

25 Core collection production photographs, Margeret Herrick Library

26 Joseph Mankiewicz to Darryl Zanuck, 5 May 1950, Joseph L. Mankiewicz papers, Margaret Herrick Library

A PLACE IN THE SUN

1 'Big Dig', *Time*, 22 August 1949

2 *Los Angeles Times*, 29 July 1951

3 Ibid.

4 Ibid.

5 *Variety*, 18 July 1951

6 Head, Edith and Calistro, Paddy, *Edith Head's Hollywood* (Angel City Press, Los Angeles, 2008), p.128

7 Ibid., p.128

8 *Photoplay*, July 1957

9 *Holiday*, August 1951

10 Head and Calistro (2008), p.126

11 Head, Edith and Kesner, Jane, *The Dress Doctor* (Little Brown, Boston, 1959)

12 *Vanity Fair*, March 1998

13 Head and Calistro (2008), p.127

14 Irene Dunne to George Stevens, telegram, 15 August 1951, George Stevens collection, Margaret Herrick Library

A STREETCAR NAMED DESIRE

1 Walker, Alexander, *The Life of Vivien Leigh* (Weidenfield & Nicolson, London, 1987), p.274

2 Lucinda Ballard obituary, *New York Times*, 20 August 1993

3 Walker, p.274

4 Ibid., p.269

5 Edwards, Anne, *Vivien Leigh: A Biography* (Simon & Schuster, London,1977), p.170

6 Elia Kazan to Jack Warner, memos and correspondence, USC Warner Brothers Archive

7 Ibid.

8 Ibid.

9 Ibid.

10 Walker (1987), p.271

11 Don Page to T.C. Wright, 24 July 1950, USC Warner Brothers Archive

12 Lucile Donovan to T.C. Wright, inter-office communication, 3 August 1950, USC Warner Brothers Archives

13 Don Page to T.C. Wright, 9 August 1950, USC Warner Brothers Archive

14 Walker (1987), p.272

15 Mens' wardrobe plot, USC Warner Brothers Archive

16 Press release, 5 March 1950, USC Warner Brothers Archive

17 Telegram to Jack Warner, 16 January 1952, USC Warner Brothers Archive

18 Nadoolman Landis, Deborah, *Dressed: A Century of Hollywood Costume Design* (HarperCollins, New York, 2007), p.197

19 Press release, USC Warner Brothers Archive

GENTLEMEN PREFER BLONDES

1 Production notes, Margaret Herrick Library

2 Russell, Jane, *An Autobiography* (Sidgwick & Jackson, London, 1986), p.58

3 James, Noah, *The Globe and Mail*, 19 June 1984

4 Russell (1986), p.119

5 Ibid., p.120

6 Motion Picture Association of America Production Code Administration Records, 14 November 1952, Margaret Herrick Library

7 Ibid.

8 Seder, Jennifer, 'Travilla's Monroe Doctrine', *Los Angeles Times*, 17 August 1979

9 Reilly, Maureen, *Hollywood Costume Design by Travilla* (Schiffer, Atglen, 2003), p.90

10 Ibid., p.87

11 Nadoolman Landis, Deborah, *Dressed: A Century of Hollywood Costume Design* (HarperCollins, New York, 2007) p.200

12 Summers, Anthony, *Goddess: The Secret Lives of Marilyn Monroe* (Victor Gollancz, London, 1985), p.82

13 Houston-Montgomery, Beauregard, interview with William Travilla, July 1986

FROM HERE TO ETERNITY

1 Zinnemann, Fred, *An Autobiography* (Bloomsbury, London, 1992), p.122

2 Ibid., p.123

3 Jerry Wald to Fred Zinnemann, Margaret Herrick Library

4 Joseph Breen to Harry Cohn, 4 August 1952, Margaret Herrick Library

5 Ibid.

6 Ibid.

TO CATCH A THIEF

1 Spoto, Donald, *Spellbound by Beauty: Alfred Hitchcock and his Leading Ladies*, (Hutchinson, London, 2008), p.143

2 Leigh, Wendy, *True Grace* (JR Books, London, 2008), p.51

3 Ibid., p.297

4 Head, Edith and Calistro, Paddy, *Edith Head's Hollywood* (Angel City Press, Los Angeles, 2008), p.139

5 Ibid.

6 Ibid., p.141

7 Robyns, Gwen, *Princess Grace*, (McKay, New York 1976), p.103

8 Head and Calistro (2008), p.140

9 Chierichetti, David, *Edith Head: The Life and Times of Hollywood's Celebrated Costume Designer* (Harper Collins, New York, 2003), p.128

10 Research file, Margaret Herrick Library

11 Head and Calistro (2008), p.138

SABRINA

1 Production files, Margaret Herrick Library
2 Head, Edith and Kesner, Jane, *The Dress Doctor* (Little Brown, Boston, 1959), p.103
3 Ibid., p.104
4 Memo, 5 June 1953, Margaret Herrick Library
5 Head, Edith and Calistro, Paddy, *Edith Head's Hollywood* (Angel City Press, Los Angeles, 2008)
6 Frank Caffey to Russell Holman, 5 June 1953, Margaret Herrick Library
7 Russell Holman to Frank Caffey, 18 June 1953, Margaret Herrick Library
8 Ibid.
9 Frank Caffey to Russell Holman, 27 June 1953, Margaret Herrick Library
10 Russell Holman to Jack Karp, 7 July 1953, Margaret Herrick Library
11 Russell Holman to Jack Karp, 9 July 1953, Margaret Herrick Library
12 Head and Calistro (2008), p.134
13 Billy Wilder to Jack Karp, 14 August 1953, Margaret Herrick Library
14 Wardrobe plot for Bogart, Margaret Herrick Library
15 Spoto, Donald, *Enchantment: The Life of Audrey Hepburn* (Hutchinson, London, 2006), p.86
16 Keogh, Pamela Clarke, *Audrey Style*, (Harper Collins, New York, 1999), p.37

THE SEVEN YEAR ITCH

1 Darryl Zanuck to Charles Feldman and Billy Wilder, memo, 20 September 1954, www.afi.com
2 Reilly, Maureen, *Hollywood Costume Design by Travilla* (Schiffer, Atglen, 2003), p.109
3 Summers, Anthony, *Goddess: The Secret Lives of Marilyn Monroe* (Victor Gollancz, London, 1985), p.102
4 Ibid.
5 *New York Journal American*, 15 September 1954
6 Ibid.
7 Evans, Mike, *The Marilyn Handbook*, (Spruce, London, 2004), p.228
8 Spoto, Donald, *Marilyn Monroe: The Biography* (Harper Collins, New York, 1993)
9 *New York Post*, 15 June 1955

REBEL WITHOUT A CAUSE

1 Story, memos and correspondence, British Board of Film Censors, 17 October 1955, USC Warner Brothers Archive
2 *New York Times*, 27 October 1955
3 Nicholas Ray to William Orr, story, memos and correspondence, casting, 13 December 1954, USC Warner Brothers Archive
4 Jack Warner to Dave Weisbart, story, memos and correspondence, 2 April 1955, USC Warner Brothers Archive
5 Production notes, USC Warner Brothers Archive
6 Frascella, Lawrence and Weisel, Al, *Live Fast and Die Young: The Wild Ride of Making Rebel Without A Cause* (Touchstone, New York, 2005), p.117
7 Ibid., p.119
8 Nadoolman Landis, Deborah, *Dressed: A Century of Hollywood Costume Design* (HarperCollins, New York, 2007) p.210
9 Press release, USC Warner Brothers Archive
10 Frascella and Weisel (2005), p.118
11 Ibid.
12 Ibid.
13 Press release, USC Warner Brothers Archive
14 David Weisbart to Steve Trilling, story, memos and correspondence, 28 March 1955, USC Warner Brothers Archive
15 Frascella and Weisel (2005), p.119
16 Ibid., p.120
17 Nick Ray to William Orr, 13 December 1954, USC Warner Brothers Archive
18 Nick Ray to David Weisbart, 1 March 1955, USC Warner Brothers Archive
19 Frascella and Weisel (2005), p.92
20 Ibid., p.165
21 Press release, USC Warner Brothers Archive

HIGH SOCIETY

1 *New York Times*, 10 August 1956
2 Bosley Crowther, *New York Times*, 12 August 1956
3 *Collier's*, 8 June 1956
4 Rose, Helen, *The Glamorous World of Helen Rose* (Rubidoux, Palm Springs, 1983), p.58
5 Rose, Helen, *Just Make them Beautiful* (Dennis-Landman Publishers, Santa Monica, 1976), p.102
6 Robyns, Gwen, *Princess Grace*, (McKay, New York 1976), p.138
7 Ibid.
8 Rose (1976), p.105
9 Ibid.
10 Ibid.
11 Ibid., p.104
12 Wardrobe department records, Margaret Herrick Library
13 *Los Angeles Times*, 7 March 1956
14 *Hollywood Reporter*, 17 July 1956
15 Haughland, H. Kristina, *Grace Kelly: Icon of Style to Royal Bride* (Yale University Press, New Haven and London, 2006), p.22

CAT ON A HOT TIN ROOF

1 Rose, Helen, *Just Make them Beautiful* (Dennis-Landman Publishers, Santa Monica, 1976), p.115
2 Ibid., p.116
3 Ibid.
4 Ibid.
5 Ibid.
6 Ibid., p.117
7 Production files, 18 April 1958, Margaret Herrick Library
8 Rose (1976), p.151
9 Ibid., p.152
10 *Motion Picture Daily*, 13 August 1958
11 *Variety*, 13 August 1958
12 Rose (1976), p.116

IMITATION OF LIFE

1 *Hollywood Reporter*, 3 February 1959
2 Fischer, Lucy, *Imitation of Life* (Rutgers, New Brunswick, 1991), p.237
3 *Hollywood Reporter*, 3 February 1959
4 Staggs, Sam, *Born to be Hurt: The Untold Story of Imitation of Life* (St Martin's Press, New York, 2009), p.83
5 Vallance, Tom, Jean Louis obituary, *The Independent*, 23 April 1997
6 Fischer (1991), p.282
7 Ibid.
8 Crane, Cheryl, *Lana: The Memories, the Myths, the Movies* (Running Press, Philadelphia, 2008), p.58
9 Staggs (2009), p.105
10 Ibid.
11 Ibid., p.255
12 Ibid., p.162
13 Ibid., p.127
14 Ibid., p.143

15 Fischer (1991), p.284
16 Ibid.
17 Staggs (2009), p.137

BREAKFAST AT TIFFANY'S

1 Archer, Eugene, *New York Times*, 9 October 1960
2 Spoto, Donald, *Enchantment: The Life of Audrey Hepburn* (Hutchinson, London, 2006), p.349
3 Capote, Truman, *Breakfast at Tiffany's* (Penguin, London, 1998), p.17
4 Press release, 19 October 1960
5 Press release, 26 October 1960
6 *Life*, 8 September 1961
7 Paramount press release, 3 May 1961
8 *Screen Stories*, December 1961, p.45
9 Press release, 10 November 1960
10 Press release, 19 September 1960
11 Bailey, Sarah, 'The Million Dollar Dress', *Harper's Bazaar*, November 2006
12 Chierichetti, David, *Edith Head: The Life and Times of Hollywood's Celebrated Costume Designer* (Harper Collins, New York, 2003), p.137
13 Nourmand, Tony, *Audrey Hepburn: The Paramount Years* (Boxtree, London, 2006), p.60

MY FAIR LADY

1 DVD, *The Making of My Fair Lady*
2 Letter, volume 1, no. 3, USC Warner Brothers Archive
3 Cecil Beaton to George Cukor, 14 September 1962, George Cukor collection, Margaret Herrick Library
4 'On Location with John Whitcomb', *Cosmopolitan*, February 1961
5 Audrey Hepburn to George Cukor, 6 April 1963, George Cukor collection, Margaret Herrick Library
6 Beaton, Cecil, *Cecil Beaton's Diaries: 1955–63, The Restless Years* (Weidenfeld & Nicolson, London, 1976), p.180
7 Beaton, Cecil, *Cecil Beaton's Fair Lady* (Weidenfeld & Nicolson, London, 1964), p.62
8 Press book, volume 4, USC Warner Arothers Archive
9 'My Fair Lady', *New York Times*, 29 September 1963
10 Beaton (1964), p.52
11 Ibid.
12 Ibid., p.64
13 Ibid., p.32
14 Rex Harrison to George Cukor, 18 October 1962, USC Warner Brothers Archive
15 Beaton (1964), p.46
16 Ibid., p.56
17 Ibid., p.30
18 *The Independent*, 27 July 2006
19 Beaton (1964), p.62
20 Press book, volume 1, p.179, USC Warner Brothers Archive
21 Beaton (1964), p.63
22 Beaton (1976), p.105
23 Beaton (1964), p.56
24 Press book, volume 4, USC Warner Brothers Arcive
25 Beaton (1964), p.67
26 Ibid.
27 Audrey Hepburn to George Cukor, 8 March 1965, George Cukor collection, Margaret Herrick Library
28 Vickers, Hugo, *Cecil Beaton* (Weidenfeld & Nicolson, London, 1993), p.467
29 Beaton (1964), p.52
30 Ibid., p.68

BONNIE AND CLYDE

1 Friedman, Lester D., *BFI Film Classics: Bonnie and Clyde* (BFI, London, 2000), p.16
2 DVD commentary
3 Lindstrom, Jan, 'Grande Dame: Theadora Van Runkle', *Daily Variety*, 22 February 2002
4 Toland, John, 'Sad Ballad of the Real Bonnie and Clyde', *New York Times Magazine*, 18 February 1968
5 Dunaway, Faye, *Looking for Gatsby* (Harper Collins, London, 1995), p.58
6 Livingstone, David, 'Designing Woman', *The Globe and Mail*, 11 May 1989
7 Chierichetti, David, *Edith Head: The Life and Times of Hollywood's Celebrated Costume Designer* (Harper Collins, New York, 2003), p.180
8 DVD commentary
9 Wake, Sandra and Hayden, Nicola, *The Bonnie and Clyde Book* (Lorrimer, London, 1972), p.221
10 Berger, Reva, 'Bonniest Fashions of All', *Los Angeles Times West*, 4 February 1968
11 *Women's Wear Daily*, 19 April 1967
12 Dunaway (1995), p.143
13 *New York Times*, 12 May 1968

THE THOMAS CROWN AFFAIR

1 Sandford, Christopher, *Steve McQueen: The Biography* (Harper Collins, London, 2002), p.196
2 Production notes, Margaret Herrick Library
3 Publicity release, Margaret Herrick Library
4 Dunaway, Faye, *Looking for Gatsby* (Harper Collins, London, 1995), p.164
5 Quintanilla, Michael, 'Screen Style: Dressing For An Affair', *Los Angeles Times*, 30 July 1999
6 Dunaway (1995), p.167
7 *Hollywood Reporter*, 19 June 1968
8 Quintanilla (1999)
9 Dunaway (1995), p.167
10 Quintanilla (1999)
11 Dunaway (1995), p.159
12 Production notes, Margaret Herrick Library
13 Dunaway (1995), p.158
14 Costume sketches, core collection photographs, Margaret Herrick Library
15 Quintanilla (1999)
16 Costume sketches, core collection photographs, Margaret Herrick Library
17 Production notes, Margaret Herrick Library
18 Quintanilla (1999)
19 Production notes, Margaret Herrick Library
20 Dunaway (1995), p.164
21 Production notes, Margaret Herrick Library
22 *Time*, Friday, 12 July 1968
23 Production notes, Margaret Herrick Library
24 *Hollywood Reporter*, 19 June 1968

INDEX

Page numbers in *italic* refer to illustrations and captions

ACKNOWLEDGEMENTS

I'd like to thank Andrew Dunn for originally commissioning this book and Nicki Davis and Maria Charalambous for doing such a great job in editing and designing it. It was pretty special to see all the words and photos laid out in such a fantastic way.

I also received some great help when it came to researching in LA. Sandra Aguilar and Jonathon Auxier at USC Warner Brothers Archive were both really accommodating. Staff at the Margaret Herrick Library were incredibly knowledgeable, and I would particularly like to thank Jenny Romero, Kristine Kreuger, Faye Thompson and Mary Mallory for their help.

To Charlie Hopewell Fraser (and Vicki) for taking my author portrait on a Sunday in Glasgow, to my parents for being supportive of everything and to my friends for being so enthusiastic when I told them about this book.

PICTURE CREDITS

Frances Lincoln Limited
www.franceslincoln.com

Half title page Costume designer Natacha Rambova with her husband Rudolph Valentino in 1923.

Title page Contact sheet from *Bonnie and Clyde* (1967).

Contents page Bette Davis as Julie Marsden in *Jezebel* (1938).